Walking in Art Education

Artwork Scholarship: International Perspectives in Education

Series editors: Anita Sinner and Rita L. Irwin
Print ISSN: 2632-7872 | **Online ISSN:** 2632-9182

The aim of the Artwork Scholarship series is to invite debate on, and provide an essential resource for, transnational scholars engaged in creative research involving visual, literary and performative arts. Approaches may include arts-based, practice-based, a/r/tography, artistic, research creation and more, and explore pedagogical and experimental perspectives, reflective and evaluative assessments, methodological deliberations, and ethical issues and concerns in relation to a host of topic areas in education.

In this series:

Provoking the Field: International Perspectives on Visual Arts PhDs in Education, edited by Anita Sinner, Rita L. Irwin, and Jeff Adams (2019)
Living Histories: Global Perspectives in Art Education, edited by Dustin Garnet and Anita Sinner (2022)
Community Arts Education: Transversal Global Perspectives, edited by Ching-Chiu Lin, Anita Sinner, and Rita L. Irwin (2023)
A/r/tography: Essential Readings and Conversations, edited by Rita L. Irwin, Alexandra Lasczik, Anita Sinner, and Valerie Triggs (2024)
Art, Sustainability and Learning Communities: Call to Action, edited by Raphael Vella and Victoria Pavlou (2024)
Walking in Art Education: Ecopedagogical and A/r/tographical Encounters, edited by Nicole Rallis, Ken Morimoto, Michele Sorensen, Valerie Triggs, and Rita L. Irwin (2024)

Walking in Art Education

ECOPEDAGOGICAL AND A/r/tOGRAPHICAL ENCOUNTERS

Edited by
Nicole Rallis, Ken Morimoto, Michele Sorensen,
Valerie Triggs, and Rita L. Irwin

Bristol, UK / Chicago, USA

First published in the UK in 2024 by
Intellect, The Mill, Parnall Road, Fishponds, Bristol, BS16 3JG, UK

First published in the USA in 2024 by
Intellect, The University of Chicago Press, 1427 E. 60th Street,
Chicago, IL 60637, USA

Copyright © 2024 Intellect Ltd

All rights reserved. No part of this publication may be reproduced, stored in a retrieval system or transmitted, in any form or by any means, electronic, mechanical, photocopying, recording or otherwise, without written permission.

A catalogue record for this book is available from the British Library.

Cover designer: Tanya Montefusco
Cover image: Takeshi Kawahito, *Painting through creative inquiry*, 2020. Photograph. Tokyo
Production editor: Laura Christopher
Series: Artwork Scholarship: International Perspectives on Education
Series editors: Anita Sinner and Rita L. Irwin
Typesetting: MPS Limited

Hardback print ISBN: 978-1-78938-919-7
ePDF ISBN: 978-1-78938-921-0
ePUB ISBN: 978-1-78938-920-3
Series ISSN 2632-7872 / Online ISSN 2632-9182

In dedication to all missing and murdered
Indigenous women and girls.

Contents

List of Figures		xi
Foreword		xv
Jocelyne Robinson		
Acknowledgements		xvii
Introduction: Encountering Kinship and Relationality		1
Nicole Rallis and Ken Morimoto		
Grounding	**Our Walks Begin with Prayer**	**11**
	Anna-Leah King	
Chapter 1	Mapping Five Months of *Treaty Walking*	15
	Sheena Koops, Michele Sorensen, and Valerie Triggs	
Grounding	**Being Anecdotal**	**31**
	Natalie Owl	
Chapter 2	Walking Trails Connected to the Thirteen Moons	35
	Jennifer MacDonald	
Grounding	***Noodinoon* ("The Winds"): A Life-Giving Force We Cannot See**	**49**
	Shelly Johnson	
Chapter 3	Conversations With Transitory Spaces: The Relationality of Tide, Time, and Transit on the St. Lawrence River	55
	Patricia Osler	
Grounding	**We Come from Walking**	**73**
	Shannon Leddy	
Chapter 4	Walking for Plant Re-Creation	77
	Jun Hu	

Grounding	**Lessons From the Forest** Cathy Rocke	**95**
Chapter 5	**Walking to Where the Grid Breaks Up: Accessing the Aesthetic** Valerie Triggs and Michele Sorensen	**99**
Grounding	**Walk, Walking, Walker** Gloria Ramirez	**119**
Chapter 6	**Don't Move! Desired, Hairy, and Forbidden Surface Encounters in (Motionless) Walking With Alpacas** Biljana C. Fredriksen and Isabel Scarborough	**123**
Grounding	***mosom* calls** Shauneen Pete	**141**
Chapter 7	**An A/r/tographic Inquiry of Yo/Haku and Warm Freeze: Returning to Land and Relationship During the Pandemic** Koichi Kasahara, Nanami Inoue, Mika Takahashi, Chiaki Hatakeyama, Yukito Nishida, Takeshi Kawahito, Naoko Kojima, Kanami Ban, Seisuke Ikeda, Momoka Kiyonaga, and Kanae Shimoji	**145**
Grounding	***Luu amhl goo'y gyalk ganiis* ["I Am Happy OutsidE ALWAYS"]: Ecopedagogical Interconnectedness to Indigenous Knowledge** Sheila Blackstock	**169**
Chapter 8	**Making Oddkin With Plantly Relations as Wayfaring Through Colonial Legacies** April Martin-Ko	**175**
Grounding	**Resonances and Re-Entanglements in an Era of Climate Change: Performing Reciprocity with the Cosmos** Peter Cole and Pat O'Riley	**189**
Chapter 9	**My Responsible Stewardship of a Place: The Mother Tree Taught Me How** Kwang Dae (Mitsy) Chung	**199**
Grounding	**Opening the Gate** Yasmin Dean	**215**

Contents

Chapter 10	Collapsing Landscapes: Walking as Acts of Belonging and Becoming Tormod Wallem Anundsen	219
Grounding	***Mihšwēndam dakīn ohtē kowōndosayān*—"I Love the Land From Where I Come"** Benjamin Ironstand	**231**
Chapter 11	(Random) Encounters in the Uncanny City Chrysogonus Siddha Malilang	237
Grounding	**My Body, My Spirit Is Tied to This Land** Marg Boyle	**255**
Notes on Contributors		**261**

Figures

2.1	Jennifer MacDonald. *Nose Hill Vignette*, 2019. Photograph. Calgary. © Jennifer MacDonald.	42
G3.1	Shelly Johnson. *Noodinoon ("the winds")*, 2019. Photograph. Kamloops. © Thompson Rivers University.	53
3.1	Patricia Osler. *Patterns of meaning-making*, 2019. Oil on canvas. Montreal. © Patricia Osler.	60
3.2	Patricia Osler. *Wind turbines*, 2019. Photograph. Montreal. © Patricia Osler.	66
3.3	Patricia Osler. *The shoreline*, 2019. Photograph. Montreal. © Patricia Osler.	67
4.1	Jun Hu. *Students classifying plants*, 2019. Photograph. Hangzhou. © Jun Hu.	83
4.2	Jun Hu. *Xiangxiang hammers on plants*, 2019. Photograph. Hangzhou. © Jun Hu.	85
4.3	Jun Hu. *Poster of exhibition New Legendary of Nine Treasures of Luding at Luding Bridge Primary School*, July 27, 2020. Photograph. Hangzhou. © Jun Hu.	89
G5.1	Cathy Rocke. *Fort Richmond park path*. Photograph. Regina. © Cathy Rocke.	97
5.1	Valerie Triggs. *Clouds*, 2020. Photograph. Regina. © Valerie Triggs.	102
5.2	Whitney Blaisdell. *Walk in the woods*, 2020. Photograph. Regina. © Whitney Blaisdell.	105
5.3	Whitney Blaisdell. *Cyanotype image*, 2020. Photograph. Regina. © Whitney Blaisdell.	106
5.4	Nicole Gebert. *Not afraid of the void*, 2020. Photograph. Regina. © Nicole Gebert.	109
5.5	Tom Janisch. *The Thaw*, 2020. Photograph. Regina. © Tom Janisch.	111
5.6	Sheena Koops. *Treaty sunset*, 2020. Photograph. Regina. © Sheena Koops.	114

6.1	Biljana C. Fredriksen. *Lotta kisses*, 2020. Photograph. Bø. © Biljana C. Fredriksen.	126
6.2	Biljana C. Fredriksen. *Walking with four alpacas*, 2020. Photograph. Bø. © Biljana C. Fredriksen.	128
6.3	Biljana C. Fredriksen. *Jorgen and Fredrik love snow*, 2020. Photograph. Bø. © Biljana C. Fredriksen.	133
6.4	Ada Marlene Vrolijk. *Biljana's son with baby Leo*, 2020. Photograph. Bø. © Ada Marlene Vrolijk.	135
7.1	Mika Takahashi. *Warm freeze: Flyer for the project exhibition*, 2020. Flyer. Tokyo. © Mika Takahashi.	149
7.2	Koichi Kasahara. *Art Bay Tokyo, new garden for Olympics, walking and feeling the place around*, 2020. Collage. Tokyo. © Koichi Kasahara.	151
7.3	Nanami Inoue. *Tracing the remained forms: Photo taken at the bicycle parking lot, prototype drawing with colour*, 2020. Collage. Tokyo. © Nanami Inoue.	152
7.4	Nanami Inoue. *Gaze at*, 2020. Oil on canvas. Tokyo. © Nanami Inoue.	153
7.5	Mika Takahashi. *Mask fallen*, 2020. Photograph. Tokyo. © Mika Takahashi.	154
7.6	Chiaki Hatekeyama. *Drawing on glass walls of ABT*, 2020. Photograph. Tokyo. © Chiaki Hatekeyama.	155
7.7	Takeshi Kawahito. *Painting through creative inquiry*, 2020. Photograph. Tokyo. © Takeshi Kawahito.	157
7.8	Naoko Kojima. *Kaleidoscope games*, 2020. Photograph. Tokyo. © Naoko Kojima.	158
7.9	Kanami Ban. *Map of the last day of the exhibition*, 2020. Photograph. Tokyo. © Kanami Ban.	159
7.10	Seisuke Ikeda. *Rhythm movie stills*, 2020. Collage. Tokyo. © Seisuke Ikeda.	161
7.11	Kanae Shimoji. *Photos on glass wall*, 2020. Photograph. Tokyo. © Kanae Shimoji.	163
9.1	Kwang Dae Chung. *Rocks*, 2019. Photograph. Vancouver. © Kwang Dae Chung.	203
9.2	Kwang Dae Chung. *Mitsy's outdoor atelier*, 2019. Photograph. © Kwang Dae Chung.	205

9.3	Kwang Dae Chung. *Honouring the mother tree*, 2019. Photograph. Vancouver. © Kwang Dae Chung.	211
G10.1	Yasmin Dean. *The gate*, 2020. Photograph. Vancouver. © Yasmin Dean.	218
10.1	Tormod Wallem Anundsen. *These modest hills*, 2020. Photograph. South Norway. © Tormod Wallem Anundsen.	222
10.2	Tormod Wallem Anundsen. *Co-walking*, 2020. Photograph. South Norway. © Tormod Wallem Anundsen.	223
10.3	Tormod Wallem Anundsen. *Reaching his mountain*, 2020. Photograph. South Norway. © Tormod Wallem Anundsen.	227
G11.1	Benjamin Ironstand. *Students stretching and fleshing hides harvested from territory*, 2020. Photograph. Valley River. © Benjamin Ironstand.	234
G11.2	Benjamin Ironstand. *Tipi liner*, 2020. Photograph. Valley River. © Benjamin Ironstand.	235
G11.3	Benjamin Ironstand. *Tipi liner 2*, 2020. Benjamin Ironstand. Photograph. Valley River. © Benjamin Ironstand.	236
G12.1	Marg Boyle. *Outside the universe*, 2022. Photograph. Gespeg. © Marg Boyle.	258
G12.2	Marg Boyle. *The gifts of the eagle*, 2021. Photograph. Gespeg. © Marg Boyle.	259

Foreword

Jocelyne Robinson

Reading *Walking in Art Education* brought back memories of my earlier years working on a Ph.D. at The University of British Columbia. As an Indigenous artist and educator, I joined the emerging dialectical conversations about the diverse world-views operating at the interface between the dominant Western science paradigm and Indigenous knowledge. Through an engagement with a/r/tography, I charted a unique and creative space to interface with diverse ways of knowing across disciplines and cultures in the spirit of reconciliation and ecological consciousness. I shared narrative inquiry through story, embodied as a living, breathing space, animated by/with/in an All My Relations cyclical context. Ecopedagogical and a/r/tographical research offers a unique style of inquiry that ambulates across epistemological and axiological territories of thought and practices that may provide valuable pathways for reconciliation and ecological consciousness. The artist-educators share their sentient experiences of ecopedagogical and a/r/tographical walking in their research, teaching, and their creative practices as they traverse the geographical and cultural boundaries of Turtle Island and beyond. As the artists and educators share their stories of ecopedagogical inquiry they are attuned to an Indigenous concept of being grounded. The interwoven placement of Indigenous story invites a cyclical movement for thinking, walking, and grounding along the paths of a/r/tographical and ecopedagogical inquiring possibilities. In the tacit spaces of thought and practice these artists, researchers, and educators share their stories of encountering and entangling with/in kinships and relationality. As Indigenous and non-Indigenous stories are interwoven through the book, a space opens that may unite and nourish harmonious understandings of land, place, and self to build sustainable environmental and social consciousness in art education. I hope that the reader may encounter the a/r/tographical and ecopedagogical walking, text, story, and images as transformative and grounded explorations of the world as alive, sentient and our relative. Also, I wish you *Mino Pimatsowowin*, the good life!

Acknowledgements

As editors of this collection, we raise our hands in respect and gratitude to the lands and territories we find ourselves living and learning with. As a team made up of both settler scholars and one with partial Mi'kmaq ancestry (Newfoundland and Labrador), we acknowledge our shared responsibilities as Treaty People to honour the lands, territories, and traditional cultural teachings of First Nations and Indigenous peoples. They continue to steward these lands as they have for millennia. We would like to give thanks through formal land acknowledgements of each of the territories where the editorial team resides.

Land acknowledgements are often created collectively with leaders of Indigenous governing bodies, and we would like to use the words chosen by these bodies. It is important to note that land acknowledgements are not just a formality but a recognition of appreciation and a commitment to reconciling and sustaining relationships with Indigenous communities and with the lands we find ourselves guests on. In Canada, three terms are often used in land acknowledgements: traditional, ancestral, and unceded. The word traditional recognizes lands traditionally used and/or occupied by First Nations. The word ancestral recognizes land that is handed down from generation to generation. Lastly, unceded refers to land that was not turned over to the Crown (government) by a treaty or other agreement. As editors, we respect and honour the Treaties that were made on all territories, we acknowledge the harms and mistakes of the past and present, and we are committed to moving forward in partnership with Indigenous communities and Nations in the spirit of reconciliation and collaboration for the sustainability of the lands we call home so that future generations will walk, create, and flourish after us.

Nicole Rallis would like to give thanks and acknowledge that she lives and learns in what is now called Shawnigan Lake, British Columbia, Canada, the unceded, ancestral, and traditional territories of the Hul'qumi'num speaking peoples of the Cowichan Valley. She acknowledges that for thousands of years the Quw'utsun, Malahat, Ts'uubaa-asatx, Halalt, Penelakut, Stz'uminus, and Lyackson peoples have walked gently and continue to be stewards of these lands and waters.

Ken Morimoto and Rita L. Irwin wish to acknowledge that they live and work in what is now called Vancouver and Richmond, British Columbia, Canada and is the unceded,

ancestral, and traditional territories of the xʷməθkʷəy̓əm ('Musqueam'), Sḵwx̱wú7mesh ('Squamish'), and Selílwitulh ('Tsleil-Waututh') Nations. We honour these Nations for their stewardship, histories, teachings, and guidance.

Michele Sorensen and Valerie Triggs wish to acknowledge that they live and work in what is now called Regina, Saskatchewan, Canada, situated on Treaty 4 lands. These are the territories of the nêhiyawak (Cree), Anihšināpēk (Saulteaux), Dakota, Lakota, and Nakoda, and the homeland of the Métis/Michif Nation. Today, these lands continue to be the shared Territory of many diverse peoples from near and far.

We would like to give thanks to the collection contributors who have so beautifully reflected on the lives, places, and kinship networks that sustain them. We are grateful and give thanks for the generosity of our grounding authors who have shared important lessons from their homelands. We would also like to give thanks and honour our relationships with the abundance of plant teachers; the trees and forests; the waterways; the two-legged, four-legged, eight-legged, slithering, swimming, and winged more-than-human friends and teachers; the mountains and valleys; the winds; the clouds; and sky. Thank you to all our family and friends.

Lastly, we would like to thank the Social Sciences and Humanities Research Council of Canada for their generous funding of the Partnership Development Grant that inspired this collection, titled, *Mapping A//r/tography: Transnational storytelling across historical and cultural routes of significance.*

 Social Sciences and Humanities Research Council of Canada Conseil de recherches en sciences humaines du Canada

Introduction: Encountering Kinship and Relationality

Nicole Rallis and Ken Morimoto

In our increasingly complex, damaged, and fast-paced world, there seem to be fewer moments for us to connect—to connect with our families, our friends, our colleagues, our culture; to connect with the land, with animals, the sky, and the waters. This connection, something so many of us desperately yearns for, gets distorted or re-oriented through major structural forces like capitalism, industrialization, patriarchy, and colonialism. In a rush to "get things done," we sometimes disregard the significance of the minutia of everyday life. Perhaps, it is in the minutia, in the little steps we walk each day that we can re-learn and re-connect more deeply with the world and relationships that surround us and sustain us.

The dictionary defines the word kinship as, "the relationship between members of the same family" or "a feeling of being close or similar to other people or things" (Cambridge, 2022). In Turtle Island (North America) where the co-editors of this collection reside, kinship is both a living concept and central value across multiple Indigenous cultures and communities (Archibald, 2008; Battiste, 2013; Kimmerer, 2013). However, rather than a pan-Indigenous concept or idea, it is important to recognize that kinship is practiced within land-based and culturally specific frameworks of knowing. For example, the Cree legal principle and word practiced by both Cree and Métis living within the plains of central Canada, "wahkohtowin", directly translates to kinship/relatedness. Métis scholar, Zoe Todd (2020), quotes scholar Brenda Macdougall who explains "wahkohtowin" as:

> a worldview that privileged relatedness to land, people (living, ancestral and those to come), the spirit world, and creatures inhabiting the space. In short, this worldview, wahkohtowin, is predicated upon a specific Aboriginal notion and definition of family as a broadly conceived sense of relatedness of all beings, human and non-human, living and dead, physical and spiritual.
>
> (p. 178)

Kinship is complex, diverse, and sometimes even contradictory. It encompasses both societal customs and spiritual beliefs and is grounded within land-based frameworks of knowing and being. Reflecting on their Anishinaabe culture and language that emphasizes the animacy of the world, Melissa Nelson considers kinship as something alive and relational: "Using kin as a verb reminds us that kin is always alive. It's a movement and it's a flow and it's a process" (Kimmerer et al., 2021, n.p.).

Relationality refers to a general sense of connectedness as well as "a view of the world that underlines how no person or thing exists in isolation, because existence necessarily means

being 'in relationship'" (Wijngaarden, 2022, p. 394). In this collection, we highlight some of the ways that artists and art-educators are thinking about kinship and relationality through their creative walking practices, what we call ecopedagogical and a/r/tographical walking. Weaving together Indigenous grounding stories and teachings with chapters by artists and art-educators across three continents, this collection attends to different ways that kinship and relationality are taken up in research, teaching, and creative-walking practices, while also taking into serious consideration what relationships (to self, other, and earth) might offer in terms of reimagining a sense of belonging and a sense of responsibility to the world.

Bringing together artful, emergent, and critical studies of ecologically and socially conscious art education across cultural differences and worldviews, this collection seeks to challenge Western-centric histories, conceptions, and cartographies of space and place. Indigenous education scholar Dwayne Donald (2012) states that we need more complex understandings about our existing relationships to one another in order to see, "that perceived civilizational frontiers are actually permeable and that perspectives on history, memory, and experience are connected and interreferential" (p. 534). It is important for art-educators to investigate diverse and complex kinship networks and pedagogically engage in what Donald refers to as an ethical relationality:

> The key challenge is to find a way to hold these understandings in tension without the need to resolve, assimilate, or incorporate [...] Ethical relationality is an ecological understanding of human relationality that does not deny difference, but rather seeks to understand more deeply how our different histories and experiences position us in relation to each other.
>
> (Donald, 2012, p. 535)

With this understanding, ethical relationality can be considered both a practice and a deep philosophical commitment.

In Canada, where the co-editors of this collection and many of the book contributors work, live, and learn, urgent calls to action outlined by the Truth and Reconciliation Commission of Canada (TRC, 2015) and the National Inquiry into Missing and Murdered Indigenous Women and Girls (MMIWG, 2019) compel art-educators to question existing relationships with educational and governance structures that perpetuate violence towards Indigenous communities and the natural world. Some of the ongoing injustices raised by the TRC and MMIWG include social and cultural policing of Indigenous communities, intergenerational trauma, murder, and abuse from the Residential School System, environmental pollution and degradation, and the loss of biodiversity through urban development and unsustainable farming, logging, and fishing practices. A specific call for educators is centred around, "building student capacity for intercultural understanding, empathy and mutual respect" (TRC, 2015, p. 7). Through these calls to action, many art-educators are striving to educate students to attune to and understand the connections between culture and land, and to see the land and water as living, sentient entities with materiality, affect, and memory,

and existence within an ecological consciousness. For those of us working with and alongside Indigenous scholars, the conversation around kinship and relationality is further enriched by Indigenous Knowledges about ethical relationality that challenge colonial and anthropocentric frameworks of ecological and cultural violence.

Many contributors to this collection explore their identities as art-educators in relation to the lands in which they live, teach, and practice, while others explore their cultural identities in relation to studying in a foreign country, walking in (un)familiar landscapes, or walking with non-human or more-than-human kin. Crucial to all is a "coming to know" through reflexive and creative ecopedagogical and a/r/tographical walking practices that demonstrate how identities and relationships are intimately shaped and challenged by the lands, people, and more-than-human worlds with whom they walk. Through engaging in ecopedagogical and a/r/tographical walking practices, contributors to this collection pose an important question for the reader to consider: How can creative walking practices grounded in kinship and relationality transform, complicate, and help us re-imagine understandings of history, place, and the self?

Attuning to the ecopedagogical and a/r/tographical in art education

Essential to this collection is a growing line of inquiry highlighting the pedagogical implication of entangled movement. Walking practices can show how "sensate and kinaesthetic attributes facilitate connections with lived experiences, journeys and memories, communities and identities" (O'Neill & Roberts, 2020, p. 1). Walking can be understood as both an embodied and phenomenological practice in art education research. Walking, and movement more broadly, as an embodied research practice has been a reoccurring and central aspect of a/r/tography throughout its development: "Walking embodies the art. Walking embodies thought" (Lasczik Cutcher & Irwin, 2018, p. 144). As a concept and physical practice, movement is understood as the potential "to create anew, to alter perceptions, to see again differently, to change the viscosity of materials to become something else" (Irwin, 2013, p. 210). Walking as an a/r/tographic practice places emphasis on the ways in which we come to know as beings *situated in* that shift our understanding of time and place. Walking together, Lasczik Cutcher and Irwin (2018) suggest, "Our collaborative walkings allowed us to make connections across our environmental wanderings, theoretical readings, aesthetic delights and embodied desires for slower scholarship" (p. 145). Although not directly recognized in every instance, the presence of what one walks with—others, concepts, the environment, our histories, and kinship networks—offer a vitalism that enables the unfolding of such scholarship (Lee et al., 2019; Ursino et al., 2022). Attending to walking and the presence of what we walk with is both a recognition of our situatedness as well as a gesture towards a way of knowing relationally and ethically.

Complimentary to a/r/tography, ecopedagogical inquiry insists on considering human, non-human, and more-than-human worlds not simply as concepts but as intra-actions of

interdependency and reciprocity. Ecopedagogical inquiry encourages one to develop art practices and narratives grounded in cultural knowledge, histories, lived experiences, local geographies, and ecologies. Peter Cole (2019) describes the term ecopedagogy as:

> Learning to "read" and navigate land, sky, water, words, how a raven flies, a fish swims, a tree sways, presence or not of insects, birds, moss, lichen, bark, fungus, berries, accustomed sounds, signs of presence or absence, freshness of tracks and traces, weather- and-predicative "meanings" inscribed within storying.
>
> (p. 2)

This type of inquiry requires an ontological openness (Emmanouil, 2017)—to be open to new ways of knowing and to sources of knowledge that may seem unfamiliar. It is "not only the visual, but the auditory, olfactory, tactile, gustatory, and intuitional senses that are important reading and transliterating agencies to connect, resituate, realign and regenerate" (Cole, 2019, p. 2). Ecopedagogical walking encourages diverse perspectives and practices-in-motion that honour the animacy of the earth and self. Through repetitive environmental encounters and walking (un)familiar paths, we may develop special relationships with trees, plants, and rivers, a favourite neighbourhood street, the local grocer, a sidewalk bench, or a public green space. Perhaps we stumble across a nest in the springtime and pay attention to the interaction between the swallow and the hollowed tree from which it builds its home. The list of ecopedagogical possibilities and encounters becomes diffractive, entangled, and endless.

Igniting curiosities and responsibilities to the world around us, ecopedagogical encounters help inform and transform our sense of place. Critical artistic and ecological inquiry helps us to develop and remember a sense of love for the world that is foundational for survival. Importantly, ecopedagogical and a/r/tographical walking practices may help art-educators attend to a question posited by Indigenous artist and scholar Patty Krawc in their book *Becoming Kin* (2022): "How might we become better relatives to the land, to one another, and to Indigenous movements for solidarity?" (n.p.).

Book structure

Unique to this collection is the weaving of groundings that both guide each chapter and emphasize the philosophical commitment of the book. Each grounding is written by scholars or artists with Indigenous backgrounds to Turtle Island (North America) or scholars who are Indigenous to other countries and places who are now working in Canadian university settings. Many are Elders, cultural stewards, knowledge keepers, and stewards of the land who find themselves immersed in practices that are artful, ecological, and in many instances involve the practice of walking. As opposed to an interlude which is often considered as an accessory or an afterthought to the main contributions, we situate

the groundings as centred and cyclical teachings. Placing emphasis on the groundings, the chapter contributions become decentred, inviting the reader to attend to the text in a way that challenges implicit linearity and power structures often found within Western writing traditions. Each grounding offers an important lesson or prompts for readers to consider as they engage with the chapters, as well as offering a conceptual re-centring and grounding to the land and the traditional knowledge from the territories on which this collection is being produced and edited. As a diverse group of settler and Indigenous co-editors we recognize that "There is a real need for academics to move toward concrete conversations about the Land to significantly reshape settler consciousness" (Ray et al., 2019, p. 81). While resisting attempts to streamline or generalize Indigenous teachings from the diverse Turtle Island context onto varied geographical locations, cultures, and languages of our chapter contributors, the groundings are positioned in a way as to remind readers to attend to the specific lands they live, learn, and walk with.

The term grounding has often been used in research in the naturopathic and health sciences to describe embodied practices that include walking barefoot outside, lying on the ground, and being submerged in natural bodies of water (Oschman et al., 2015). Chevaliar et al. (2013) note that "Although grounding is not a new breakthrough, it is a rational way of understanding the energetic exchange between our unique vibration and the vibration of the earth" (p. 102). Some studies suggest that grounding practices help restore natural immune defences in the body and may even influence our healing abilities. In some traditional Indigenous teachings, the idea of grounding has been described as a process of connecting the spirit world, mortal world, sea, sky, and land. In Trimble's (2019) study on culturally competent research, he notes: "In describing his leadership style, not long ago, a village Elder and leader from an Alaskan Native community stated it as 'being grounded in the ancestors and looking forward'" (p. 32). We posit the notion of grounding in this collection as a conceptual framework, a philosophical commitment, and as the sharing of important lessons and sacred stories that will augment the hope of each chapter and help reconnect readers to the land in the spirit of social and ecological consciousness, reciprocity, and responsibility.

The groundings remind us that the land is not a generalized abstraction but a real and tangible life force that carries its own traditions, histories, and features. In their important work on Indigenous place-thought, Vanessa Watts (2013) explains that any type of research or theory should be understood as an extension of an animate ontology co-created in and with place and necessitates an ongoing reflexive praxis tied to the land with which one learns. Each grounding and chapter create a new opening into a way of knowing that is closely entangled with the land from which it originates. As such, we understand that Indigenous Knowledges and teachings offered in the groundings do not speak for or are exhaustive of all Indigenous cosmologies, axiologies, philosophies, and worldviews, much like how the international selection of chapters, though diverse, only represents a small fraction of the world. In centring the collection on the teachings and lessons guided by the groundings, we gesture towards a world in which Indigenous ways of knowing might have

an equally important voice in an academic environment that continues to be dominated by Western-centric theories and methods. We hope that the offering of this collection might contribute towards the growing recognition of ecopedagogy and a/r/tography in art education alongside Indigenous Knowledges in other areas of the world. In this way, the groundings and chapters are not conclusive declarations but are rather diffractive invitations to a multiplicity of ongoing conversations and imaginations that are tied to the vitality of the lands on which the contributors learn with. As Leanne Betasamosake Simpson (2014) provocatively suggests, "The context is the curriculum, and land, *aki*, is the context" (p. 155).

In their collaborative chapter, Koops, Triggs, and Sorensen offer art practices of *Treaty Walks* in Treaty 4 territory in Saskatchewan, Canada, as an invitation to re-map and re-reshape social, ecological, and political relations. MacDonald shares their experience of mapping Nose Hill Park in Alberta, Canada, as a settler Canadian working alongside Indigenous and holistic ways of knowing. Using Treaty modes of relation, MacDonald explores Nose Hill Park and creates artistic ways of troubling hierarchical frameworks and opening opportunities to listen more closely to human and non-human relations. Osler takes up walking along a shoreline in eastern Quebec, Canada, as a proposition to explore *passages*—the relational space in-between the self and the environment—as liminal waypoints to understanding.

Hu provides insights from designing and conducting plant-themed art lessons for children located in primary schools in both the Sichuan and Zhejiang provinces of China. Through a playful engagement with historical and traditional notions of education in China, Hu contemplates ways in which art education, and a/r/tographical walking in particular, might draw humans closer to nature. In Saskatchewan, Canada, Triggs and Sorensen theorize the practice of walking as akin to clouds that provokes an atmospheric logic and resists rigid rationalization. Along the backdrop of such a cloud-like ontology, they introduce the work of four of their students. In South Eastern Norway, Fredriksen and Scarborough share from their inquiry with and about alpacas to consider what animate encounters with the more-than-human might teach us. In Tokyo, Japan, Kasahara, Inoue, Takahashi, Hatakeyama, Nishida, Kwahito, Kojima, Ban, Ikeda, Kiyonaga, and Shimoji offer the ecological concepts of "yo/haku" and "warm freeze" that they created while walking in marginal spaces that emerged during the pandemic.

In British Columbia, Canada, Martin-Ko engages a walking practice with the invasive English Ivy plant and native Red Cedar tree that have made place in their neighbourhood to learn and make oddkin relations with these plants. Chung introduces their co-creative walking practice with the Mother Tree in their outdoor atelier in British Columbia, Canada. Anundsen co-walks with the notions of ritornello and territorialization to situate their sense of belonging and fellowship with others in the south of Norway. Finally, while reflecting on their time living and studying in Macao, Malilang poetically examines their Chinese and Javanese identities and values.

Although the a/r/tographic walks in each chapter are taken up in different ways and locations, pedagogical questions around kinship and relationality with human, non-human,

and more-than-human worlds emerge as consistent themes across all offerings. This collection is curated as a woven fabric of Indigenous and non-Indigenous voices who are held in intimate and reciprocal relationships with the land. We encourage readers to wander in-between the groundings and chapters, attending to and dwelling among the provocations offered. We hope that the creation of such pathways and understandings will invite readers to re-imagine and commit to ecopedagogical and artful walking practices in new ethical ways as they trace the threads of kinship and relationality in this collection.

References

Archibald, J. (2008). *Indigenous storywork: Educating the heart, mind, body and spirit*. UBC Press.

Battiste, M. (2013). *Decolonizing education: Nourishing the learning spirit*. Purich Books.

Betasamosake Simpson, L. (2014). Land as pedagogy: Nishnaabeg intelligence and rebellious transformation. *Decolonization: Indigeneity, Education & Society, 3*(3), 1–25.

Cambridge Dictionary. (n.d.). *Kinship*. Cambridge University Press. https://dictionary.cambridge.org/dictionary/english/kinship

Chevalier, G., Sinatra, S., Oschman, J., & Delany, R. (2013). Earthing (grounding) the human body reduces blood viscosity—A major factor in cardiovascular disease. *Journal of Alternative and Complementary Medicine, 19*(2), 102–110.

Cole, P. (2019). *Course syllabus*. The University of British Columbia.

Donald, D. (2012). Indigenous Metissage: A decolonizing research sensibility. *International Journal of Qualitative Studies in Education, 25*(5), 533–555.

Emmanouil, N. (2017). Ontological openness on the Lurujarri dreaming trail: A methodology for decolonizing research. *Learning Communities, 22*(10), 82–87.

Irwin, R. L. (2013). Becoming a/r/tography. *Studies in Art Education, 54*(3), 198–215.

Kimmerer, R. W. (2013). *Braiding sweetgrass: Indigenous wisdom, scientific knowledge, and the teachings of plants*. Milkweed Editions.

Kimmerer, R. W., Hausdoerffer, J., & Van Horn, G. (2021). Kinship is a verb. *Orion: Peoples and Nature*. https://orionmagazine.org/article/kinship-is-a-verb/

Krawc, P. (2022). *Becoming kin: An indigenous call to unforgetting the past and reimagining our future*. Broadleaf Books.

Lasczik Cutcher, A., & Irwin, R. L. (2017). Walkings-through paint: A c/a/r/tography of slow scholarship. *Journal of Curriculum and Pedagogy, 14*, 140–149.

Lee, N., Morimoto, K., Mosavarzadeh, M., & Irwin, R. L. (2019). Walking propositions: Coming to know a/r/tographically. *The International Journal of Art & Design Education, 38*(3), 681–690.

National Inquiry into Missing and Murdered Indigenous Women and Girls. (2019). *Reclaiming power and place: The final report of the national inquiry into missing and murdered Indigenous women and girls* (Vol. 1a). https://www.mmiwg-ffada.ca/wp-content/uploads/2019/06/Final_Report_Vol_1a-1.pdf

O'Neill, M., & Roberts, B. (2020). *Walking methods: Research on the move*. Routledge.

Oschman, J., Chevalier, G., & Brown, R. (2015). The effects of grounding (earthing) on inflammation, the immune response, wound healing, and prevention and treatment of chronic inflammatory and autoimmune diseases. *Journal of Inflammation Research*, 8(1), 83–96.

Ray, L., Cormier, P., & Desmoulins, L. (2019). Fish fry as praxis: Exploring land as a nexus for reconciliation in research. In W. Shawn, V. B. Andrea, & D. Lindsay (Eds.), *Research & reconciliation: Unsettling ways of knowing through indigenous relationships* (pp. 73–85). Canadian Scholars.

Triggs, V., Irwin, R. L., & Leggo, C. (2014). Walking art: Sustaining ourselves as arts educators. *Visual Inquiry: Learning and Teaching Art*, 3(1), 21–34.

Trimble, J. E. (2019). "Being grounded in the ancestors and looking forward…"—Blending culturally competent research with Indigenous leadership styles. *Prevention Science*, 21, 598–617.

Todd, Z. (2020). Honouring our great-grandmothers. In S. Nickel & A. Fehr (Eds.), *In good relation: History, gender, and kinship in Indigenous Feminisms* (pp. 171–181). University of Manitoba Press.

Ursino, J., Irwin, R. L., Lee, N., Morimoto, K., & Mosavarzadeh, M. (2022). Pedagogical affect and the curricular imperative in a moment of poesis. In A. Lasczik, R. L. Irwin, A. Cutter-Mackenzie-Knowles, D. Rousell, & N. Lee (Eds.), *Walking with a/r/tography* (pp. 17–38). Springer.

Watts, V. (2013). Indigenous place-thought & agency amongst humans and non-humans (first woman and sky woman go on a European world tour!). *Decolonization: Indigeneity, Education & Society*, 2(1), 20–34.

Wijngaarden, V. (2022). Relationality. In P. Ballamingie & D. Szanto (Eds.), *Showing theory to know theory. Understanding social science concepts through illustrative vignettes* (pp. 394–400). Showing Theory Press.

Grounding

Our Walks Begin With Prayer

Anna-Leah King

In the words of Alfred Manitopeyes, Saulteaux Elder from Muskcowekwun, *Pimosatamowin* or our walk in life is how "we arrive at […] knowledge or make sense of the task" (Akan, 1992, p. 18). To be wholly human means to have a good sense of right and wrong and to be able to act on that knowledge. The Elder teaches good walking and good talking as far more than a metaphor. He is accepting of "white man's education" and encourages youth to learn the skills that will ensure employment. He also views education as a spiritual process and therefore traditional Anishnabemowin or Saulteaux education are a part of it too.

Nakatawaindizowin means careful thought about oneself in the world with other beings. Walking and talking, is knowledge earned from an Elder to know to walk with great care in *Pimosatamowin*—the walk of life. *Manitopeyes* teaches a commitment to traditional education and walking and talking as the traditional educational practice.

Our walks begin with prayer

With the ones who walk through life with us,
In gratitude we sit on the earth
Forming a circle for the pipe.
We close our eyes in prayer … we can hear the faint
Rumble of the buffalo's hooves
In the distance
Become thunder across the prairie grasslands
The Elder's prayer
Spoken gently, soothing to the ear
Warming our hearts
Our imprint evident on the ground
Stone circle tipi rings
Landscape makers as reminders
Ancestral beings are with us in
Our walk through life
Revisiting these sacred spaces and places
In heightened consciousness
We know we have always been here
When the land was pristine.

Reference

Akan, L. (1992). Pimosatamowin Sikaw Kakeequaywin: Walking and talking a Saulteaux Elder's view of native education. *Canadian Journal of Native Education, 23*(1), 16–39.

Chapter 1

Mapping Five Months of *Treaty Walking*

Sheena Koops, Michele Sorensen, and Valerie Triggs

"We wonder what really happened there and who the actual inhabitants [...] were," writes Katherine Harmon (2009, p. 39) as she reflects on artist Joyce Kozloff's *American History: Age of Discovery*, a map-of-sorts, a real-map-appropriated-into-art, busy with images of pilgrims, Indigenous peoples, explorers, slaves, settlers, mythological creatures, animals, merchants, warriors, farmers, soldiers, lady bountiful, crests, waterways, land masses, borders… and the subjects of the artwork continue to multiply as one tries to name them. The title of this map-as-art cues viewers to notice the political narratives inherent in all mapping, showing power relationships between groups of people and between humanity and the land. Harmon explains that "the dissonance that Kosloff creates through appropriation and mixing sources has a curious effect, heightening the solemnity of the historical events and drawing us in to look at the maps more closely" (2009, p. 39). While mapmaking has often been used to impose order and clarity on (so-called) wildness, or irregularities of geographic spatial analyses resulting in reductions and simplifications, it can also be a way of understanding and experiencing interconnections and interdependence.

A form of map-as-art walking in a local context is discussed in this chapter as one of many inquiries in a Social Sciences and Humanities Research Council of Canada (SSHRC) international a/r/tographic research project aimed at telling transnational stories of cultural, artistic, and educational significance across local, regional, and international routes of significance. A/r/tography is a hybrid form of practice-based research within education and the arts and includes the creation of images/performances and texts while acting within the interconnected identities of artist–research–teacher. A/r/tography promotes new models of artistic collaboration and pedagogical experimentation and is a methodology for exploring and reimagining cultural and social transformation. This particular "Mapping 5 Months of *Treaty Walking*" research initiative is devoted to igniting knowledge about human–land relations associated with retracing Indigenous–settler relations in Treaty teachings and everyday interactions. Local stories will eventually mobilize elsewhere into rich dialogues regarding human–land and Indigenous–settler relationships in a world of global interdependence. In this chapter, we share text and images of a local participant: artist–researcher–teacher Sheena Koops who undertakes five months of what she has termed *Treaty Walking*. Before answering "What is a Treaty Walk?," it is important to note that the authors come to this concept in a variety of positionalities, as do citizens of the 1867 Dominion of Canada and Saskatchewan, a 1905 province, mapped in the shape of a rectangle, entirely *settled* through numbered Treaties. Koops maintains that one cannot Treaty Walk without

knowing who they are and where they come from. One of our authors, Valerie Triggs, was raised in Treaty 6 territory. Her grandparents were both settlers and refugees of war. Currently working and living in Treaty 4 territory, she strives to recognize the responsibility of being in a Treaty relationship in terms of everyday interactions in response to herself and others. Another author, Michele Sorensen, who is of partial Mi'kmaq ancestry from the Conne River area in Newfoundland/Labrador and another part of her heritage derives from Lebanon and Denmark. Currently working in Treaty 4, she situates her social work research in finding decolonizing ways of working with Indigenous populations in relation to Treaty responsibilities of reconciliation and indigenization.

Sheena Koops was born in Lampman, Saskatchewan, Treaty 2 Territory. Her Norwegian grandmothers' families emigrated to southern Saskatchewan via northern United States in search of homesteads. Her Irish/Scotts grandfather's people homesteaded near Estevan where Sheena was raised on a farm near Macoun. When her great grandparents Nancy (Isabel) McDonald and William Muirhead married, half a venison was left hanging in a tree as a gift, most likely by Nakota ancestors of the people Sheena has recently been meeting from nearby First Nations: Pheasant Rump, Ocean Man, and White Bear. Sheena's maternal grandfather's people were Irish/Cornish, coming to Canada through the Robinson Huron Peace and Friendship Treaty of 1850. When Cecil Bailey, Sheena's grandfather, was 10, he was cured of ringworm by their neighbour, Elder Frank Bamageezik from Thesslon First Nation. For Koops, these family stories demonstrate First Peoples honouring Treaty relationality.

Koops has named her walking practice *Treaty Walks*, which she has engaged repeatedly in the past decade, as a pedagogic, artistic, and research practice. Koops describes *them as* "a hike, a stroll, a field trip, with treaty on the mind" (Koops, 2012, para 1). *Treaty Walks* presents the issue of whether one can walk on Treaty land unmindfully or if those involved in Treaty relationships must let spaces-that-we-walk-through teach us something beyond what is immediately visible. Are Treaty relatives compelled to tell "(un) usual narratives" (Tupper & Cappello, 2008, p. 559), especially those erased from colonial consciousness? The Treaty Walk is a way of understanding the significance of Treaties, not only as ways of being on this land but also as legal and binding within Canada and pre-Canada. Koops claims that you cannot Treaty Walk *here* without opening your mind/heart/spirit/body to Indigenous leadership and Indigenous law. We follow Indigenous lawyer Gina Starblanket's scholarship and teachings that Treaties have been a way of being in relationship with this land from time immemorial. Sharon Venn (1997), also an Indigenous lawyer, explores Treaty as a law of the land. Likewise, Professor Emeritus, Willie Ermine (2007) points to Treaty as an *ethical space*. In considering Treaty as an ethical space, we also draw on Dwayne Donald's (2012b) claim that there is an ethical imperative requiring "attentiveness to the responsibilities that come with a declaration of being in relation" (p. 535). Donald's explanations and emphases of imperatives in an ethical relationality involve seeking to "understand more deeply how our different histories and experiences position us in relation to each other" (2012a, p. 103). The imperatives are ethical in the context of appreciating that we are all related and that ongoing potential

for peaceful and friendly relation is already entangled with Mother Earth (2012a), in places where teachings originated. When we consider Treaty as an ethical space, we are also conscious of this relationality occurring not only between humans but also between humans and more than humans, including land, flora, and fauna (Elder Alma Poitras, personal communication, July 1, 2016).

Nation-to-Nation Peace and Friendship Treaties (pre-confederation) and Numbered Treaties (post-confederation) lay the foundation for colonial Canada. The places in which Koops undertakes *Treaty Walking* in this project are in the territory covered by Treaty 4, an 1874 signed agreement between the British Crown and the sovereign Cree and Saulteaux First Nations. Treaty 4 is located across much of present-day southern Saskatchewan, with a corner of southeast Alberta and a west-central dip into Manitoba (Stonechild, 2005). Even in the beginnings of this friendship, however, records show that the Crown agreed verbally to certain things that did not show up in the signed document. Amidst high tensions, talks often falling apart and a continuing lack of agreement between the Saulteaux and The Cree Nations, the Lead Commissioner Alexander Morris applied pressure to accept the deal (Stonechild, 2005), claiming it was only available for a short time and this *bounty and benevolence* (Ray et al., 2002) would not be offered again. In this Treaty, Morris promised that care, benefits, and concern for Indigenous peoples would last as long as the sun shines and the water flows (Stonechild, 2005).

We italicize the claims for bounty and benevolence, above, in recognition that, rather than concern for Indigenous peoples, just two short years after the signing of Treaty 4, the Indian Act became Canadian law, making Indigenous peoples (in the eyes of the Crown and Government) wards of the state. The Indian Act dishonoured Treaties, making possible a string of atrocities enacted upon Indigenous peoples by the colonial state. A century of residential schooling, with forcible separation of Indigenous children from their families, was a "purposeful attempt to eradicate all aspects of Indigenous cultures" (Hanson et al., 2020, n.p.). It is evident that this Treaty-breaking also carried a destructive wave of material harm and loss of language and culture for many First Nations peoples as well as loss of relationship to the land that had sustained body and culture for millennia. The territory originally agreed upon for sharing was changed and damaged by overhunting, pollution of water, land, and air, and the gouging of topographies and ecosystems through construction and mining (Office of the Treaty Commissioner, 2007).

In mapping "What is a Treaty Walk?" as an a/r/tographic practice, it is important to consider the artistic licence and colonial biases that mapping always employs. Drawn to the way old maps depict Saskatchewan history and using the map-as-art method, Landon Mackenzie, an artist interested in Saskatchewan history, gathers material like a historian, but rather than re-presenting maps or archival material, she uses them as points of departure to sort things out, remix and grapple with "some pretty large subjects" (in Harmon, 2009, p. 40). In her work, Mackenzie notes mapping practices of the late nineteenth and early twentieth century. For example, she highlights instances in which she found maps were deliberately falsified to mislead others including "a map showing First Peoples owned all the

land and a map three years later showing they owned none of it" (in Harmon, 2009, p. 40). Another Canadian artist, Jeannie Thib (in Harmon, 2009), uses hand images on which to print fragments of early Canadian maps onto a pair of white gloves similar to those worn by British colonial women while having tea. Harmon writes: "The artist suggests that mapping swaths of uncharted wilderness for Queen and empire is dirty work, not for dainty hands" (p. 122). In our current generation, Treaty mapping is still tainted. The Office of the Treaty Commissioner argues that Treaties have yet to be fully implemented to benefit Indigenous nations culturally, economically, politically, and socially.

While teaching school in Fort Qu'Appelle, Saskatchewan, Koops observed that the parents of her settler colonial students (40 per cent of her classroom in the midst of 60 per cent Indigenous students) enacted similar behaviour to that of the teacher education student participants in Jennifer Tupper's research involving their experiences with Treaty education in K–12 practicum experience as well as in university classes. Tupper's research makes evident the "power of whiteness and of privilege in shaping identities" (Tupper, 2011, p. 9). When Koops took her students to the local, annual Treaty 4 Gathering in 2011, she realized that she was transgressing settler colonial parents' expectations, hearing statements like, "This isn't Native Studies," evidence of speculation that the gathering was not an English curricular activity, even as students were practising citizen journalism. Tupper's (2011) study resonated closely with Koops' classroom observations. For example, Tupper writes:

> While not all students expressed overtly racist thinking, the comments that follow were selected to underline the reality of racism in Saskatchewan and within teacher education spaces: "Went to treaty 4 every year: the crime rate in town increased severely for that weekend and extra police were brought in (coincidence?)."
> (Student 168, Survey, February 2010, p. 8)

Tupper analyzes a student's offering: "The student is articulating a belief that First Nations peoples are deviant members of society and as such, their increased presence would require extra policing" (p. 8). Koops experienced similar responses from students in her classroom practice. A more benevolent settler story about the Treaty 4 Gathering is presented by Sara Solvey (2018), who grew up in Fort Qu'Appelle:

> Celebrations of Treaty Days took place each fall but my memories of participating in those celebrations appear through a looking glass, gazing upon the fancy regalia, listening to the boom of the drum, and eating Indian tacos. I enjoyed being included but was keenly aware that those particular celebrations were reserved for the peoples who were connected to them and not necessarily for me.
> (p. 6)

Solvey's childhood understanding of the gathering as celebration and not-for-her is also problematic. Koops considers an alternative narrative with colleague Judy Pinay, an

accountant at Treaty Education Alliance, who told Sheena: "'It's a gathering, not a celebration, because there is nothing to celebrate'. The old ones were referring to broken Treaty promises" (personal communication, August 2019). Judy holds the instructions from the elders and when planning the yearly Treaty 4 Gathering, leadership consults with her and emphasizes that honouring Treaty promises is very much settler colonial work.

It was against this backdrop that Koops wondered if she started walking to school with Treaty on her mind and heart would she arouse curiosity about Treaty relationships, rather than ignite more settler superiority? Could these settler colonial myths and stereotypical thinking be unsettled by daily *Treaty Walking*? Beginning with her *Treaty Walks* blog, Koops advocates ethical responsibility for people of settler colonial ancestry who are in perpetuity, bound to the Treaty Agreements of land in Saskatchewan, Canada. As a resident living on Treaty 4 territory, Koops believes she has a duty to remember the Treaty relationship as a covenant in the present rather than only in the past and a duty to perform this memory in ways that interrupt her everyday moving in this territory. "Treaty-based modes of relating," writes Gina Starblanket (2019) "are about relationships with and between all elements of creation" (p. 13). Treaties invoke the relation and perpetuity of time in a world amidst constant change: few tracks of the intense and recent past remain. Present-day Treaty 4 inhabitants live in the very midst of that past, daily affected not only by the Treaty 4 relationship but also by the geological stratum of the past, the forces and materialities of which continue to resonate and complexify through each generation.

A digital map of the locations covered by each Treaty Agreement in Saskatchewan is publicly available. Koops, however, engages with a different kind of mapping. Koops uses *Treaty Walks* to survey her own footsteps in relation to landmarks established by tradition, topography, and memory. Mapping has long relied on walking, and she walks to realize Treaty forces in ways that might impact more intensely the condition of daily life. When past settler colonials stepped off boats into peace and friendship treaties, their footsteps initially followed Indigenous pathways and waterways—later onto Treaty 4 territory, they traced wagon trails, iron railways, gravel roads and finally paved grids, cross-country highways, and air corridors. On a potential Canadian map-as-art, settler colonials are one category of many figures who can be put in partial relation to something else on a map. New maps are continually needed, in which change materializes through experimentation with one's way of thinking and moving and where having a grasp of locations in a place requires a foothold along the pathways between. Jeff Malpas (1999) claims that perceiving these bodily differences is also tied to one's ability to embrace various ideas and inspirations that prevail between the world and oneself. To create such a Saskatchewan map-as-art, an artist may cross and re-cross an area, aware that each traversal overlaps and performs another.

As a/r/tographic practice, Koops' *Treaty Walks* are directed towards walking as an inquiry and performance of what art does, which Simon O'Sullivan (2001) claims is to transform itself and others. Starblanket's (2019) words seem to encourage such a vision of relational interaction: "Moving beyond a transactional approach towards a more relational interpretation of treaties gives rise to a much broader range of possible ways of maintaining respectful relationships

among and between living beings" (p. 15). Walking in this sense is about attending to an embodiment of practice, of movement, moving on the land more relationally. Brian Massumi (in Zournazi, 2003) describes walking as falling and recovering, over and over, stepping ourselves into a fall; with the next step finding balance and then doing it again—*practising*—falling forward and regaining balance, placing bodies into uncertainty. Perhaps this falling over and over again is part of a "settler precariousness of place" which Solvey and Koops (in press) characterize as "developing uncertainty, where settler descendants become more and more aware of the tensions inherent in our presence, on and with/in the land that we call home." The photos and reflections offered in this chapter map this movement practice, this teetering forward (and backwards), this uncertainty, offering stories of relationality which the reader may recognize or seek within their own walking.

Walking in this way does not mean non-Indigenous become Indigenous, rather a *Treaty Walk* is a way of living, moving, reconciling, falling, and balancing that might help in understanding Treaty in the context of walking along with. Leanne Simpson (2013), Michi Saagiig Nishnaabeg author, scholar, and grandmother, identifies the necessity of reconciliation being led by Indigenous peoples rather than colonial peoples so that Indigenous peoples themselves can set terms for a return of balance. Koops offers *Treaty Walks* as a way for settler colonials to prepare their bodies and hearts for listening to and hearing leadership from Indigenous peoples that materializes from the past and arises in the present. *Treaty Walks* offer settler colonial stepping-off-points to answer Starblanket's (2019) question: "How might all treaty partners work to disrupt the narratives that are elemental to the inner workings and future of settler colonialism and that serve to perpetuate current crises of relationship between living beings?" (p. 17).

To address Starblanket's challenge, Koops committed to five months of walking for this research project from January to May 2019. These *Treaty Walking* movements provide Koops with a kick-start into further theorizing *Treaty Walks* as she works on her Ph.D. research, taking-walking this land for granted moments and making explicit the irony, love, Indigeneity, complexity, relationality, complicity, moves-to-innocence (Tuck & Yang, 2012), moves-to-guilt (Koops, thesis proposal, in process) and "spirit first" and a/r/tography within the methodology of *Treaty Walks*.

Five months of *Treaty Walking*
1. The farm

> I spent my childhood in southern Saskatchewan, flats stretching south until a shallow coulee leads into the Souris Valley, a creek running through prairie-grass. I wandered and wondered, "Who were the people who walked this land?"
> On the summer solstice, I drive to Pheasant Rump Nakota Nation. Amos meets me and Raquel. He drives us into the back country, and we are walking towards the

sacred medicine wheel, just after the sun has blazed, a star-light line, through the centre. Amos explains how the people gathered here, from the four directions. He tells us how his dad, late Armond, brought anyone who wanted to see the medicine wheel right here. I ask if it is appropriate to lay down tobacco. Yes, he is glad and leaves us alone. I sit to the south, looking to where I was born, then a little more West towards the farm. I think of the people who first walked the land of my settler colonial birth and the uncultivated pastures of my youth. The generosity of our Treaty relative demonstrates a commitment to relationality.

Today it's cold. I'm not sure how far I'll go. Once we're at the buffalo stone, I keep going. I'm getting colder. I'm not wearing ski pants, just jeans, my son-in-law's big work gloves and orange SaskPower jacket.

I hope to invite Nakota elder Pete Big Stone from Ocean Man to this spot. I wonder what he would hear, what "wisdom sits in (these) places" (Basso, 1996). Dr. Ermine would encourage me to ask and answer my own questions (personal communication, May 2019). What wisdom does this big stone offer me as a Treaty relative?

I hear the camera snap. My footsteps and Callie's hooves are noisy on the gravel and squeakier against the snow once on the prairie trail. Callie is Appaloosa, the descendant of spirit horses associated with the Nez Perce Nation. I am using digital images to look at her, look at us.

"Those who continue to practice traditional horse culture understand that horse behaviours are functionally patterned in the same way as human intellect and spirituality; some horses are kind and affectionate, some are mischievous, while others are obstinate and indifferent" (Snowshoe & Starblanket, 2016, p. 67). Knowing now that Calli was in the last winter of her life, I wonder if her kindness was that of an elder. At the time of this walking, I was envisioning many seasons with this beautiful mare. The land is still telling the story of buffalo, scratching itchy hides, and rubbing the stone smooth. Centuries of hooves make the circular ditch.

"A history text that explains Aboriginal starvation and dislocation as a result of the extermination of the bison on the Plains does not usually account for the loss of a deep spiritual webbing between humans and the buffalo" (Marker, 2011, p. 103).

I've never paid much attention to the stone. It was on the neighbour's property on the other side of the fence. Now the fence gates are open, all the way into the valley. How easy it is for settlers like me to pay little attention to story-telling stones and the clearing of these plains.

Another fifteen minutes, the trail winds, and I see Muirhead Island, the locals named in honour of my late dad. I wonder what the place names were before my ancestors arrived.

There was a McDonald Lake, now flooded by the Rafferty Dam, named for my great-grandmother's father. She wrote about the Indigenous people travelling through; later on, she writes they were not treated well.

I've never walked on the ice with a horse before. She doesn't seem to mind.

This is good that I am listening to Calli and as Dr. Ermine advised: accept the kindness offered. Snowshoe and Starblanket (2016) write, "Fortunately, traditional horse culture suggests that the horse spirit is so kind that it will over compensate the human's ineptitude with loyalty irrespective of the technique" (p. 68).

Dad's dog, Jenny is on the ice, trotting away. I can't help but think she's looking for Dad. So am I.

"Traditionally, Indigenous peoples positioned animals as equitable partners in interconnected human and more-than human networks, animated with spirit and the ability to act and communicate" (McGinnis et al., 2019, p. 162).

It was as though wherever Jenny looked, I knew Dad had walked there and was also with us now.

"There is a mystery to this place, and it holds me and keeps me" (Weenie, 2020, p. 7).

2. A closed road

Sensations. Crunching of the snow, sparkling of the sun in the snow crystals, translucent leaves against the sun, my legs warm and strong, at first and then faltering, walking down the collapsed road, walking sideways, ready to break a fall with my hands, ready to grab onto trees. I hear sounds of vehicles on the highway, leaving and coming into the valley, sounds of people on the lake, ice fishing villages and people standing outside the shacks, visiting, dogs barking, a grouse scares up, the orange pounding of colour when I close my eyes and face into the sun.

The road past my house slumps and then falls in and we're told that it will never be rebuilt, winding along the hills of South Qu'Appelle Valley, blocking our shortcut to the town of Indian Head, the name problematic, given the lack of relationality with neighbouring Carry the Kettle First Nation. Perhaps this broken road is symbolic that there are no more shortcuts to the beautiful relationality of Treaty.

I photograph moss up close on the closed road, a ten-minute walk from my home. Dad would know what to call this tree-in-bloom. I walk sideways, along the muddy ledge, ready to grab at tree branches if I slip.

I'm two hours north of the farm. The Qu'Appelle Valley, where my husband and I raised our children, is wider and more treed. In this new-to-me-valley, I began meeting the people of the plains who had been cleared (Daschuk, 2013) making way for my settler colonial ancestors. It is in the Qu'Appelle Valley, specifically within/without the metaphorically walled (Donald, 2012a, 2012b) Fort Qu'Appelle, that I began to learn about the sacred promises made and kept by Indigenous peoples to share the land and the promises made but broken and twisted by settler colonials.

I am challenged to imagine what it could mean to be good neighbours, giving back in proportion to what settler colonials have taken unjustly, and what settler colonials

continue to benefit from this land. It is here that I began learning the language, the spirit and intent of the Treaty. In the past ten years of exploring *Treaty Walking*, I have come to see the practice as embodied Treaty mindfulness through movement.

From the windows of the File Hills Qu'Appelle Tribal Council Governance Centre, I see how visible I would have been, *Treaty Walking* to school. I usually waved to vehicles and anyone I saw. I remember the caretaker, late John Anaquod, would wave back. I wonder if that walking, and waving made a difference. It did for me.

3. A tree

I snap pictures of the men's dress ties, tied into the branches. I am on the edges of the powwow grounds at night, against the headlights of oncoming vehicles as they leave night skiing at Mission Ridge. Ties flip and twist in the wind.

I have been taught that in ceremony when cloth is offered to a lodge keeper or elder, it is then used in prayer, tied into the bending branches of a sweat lodge, and then tied into trees far away from public spaces.

I remember seeing a small group gathered around this tree, in the southwest corner of the powwow grounds, during a Treaty 4 Gathering and I remember a solemnity. I realized later they had left men's dress ties, tied in the trees, along with little trinkets, like hearts. I wonder if this is a memorial for missing men and boys.

I stop and leave tobacco, as I was taught to do by Dr. Ermine and Dr. Weenie, when I want to ask for help. I join a prayer that I do not have language for, asking for help from those who left the ties and trinkets in the trees. I touch the bark, offering gratitude to the tree for holding this space.

Mamatowisowin speaks about an enfolded dimension, in the inner spaces of all humans, as a power source that not only can unite all existence but also can provide the ultimate and secure ground of our personal realities. It is the mystery of our existence [...] It suggests that each of us can seek to know the unknown using the gifts that were placed in each of us in concert with the conditions that make us receptive to knowing.
(Ermine, 2002, p. 195)

Treaty 4 is also called the "Qu'Appelle Treaty" because it was first signed here on these grounds in Fort Qu'Appelle. This is a place of gathering, of commitment. I am a relative within this communal agreement.

4. Standing Buffalo Tansi Trans Canada Trail

I walk with university students on a guided Treaty Walk, scripted in 2017 with my high school students. It was given the name "oski-pimohtahtamwak otayisīniwiwaw" by

Elder Alma Poitras from Peepeekisis First Nation and translated from nêhiyawêwin meaning: "they are into their new journey to knowledge."

Walking along the Qu'Appelle River, I wonder about the location of where the Paskwa pictograph may have changed hands from Chief Ben Paskwa to Lord Barnaby (Beal, 2007) who then took the pictograph to England where it hung in his London home for 100 years, like a fairy tale curse. In a joint effort it was repatriated to Pasqua First Nation in June 2017 and now resides in the First Nations Gallery at the Royal Saskatchewan Museum in Regina.

"Chief Pasquah, c.1895. He argued that the land belonged to the Indians and that the £300,000 paid to the Hudson's Bay Company should have been given to them" (Cardinal & Hildebrandt, 2000, p. 6).

5. Flags

When I first started *Treaty Walking*, my walking took me past the All Nations Healing Hospital where the Union Jack floats alongside Canada, Saskatchewan, and Treaty 4 flags. As long as the sun shines, the grass grows and the river flows.

On the first National Day for Truth and Reconciliation, they lifted the orange Every Child Matters flag (in place of green and gold). All fly at half-mast in memory of those who did not come home.

Professor Willie Ermine writes:

> Indigenous humanity along with its experience and awareness of struggle in this country now represents a "gaze" upon the Western world. This gaze projects from the memory of a people and is, in essence, the continuum of a story and a history.
>
> (Ermine, 2007, p. 199)

Mapping-as-art works differently from much of the current societal logic of individualism, exceptionalism, and self-reliance. It generates a specific form of navigational knowledge in the concrete grasp of one's located existence. Robin Kimmerer (2013) argues that "the work of living is creating a map for yourself" (p. 7). The newcomers on this land are long-overdue in listening to Indigenous peoples to understand "what really happened there (here) and who the actual inhabitants [...] were (are)" (Harmon, 2009, p. 39). In *Treaty Walking*, this mapping includes listening to the land as well as developing a capacity to define both the territory and Treaty agreement within which political relations must be located and to navigate oneself within it. This is a form of mapping in which one finds a sense of self as a function of that landscape.

Each mapping cues the viewer to notice socioecological–political relations in ways that locate them within the territory mapped. Of course, there is not just one way of

answering Harmon's (2009) questions regarding *what really happened here* (p. 39). Maps-as-art acknowledges that the world still needs maps and more of them, but rather than representation, the world needs "new relations and new uses" (Kanarinka, 2006, p. 25). The title of this map-as-art, "Mapping 5 Months of *Treaty Walking*" cues readers to notice underlying political narratives and sacred Treaty relationships inherent in this work, inviting others to walk with us into ethical spaces between Nation-to-Nation covenants on this land, human and more-than-human. It is our hope we are "heightening the solemnity of the historical events and drawing us in to look at the maps more closely" (Harmon, 2009, p. 39). There has never been wilderness to map on this land, but rather deep relationality, interconnections, and interdependence.

In conclusion, Koops' *Treaty Walks* might be a source of departure for conditions in the days ahead that map something of Simpson's (2018) wishes as an Indigenous grandmother:

I want my great grandchildren to be able to fall in love with every piece of our territory. I want their bodies to carry with them every song, every story, every piece of poetry hidden in our Anishinaabe language. I want them to be able to dance through their lives with joy. I want them to live without fear because they know respect, because they know in their bones what respect feels like. I want them to live without fear because they have a pristine environment with clean waterways that will provide them with the physical and emotional sustenance which to uphold their responsibilities to the land, their families, their communities and their nations.

(n.p.)

When these conditions are finally here, the daily footsteps of Treaty teachings will have led the way for Treaty grandchildren of the future.

Acknowledgements

We would like to thank the Social Sciences and Humanities Research Council of Canada 2020 for funding this research through the project entitled: *Mapping a/r/tography: Transnational storytelling across historical routes of significance.*

References

Basso, K. (1996). *Wisdom sits in places: Landscape and language among the Western Apache.* University of New Mexico Press.

Beal, B. (2007). An Indian chief, an English tourist, a doctor, a reverend, and a member of parliament: The journeys of Pasqua's pictographs and the meaning of Treaty Four. *The Canadian Journal of Native Studies, XXVII*(1), 109–188.

Cardinal, H., & Hildebrandt, W. (2000). *Treaty elders of Saskatchewan: Our dream is that our peoples will one day be clearly recognized as nations.* University of Calgary Press.

Chambers, C. (2008). Where are we? Finding common ground in a curriculum of place. *Journal of the Canadian Association for Curriculum Studies, 6*(2), 113–128.

Daschuk, J. (2013). *Clearing the plains: Disease, politics of starvation, and the loss of Aboriginal life.* University of Regina Press.

Donald, D. (2012a). Forts, colonial frontier logics, and Aboriginal-Canadian relations: Imagining decolonizing educational philosophies in Canadian contexts. In A. A. Abdi (Ed.), *Decolonizing philosophies of education* (pp. 91–111). Springer.

Donald, D. (2012b). Indigenous métissage: A decolonizing research sensibility. *International Journal of Qualitative Studies in Education, 25*(5), 533–555.

Ermine, W. (2002). The Cree first nations sweat lodge. In J. Downes and A. Ritchie (Eds.), *Sea change: Orkney and Northern Europe in the later iron age AD 300–800* (p. 204). Pinkfoot Press.

Ermine, W. (2007). The ethical space of engagement. *Indigenous Law Journal, 6*(1), 193.

Haig-Brown, C., & Dannenmann, K. (2002). A pedagogy of the land: Dreams of respectful relations. *McGill Journal of Education, 37*(3), 451–468.

Hanson, E., Gamez, D., & Manuel, A. (2020, September). The residential school system. Indigenous Foundations. https://indigenousfoundations.web.arts.ubc.ca/residential-school-system-2020/

Harmon, K. (2009). *The map as art: Contemporary artists explore cartography.* Princeton Architectural Press.

Kanarinka, F. A. (2006). Art-machines, body-ovens and map-recipes: Entries for a psychogeographic dictionary. *Cartographic Perspectives, 53*, 24–40.

Kimmerer, R. W. (2013). *Braiding sweetgrass: Indigenous wisdom, scientific knowledge, and the teachings of plants.* Milkweed Editions.

Koops, S. (2012). *Treaty Walks for Kids Treaty Walks.* http://treatywalks.blogspot.com/2012/10/treaty-walks-for-kids_11.html

McGinnis, A., Tesarek Kincaid, A., Barrett, M. J., Ham, C., & Community Elders Research Advisory Group. (2019). Strengthening animal-human relationships as a doorway to Indigenous holistic wellness. *Ecopsychology, 11*(3), 162–173.

Malpas, J. (1999). *Place and experience: A philosophical topography.* Cambridge University Press.

Marker, M. (2011). Teaching history from an indigenous perspective: Four winding paths up the mountain. In P. Clark (Ed.), *New possibilities for the past: Shaping history education in Canada* (pp. 97–112). UBC Press.

Office of the Treaty Commissioner. (2007). *Treaty implementation: Fulfilling the covenant.* www.otc.ca

O'Sullivan, S. (2001). The aesthetics of affect: Thinking art beyond representation. *Angelaki: Journal of the Theoretical Humanities, 6*(3), 125–133.

Ray, A., Miller, J., & Tough, F. (2002). *Bounty and benevolence: A history of Saskatchewan treaties.* McGill-Queen's University Press.

Simpson, L. (2013). *Restoring nationhood: Addressing land dispossession in the Canadian reconciliation discourse* [Simon Fraser University lecture]. Vancouver, BC. https://www.youtube.com/watch?v=fH1QZQIUJIo

Simpson, L. (2018). Coming into wisdom: Community, family, land & love. *Northern Public Affairs Magazine*. http://www.northernpublicaffairs.ca/index/

Snowshoe, A., & Starblanket, N. V. (2016). Eyininiw mistatimwak: The role of the Lac La Croix Indigenous Pony for First Nations youth mental wellness. *Journal of Indigenous Wellbeing: Te Mauri – Pimatisiwin, 1*(2), 60–76.

Solvey, S. (2018). *Treaty entanglements: Exploring educational significance of Treaty understandings amongst Alberta preservice teachers* [Master's thesis, University of Alberta]. https://doi.org/10.7939/R3NP1X044

Solvey, S., & Koops, S. (in press). Going beyond the space of acknowledgement: Place, provocations, and precarious practice. In J. Markides & J. MacDonald (Eds.), *Brave work in Indigenous education*. DIO Press.

Starblanket, G. (2019). Crisis of relationship: The role of treaties in contemporary Indigenous-settler relations. In G. Starblanket, D. Long, & O. P. Dickason (Eds.), *Visions of the heart: Issues involving Indigenous peoples in Canada* (5th ed., pp. 175–208). Oxford University Press.

Stonechild, B. (2005). Treaty 4. *Indigenous Saskatchewan Encyclopedia*, University of Saskatchewan. https://teaching.usask.ca/indigenoussk/index.php

Tuck, E., & Yang, K. W. (2012). Decolonization is not a metaphor. *Decolonization: Indigeneity, Education & Society, 1*(1), 1–40.

Tupper, J. (2011). Disrupting ignorance and settler identities: The challenges of preparing beginning teachers for treaty education. *Education, 17*(3), 38–55.

Tupper, J., & Cappello, M. (2008). Teaching treaties as (un)usual narratives: Disrupting the curricular commonsense. *Curriculum Inquiry, 38*(5), 559–578.

Venn, S. (1997). Understanding Treaty 6: An Indigenous perspective. In M. Asch (Ed.), *Aboriginal Treaty rights in Canada: Essays of law, equality, and respect for difference*. (pp. 173–207). UBC Press.

Weenie, A. (2020). Askiy Kiskinwahamakewina: Reclaiming land-based pedagogies in the academy. In S. Cote-Meek & T. Moeke-Pickering (Eds.), *Decolonizing and Indigenizing education in Canada* (pp. 1–17). Canadian Scholars.

Zournazi, M. (2003). *Hope: New philosophies for change*. Routledge.

Grounding

Being Anecdotal

Natalie Owl

adjective

1. (of an account) not necessarily true or reliable, because based on personal accounts rather than facts or research.

Similar:
informal
unreliable
based on hearsay
unscientific

Opposite:
experimental
scientific
 Characterized by or fond of telling anecdotes.
Being
Born
And Bled
Becoming
Anecdotal
Being not necessarily true
Being not necessarily reliable
Being a Thunderbird unseen

If hardened by fact
And sharp research tools
Would I become less of a Being
But more of being less anecdotal

Where I am anecdotal
As some professor narrates,
I sit
Red face
Red for sacrifice

Red for suffering
Red where Grandfathers sit
That's needed for …

Your birth, your growth
Your life, your being
Less Scientific
And more anecdotal

Chapter 2

Walking Trails Connected to the Thirteen Moons

Jennifer MacDonald

As a non-Indigenous, white, Canadian woman with a background in taking high school students on multi-day wilderness journeys, I came to Calgary several years ago from the north-eastern shores of Lake Ontario to pursue graduate studies. My interest was around decolonizing my outdoor education pedagogy as I could pinpoint aspects of the tradition that made me uncomfortable. For example, as I began to learn more about colonialism, I was faced with my own ignorance towards the traditional territories where we travelled, and the violence endured by Indigenous communities on these lands. I started to deconstruct the purpose of our outdoor trips—for example, canoeing in Algonquin Park or backpacking in the Adirondack mountains—to surface anthropocentric tendencies of conquering nature and achieving human self-actualization (Newbery, 2003; Root, 2010). Simultaneously, however, our journeys came with subtle, yet fleeting, feelings that deeper connections, in relation to our surroundings, were occurring as students and I encountered rhythms and tones of the unknown.

When I moved to Calgary, it took almost a year to begin to feel a sense of belonging. At first, I characterized my unease with tensions of differing politics and contrasting priorities in alignment with environmental concerns. The more that I walked the city I recognized the various ways in which it is designed and built for the automobile and not the walker. Through my movement, however, I developed a deeper understanding that the city is not separate from kinship relations, to say that humans are in constant relation with many living entities, for example the sun and air, that sustain life even in urban settings. The absence of humidity and large bodies of water, and the invisible presence of elevation, was influencing me and contributing to my longing for home (MacDonald, 2017). As I walked, I also became more aware of the confluence of different ecologies. To the east, there is wide open Prairie; to the west, the rugged spine of the Rocky Mountains. With experience, I learned that the shifting winds signalled drastic changes in the weather. On some days, I might experience all four seasons within just a few hours.

Nose Hill Park in the north-west of the city is a place where I did a lot of reflecting. My first interactions with this place were from a distance as I admired the hill as a landmark on bus trips to and from the university. At first, I wondered how the land escaped urban development as suburbs sprawled along the rolling hills of its circumference in an ever-expanding city. Moreover, I appreciated watching the mood change through the different seasons. *Yellow, white, green, brown, pink*; the colour shifted in relation to the skies. Although the hill was constantly working on me, providing grounding and orientation during the first

several months, I did not fully appreciate the presence or anticipate how important our relationship would become.

In the second year of my programme, I had the opportunity to participate in a course at the University of Alberta with Elder Bob Cardinal and Dr. Dwayne Donald. The course, *Four-Direction Teachings: Holistic Approaches to Support Life and Living*, followed teachings of the thirteen-moon nêhiyaw (Cree) calendar. While I had engaged with Donald's (2012, 2016) writing around ethical relationality prior to the course, I knew it mostly through thinking about it as an academic concept regarding Indigenous-Canadian relationships. Ethical relationality, in his words, is "an ecological understanding of human relationality that does not deny difference but seeks to more deeply understand how our different histories and experiences position us in relation to each other" (2012, p. 45). Through the course, I came to recognize the four-dimensional (emotional, spiritual, mental, and physical) nature of particular philosophies, which inevitably includes all that gives life—human and more-than-human (Donald, 2016). As part of this process, we were invited to study a place by attending to the ecological insights and how we might live out course teachings in our own context. I immediately knew that I wanted to spend time with Nose Hill and commit to walking the trails there.

In this chapter, I will share my learning with Nose Hill and what I learned through my engagements about being a relative, a human, and an educator. In what follows, I first provide more nuance to my position and the importance of interweaving critical and creative dialogues. I then outline how map-making emerged as a relational sensibility which helped me to document my learning and, in turn, how this process started to map me. Through image and text, and guided by metaphors other than the grid map, I share some of my experiences with Nose Hill. By way of centring the holistic character and multiplicity of what gives life through the seasons, I conclude by offering some pedagogical meaning of these learnings as I carry them forward with a commitment to teach and live more responsibly in relation to earthly kin.

Walking as a treaty relative

James Tully (2018) writes about the interconnected and dual projects of Indigenous-Canadian and human–earth relations.[1] He writes:

> The ways that "life sustains life" in webs of life that comprise the ecosphere are our primary teacher in both cases of reconciliation. Indeed, this multidisciplinary education [...] is the most important pedagogical task of the twenty-first century if we are to have sustainable shared future.
>
> (p. 86)

Given the interweaving projects, I see now that I was naïve in my first considerations of how one might decolonize educational practice. I felt resonance with Indigenous

philosophies of place to understand moments of vulnerability and connectivity, but I did not have any relationships with Indigenous people nor a good understanding of how my access to wilderness has always occurred at the expense of Indigenous sovereignty. Thus, the question is quick to surface: how might a white woman do this work? I could not engage in the project of questioning student experiences with the places we visit, without my own critical study of the ground where I walk. I had to undergo the deeper, difficult, and personal work of understanding what it means to be Canadian: of unsettling the settler within (Regan, 2010).

A lot of scholarly literature on the topic of decolonization asks me to be very critical of my position. I am advised to consider how my whiteness and privilege have led to many social and environmental problems (Newbery, 2012; Tuck & Yang, 2012). As a result, I have spent much time reflecting on my complacency with violent and harmful truths. Part of my struggle is coming to hold these understandings, while also navigating pathways to come into dialogue with relational wisdom. I often felt isolated and confused in my negotiations for restoring a balanced relationship. What might I do after I become aware of colonial and anthropocentric logic? Of course, saturated in a worldview that values individualism, competition, consumption of material goods, and scientific-technological explanations of the world, unpacking the narrative that separates humans from the earth, will be a lifelong task, but might I also hold enhanced kinship relations on the horizon? While inquiring how we might go on together, an important part of my learning was seeing myself as part of an ongoing process of colonialism (Donald, 2012; Starblanket, 2019), and not separate from kin relations. As Donald (2010) shares:

> Everybody's been colonized—it doesn't matter what colour your skin is or where you're from. So, we need to sort of sit together and think about this and try to figure out a way where we can speak to each other on more ethical terms.
>
> (p. 12)

The *Four Directions Teachings* course was a turning point for me because it opened the needed space to sit and learn together. I approached the course cautiously at first, constrained by political pieces, such as who can engage in this work and what space am I taking up, that I had previously internalized, but I quickly felt invited to participate and share in something that provided deeper possibilities. There were many new-to-me ways of communicating, gathering, participating, and validating. For example, from our first meeting, I was intrigued by how sharing in the circle was the primary way that we learned together. I anticipated the Elder might "teach us" more directly. Over time, however, I appreciated that the circle modelled a non-hierarchical frame that honoured our subjective experiences, and that the Elder's insights in response were teaching us all differently based on where we were at. I came to recognize Nose Hill in the same way; addressing me where I was at with each visit and going deeper with time. While

not addressed directly, the course was aligned with treaty principles: good relations, peaceful coexistence, and honouring the gifts (D. Donald, personal communication, March 9, 2020).

Margaret Kovach (2013) writes that "a treaty education, for Canadians, holds the potentiality for conversations that investigate a multiplicity of worldviews, contrasting political process, environmental stewardship, and differing economies" (p. 123). This sensibility needs to be extended beyond Indigenous-Canadian relations to include more-than-human kin. Gina Starblanket (2019) guides me with her description of a relational paradigm that pre-dates European contact. She writes:

> Treaties were not intended to establish a static set of terms that would be fixed in time, but to provide a framework that is dynamic, relational, and contextual and that could guide interaction of treaty partners over time [...]. frameworks of coexistence were not exclusively concerned with the nature of human interactions, but also with the ways in which humans would coexist in *relation to creation* [...]. The responsibilities and rights that are affirmed in treaties are shared by all living beings, and implicate the animals, birds, waterways, land, ancestors, spirits, and Creator as political actors. Understood in this way, treaty-based modes of relating give rise to an understanding of political community as something far greater than a collective of individual humans, but rather as something comprising the relationships between people and places interacting in the present and in different time periods.
>
> (pp. 23–25)

I am taken by how these treaty modes of relating underscore the original agreements found within Indigenous creation stories, oral histories, and natural laws and already provide guidance for how humans might live well with the living earth in respectful and reciprocal ways. As a Canadian, who wants to enact learning from Elder Cardinal in my life, to be in better relation, I want to move thoughtfully knowing that I have Treaty rights and responsibilities to uphold.

Moving with treaty modes of relating: Unlearning the grip map

In his book, *Masons, Tricksters, and Cartographers*, David Turnbull (2000) states: "The development of 'scientific maps' has come to be identical with progressive, cumulative, objective and accurate representation of geographic reality, synonymous with the growth of science itself" (p. 97). His description draws my attention to the link between mapping and the concepts of discovery and exploration—common colonial discourse (i.e., Terra Nullius and Doctrine of Discovery)—that denies relationships by promoting the essence of objective *space*. In outdoor learning situations, reading maps and using a magnetic compass to navigate are naturalized as fundamental skills. They are taught early, fine-tuned, and progressively

advanced to more complex systems for moving through space. The mastery of these skills becomes taken for granted and falls into the background. Through my engagement with treaty modes of relating, I am increasingly more aware of how such skills may implicitly direct how one might interact with place. In other writing (MacDonald, 2020), for instance, I reflect on the linearity of my experiences as an outdoor educator, for instance going out *there* to have a pre-planned adventure and then returning home afterwards to await the next adventure and the learned efficiency of going in a straight line. Navigational practices serve as another example of colonial and scientific-technocratic frames that can manifest a certain experience. While there is a real function to these skills, I believe possibilities to generate more balance—through attuning to place through our whole bodies exist.

Therefore, through studying the work of Indigenous scholars, such as Manulani Aluli Meyer (2008), my curiosity was drawn to more holistic sensibilities of triangulation (mind/body/spirit) that offered more opportunities for experiencing and expressing place in multidimensional ways. Thus, I was interested in how to map my experiences with Nose Hill to document my expanding sense of relationality. While considering how my mapping process might transpire, I was inspired by the counter-mapping project (Loften & Vaughan-Lee, 2018) offered by Zuni artist and museum director Jim Enote, whose approach to creating maps of place unique to Zuni stories and understandings. His project pushed me to further recognize how grid maps can confuse our sense of relationship with the world, always looking with a bird's eye view, and finding our precise location. While I do not aspire to co-opt his process, or pretend to be Zuni, the idea to capture vignettes of experience resonated as an insightful way to provoke reflection within my growing encounters with the thirteen moons, as I describe below. To me, paying attention to the teachings of each moon centred a different sense of time in relation to place and what was going on within my surroundings. In turn, I understood that coming to learn the ecological insights of place was also about coming to know myself.

Observing the thirteen moons through walks with Nose Hill

My participation in the *Four Directions* course involved travelling from Calgary to near Edmonton once a month for course gatherings. This meant that I was learning from a Cree Elder while living on traditional Siksikaitsitapi (Blackfoot) territory in Calgary. I want to make it clear that I was doing my best to carry forward sensibilities of relationality— paying attention to the insights connected to the waxing and waning moon—while moving dynamically within the context of where I was. This came with an understanding that there are differences in the knowledge systems, languages, and ecologies of these two places.

Figure 2.1 shows the overall map of my study with Nose Hill through the four seasons; thirteen moons. I generated this map by reviewing field notes and photos that I collected over the year-long cycle. I have learned from Elder Cardinal that one should begin in the east and follow the sun. However, given that my formal engagement attending to Nose Hill began in September and went deeper with time, I will begin sharing vignettes from the map in the west.

Walking in Art Education

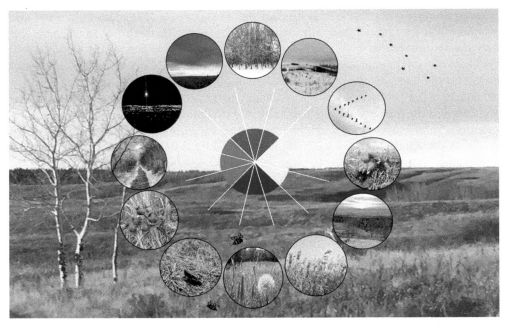

Figure 2.1: Jennifer MacDonald. *Nose Hill Vignette*, 2019. Photograph. Calgary. © Jennifer MacDonald.

Fall/west/mental

I always approach the hill from the west as I come from the university. At first, I keep looking outward. Getting to the top of the hill and tracing my urban routes through the city streets from the elevated vantage point. It looks much different from above. I am drawn to the juxtaposed worlds: the core of the city contrasting with this open space. I note the variety of sounds, human activity along the nearby road in harmony with the birds and wind in the tall grasses behind me. Shifting my view, I look to my feet and notice rose hips all around where I am standing. Kneeling down I consider the lifecycle and ecosystem supporting the survival of the rose flower, now at the end of its life. I reflect on how it will continue to give by being gathered and used to make tea.

Looking to the west, I see a blanket of snow covering the mountains. The wind catches me off guard as it did not seem this intense before I set out. It is now all I can focus on. I find it annoying and feel pushed off balance. I follow trails leading to shelter in a coulee and am more relaxed. Snow is beginning to gather on the sides of the trail. I am drawn to the aesthetic of the many colours: the yellow trees, white patches of snow on yellow, and bright blue sky. Once more protected by the trees, I can hear some crow, but I cannot see them. They are also taking refuge. I reflect on my feeling of stress and the importance of being prepared as the seasons shift.

I take two friends who are visiting from out of town to visit Nose Hill. Being with other humans changes the dynamic since I am typically alone. The focus is different, as they ask interesting questions about the park, which I had not given attention to before, but I am also not attending in the same way. Going to this place at night is a new experience and we rely on the light of the moon for guidance. It seems frost is forming before me. The ground is frozen, and the air feels heavier. Perhaps snow is near.

Winter/north/physical

I begin with the morning light, meeting the rising sun at the top of the hill. The snow crunches beneath my feet and I can hear the trees crackle under a deep cold. The winter temperatures have been harsh the past few days, around −30 degrees and colder with the windchill. I am curious how all the other beings who live here have methods for winter survival. They are much more intelligent than I am, as I feel exposed going up the usual trail and need to cut my walk short. What might I learn from them? As I return indoors, I am grateful for the gifts of warmth and shelter.

As the shortest day of the year approaches, I am reminded that I am much further north than my hometown in Ontario. In Calgary, it gets dark much earlier and stays dark later in the morning. These differences throw me off when I return after the holiday break. In early January, when I struggle to get going, I am reminded again of all the natural offerings that give life. In this instance, it is the absence of light. A few days later, the extreme cold is broken by the warmer Chinook winds that blow down the eastern slope of the Rockies to greet me. I learn that the low-hanging arch cloud indicates the dramatic shift in temperatures. While this brings relief it also melts the snow during the day and then it freezes at night making the trails slippery. As I change my route, I see a porcupine resting at the base of a small tree. Another gift.

I find that this visit is lonely. There is very little activity on the hill; I do not encounter any other humans and only see traces of other animals left in the snow. The days seem to drag, but time goes fast. I feel unproductive and keen to be active, yet I lack the energy to do so. As I am more attentive to my energy in relation to darkness, I find myself questioning why one of my busiest times of year is when all the other beings are resting. This insight leads me to consider the structure of school and pedagogical practices as they seem to be out of sync with the ecological insights that I am gathering.

Spring/east/emotion

The silence is broken one day as geese approach my position from the southeast. Their presence brings memories of my grandmother. I remember watching the birds migrate over the bay with her when I was growing up, soon after the bay would open up. The geese indicate the changing season and are a welcome sound at the end of winter. As I watch them

go overhead, I consider how much there is to learn from their resilience and how they take care of each other through migration patterns.

I am delighted when I spot a small purple crocus and kneel to admire its outer layer of fur more closely. Once I see one crocus, I remark that they are everywhere, brightening up the otherwise yellow and brown landscape as I wander. The Siksikaitsitapi significance of the ki'piaapi (prairie crocus) is brought to my attention[2]—bringing the arrival and newness of spring. I am reminded that the landscape is storied with meaning and instructions. On another occasion, I was called into deeper relation by a friend who had a similar experience with a crocus, which began an important dialogue recognizing the spirit of our encounters (Bouvier & MacDonald, 2019). In this instance, cultural traditions expose different layers of spiritual and relational exchange, and I learn more about intentional practices to live in relationship. With that, I feel a lightness in the air and my own budding sense of excitement and hope. I am taught patience, however, when a snowstorm covered the hill a couple of days later.

I find that I am breathing deeper and feeling more energized while I walk. I inhale the smell of the earth as it comes to life after a winter rest. I feel a softness beneath my feet and observe that the thawing does not transpire evenly over the land. The wind is warmer from the west, robins sing, and hawks are easily spotted.

Summer/south/spiritual

Donald (2019) writes, "First and foremost, we acknowledge that the sun is literally the giver of life. We acknowledge that our bodies are comprised of sunlight-inspired energy that inhabits the air, water, minerals, plants, and animals that we consume" (p. 104). I think about my relationship with the sun, the sustenance and inspiration it provides, as the solstice approaches. It provides life to all—this simple truth is profound in that connectivity is highlighted. Through the year I have learned about the importance of asking for permission and make an offering; to speak from the heart.

Through the cycle, I feel more relaxed as I sit more and visit familiar spots regularly to study them more carefully. Instead of focusing on how worldviews collide as I was at the beginning of the course, my attention expands to how we all depend on the same things and the diversity of life. I learn about different species of grass and the ecosystem in which they support. Everything has a purpose. Coming from Ontario, where I love to study trees, I am surprised by the nuances within the prairie landscape that all looked the same to me a year ago. As the summer advances, variances become more prominent with flowers and cyclical processes. I am grateful for the smell of sage surrounding me.

I return to the hill after being east for several weeks. I am alarmed by how dry the ground is and note that the chokecherry shrubs are nearly ready for harvest. The grasshoppers beneath me make themselves known as they jump up on my legs and their stridulations echo. As they pull into my awareness, I think about how they help maintain the balance here by consuming the overgrowth and providing fertilizer back to the land through their waste. As I begin preparing for

the cycle ahead, to return for another year, I am enthralled by the simplicity of the grasshopper insight, as a reminder to renew the intentions of my purpose for being a good relative.

Enacting wisdom: Circling the teachings outward

My inquiry with Nose Hill Park is never finished. While my relationship with this place began several years ago, I keep returning and noticing different patterns and insights along the same trails. With each cycle, a different map could be generated as the context shifts and my understanding deepens. I recognize the need to keep visiting to keep trying my best to live out relational teachings in my day-to-day life. In this sense, walking the trails at Nose Hill has become a regular practice of renewing relations. Reflecting on my encounters and the responses that surfaced helps me triangulate my holistic position in different moments and this helps me be present in my surroundings and recognize how much I depend on various entities.

My experience studying this place has helped me appreciate that relations need constant renewal and that I have a responsibility to widen the circle and share the learning outward. To do so, the task is not about detailing my experience as the only way one might engage place in this work, but about sharing the sensibilities in which I engaged to offer the process as an inspiration for others. Thus, returning to pedagogical tensions and questions at the beginning of this chapter, around Western notions of nature and how they are embedded in traditions of outdoor education, I am encouraged to nuance my practice in ways that accentuate the various dialogues that are already part of being a participant in place, but that are often overlooked. I see the first undertaking as simply to support and guide students to see themselves as part of an ecological web, not separate from it. With this understanding, I see possibilities for students to appreciate the gifts that are already part of place and to understand their own gifts and how they might reciprocate. In my study, my experience with multimodal walking, such as using photographs to capture moments of felt connection and teachings with each moon, was important for expressing the multidimensions of connection that can be difficult to articulate. In addition, engaging with multimodality was an important way to archive my growth, and map out the teachings of the different seasons.

I understand that my mapping study positions Nose Hill as the teacher. In consideration of treaty modes of relating, seeing place as a teacher is purposeful to disrupt the hierarchy that the human–teacher is the holder of knowledge. Learning to pay attention instead to simple truths, for example, that the sun will rise, the wind will blow, the grass will grow, and the water will flow, supports me in letting go of my learned yearning for control, to just be present with the fullness of my kin relatives. They will expose themselves more deeply as I learn to listen more closely. In consideration of how I might translate my learning from this place-study to my outdoor education practice, the most concrete steps to which I wish to commit involve acknowledging a need for subjective experience (we all experience events differently), slowing down to listen, encouraging dialogue with the living world

(point certain aspects out to students so they can have an experience of it for themselves), and sharing stories of kinship relations as part of everyday practice (instead of focusing on human-centred debrief questions, and asking questions like: what did you encounter today?).

Acknowledgements

This chapter is guided by the teachings of Elder Bob Cardinal of Maskêkosihk Enoch Cree Nation. I am grateful for his generosity and for his permission to share his oral teachings.

Notes

1. I use the term Indigenous-Canadian here to emphasize nation-to-nation relationships and how the grand narratives of my positionality, Canadian, position me within complex histories and compliances that have caused harm to Indigenous communities. I do not refer to myself a "settler," which is common for non-Indigenous people in the field of decolonizing education, to honour the wisdom teachings that I take up with the understanding that I am part of a relationship, and it is possible for me to live, at home, here responsibility.
2. For an example of the Siksikaitsitapi crocus story can be heard here: https://galileo.org/kainai/pasque-flower/

References

Bouvier, V., & MacDonald, J. (2019). Spiritual exchange: A methodology for a living inquiry with all our relations. *International Journal of Qualitative Methods, 18*, 1–9.

Donald, D. (2010). On what terms we speak? [Video]. Vimeo. https://vimeo.com/15264558

Donald, D. (2012). Indigenous métissage: A decolonizing research sensibility. *International Journal of Qualitative Studies in Education, 25*(5), 533–555.

Donald, D. (2016). From what does ethical relationality flow? An Indian Act in three artifacts. In J. Seidel & D. W. Jardine (Eds.), *The ecological heart of teaching: Radical tales of refuge and renewal for classrooms and communities* (pp. 1–16). Peter Lang.

Donald, D. (2019). Homo ecomonmicus and forgetful curriculum: Remembering other ways to be a human being. In H. Tomlins-Jahnke, S. Styres, S. Lilley, & D. Zinga (Eds.), *Indigenous education: New directions in theory and practice* (pp. 103–125). University of Alberta Press.

Kovach, M. (2013). Treaties, truths, and transgressive pedagogies: Re-imagining Indigenous presence in the classroom. *Socialist Studies, 9*(1), 109–127.

Loften, A., & Vaughan-Lee, E. (2018). Counter mapping. *Emergence Magazine*, Issue 1. https://emergencemagazine.org/story/counter-mapping/

MacDonald, J. (2017). Curriculum encounters while walking the city. *Journal of the Canadian Association of Curriculum Studies, 15*(2), 20–33.

MacDonald, J. (2020). A poor curriculum in urban place: An atlas for ethical relationality. In T. Strong-Wilson, C. Ehret, D. Lewhowich, & S. Chang-Kredl (Eds.), *Provoking curriculum encounters across educational experience: New engagements with the curriculum theory archive* (pp. 25–41). Routledge.

Meyer, M. A. (2008) Indigenous and authentic: Hawaiian epistemology and the triangulation of meaning. In N. K. Denzin, Y. S. Lincoln, & L. Smith (Eds.), *Handbook of critical and Indigenous methodologies* (pp. 217–232). Sage.

Newbery, L. (2003). Will any/body carry that canoe? A geography of the body, ability, and gender. *Canadian Journal of Environmental Education, 8*(1), 204–216.

Newbery, L. (2012). Canoe pedagogy and colonial history: Exploring contested spaces of outdoor environmental education. *Canadian Journal of Environmental Education, 17*(1), 30–45.

Regan, P. (2010). *Unsettling the settler within: Indian residential schools, truth telling, and reconciliation in Canada*. UBC Press.

Root, E. (2010). This land is our land? This land is your land: The decolonizing journey of white outdoor environmental educators. *Journal of Environmental Eudcation, 15*, 103–119.

Starblanket, G. (2019). Crises of relationship: The role of treaties in contemporary Indigenous settler relations. In G. Starblanket & D. Long (Eds.), *Visions of the heart: Issues involving Indigenous people in Canada* (5th ed., pp. 34–67). Oxford University Press.

Tuck, E., & Yang, K.W. (2012). Decolonization is not a metaphor. *Decolonization: Indigeneity, Education & Society, 1*(1), 1–40.

Tuck, E., McKenzie, M., & McCoy, K. (2014). Land education: Indigenous, post-colonial, and decolonizing perspectives on place and environmental education research. *Environmental Education Research, 20*, 1–23.

Tully, J. (2018). Reconciliation here on earth. In M. Asch, J. Borrows, & J. Tully (Eds.), *Resurgence and reconciliation: Indigenous-settler reconciliation and earth teachings* (pp. 83–131). University of Toronto Press.

Turnbull, D. (2000). *Masons, tricksters and cartographers*. Harwood Academic.

Grounding

Noodinoon ("The Winds"): A Life-Giving Force We Cannot See

Shelly Johnson

Our maternal grandmother was our family historian and storyteller. She was born in 1919 in the midst of the Spanish flu that killed more than 50 million people globally. Her parents died from the deadly pandemic within two days of each other, leaving their five little girls aged newborn to 9 years old as orphans. When the children recovered, their parent's church scattered them across five provinces to live with five separate and unrelated sets of foster parents. It broke their sibling bonds that unfortunately never recovered. My grandmother was an infant, and she lived with a Saskatchewan farm family in which the parents were illiterate. Her advanced education options were limited by a one-room school experience, poverty, and early marriage expectations. Yet, in addition to a reputation for hard work, hers was also a story of loving kindness, determination, and an unwavering spirituality.

My grandmother always told a story about an early fall afternoon when the sun's rays stretched long and golden against the land and mountains, and a warm wind unexpectedly picked up as she carried me to a gathering. She said that although I was a tiny infant, it was the first time she heard me laugh aloud. In her storytelling, she included many more childhood instances that she witnessed me playing with the wind. Moments that I stood still or twirled in it, moments that I held my arms out and danced in it, and times when I somersaulted or rolled in it like a blowing tumbleweed. Always, she said, I became joyful and laughed, as the wind grew stronger, and quieter as it became weaker. She recalled how I would beg her to come dance with me in the wind. My fondest memories are the times that she did, and we laughed together, just the two of us. I remember knowing that she loved the wind as much as I did.

For as long as I can remember, feeling the wind circling my body and through my hair fills me with wonder. It makes me feel joyfully alive. I recall being a young child riding my horse along a quiet country trail on an early winter afternoon. Suddenly a cool breeze surrounded us. The horse's mane and tail began to flow in the wind, and I could feel a happy change in her step. "She feels as free as I do" was the thought that immediately came to mind.

During a spring ceremony led by Elder Alden Pompana, I learned about the teachings of the medicine wheel. He said that their colours represent its four elements, fire, earth, water, and wind. The yellow quadrant represents fire, the red represents the earth, and blue represents the water. The white quadrant, he taught us, represents the wind on the medicine wheel. Wind is the air we need to breathe; it is the life-giving force we cannot see. As we walked together after the ceremony, a playful breeze picked up across the field, and he began to dance with it as if she was a beautiful ballroom dancer. Not to be left out I danced with her behind him, trying my best to be as graceful as they were. I often wonder what others

thought as they watched that Elder and me on that spring morning, and hope it made them smile.

As I've grown older, the wind reveals herself to be a spirit. Often, she is joyful and playful as a child, as she rustles through the grass and lifts birds up and down on her gusts. She did that on the day my daughter was born, in a happy anticipation on our drive to the hospital. She did it when a shawl dancer came to my research class to teach my students about powwow dancing in anticipation of the Kamloopa powwow we were planning to attend for our last class. She took us to the grass on the university grounds to practice. A warm wind moved among us, and a group gathered around to watch the dancing. Then they all joined in, and we all danced with *Noodinoon*.

Once in Trondheim, Norway my father and I watched her in awe as she danced the Aurora Borealis across the northern night sky. Sometimes I can hear her sadness as she cries, mournfully moving through the tree branches and leaves like she did when my grandmother died, and I sat alone on our back porch, lost in grief. Occasionally she shows her anger, rage, and frustration when she takes my breath away, whips up waves on the water, or smashes against buildings. She did all those things when my mother died unexpectedly following a chemotherapy session. Throughout my life, *Noodinoon's* taught me to be respectful of her power, and thankful for her compassion and gifts when there are no words to adequately convey emotions.

It was a warm summer day when my university asked for a photograph to commemorate the day I began a new position as a Canada Research Chair in Indigenizing Higher Education. They assigned a photographer who called to ask, "Which office space at the university would you like to use as a backdrop for your official photograph?" Without hesitation, I said I preferred a photograph taken outside on the land with a friend, a life-giver. He agreed, but when he arrived at the scheduled place and time, he looked surprised when no one joined us on the unceded and occupied territory of the Secwepemc people. "Where's your friend?," he asked. "She's here, she's the wind. You just can't see her. You can only feel her, and she's around on all the important days in my life." I told him as we reached the edge of campus. Then, as if on cue, she revealed herself, and we danced. He stood back, smiling slightly and then joined in our dance. He took this photo when our dance ended, but she continued to twirl around me. *Noodinoon*, my friend. She's been with me from the beginning. My oldest friend. My life-giver.

Figure G3.1: Shelly Johnson. *Noodinoon ("the winds")*, 2019. Photograph. Kamloops. © Thompson Rivers University.

Chapter 3

Conversations With Transitory Spaces:
The Relationality of Tide, Time, and Transit on the St. Lawrence River

Patricia Osler

A shoreline is an unprepossessing and mutable intermediary; in theory, it is the liminal space between water and land. Liminality can be found in the way an estuary negotiates the merging across material and temporal boundaries; how tidal shifts and the ebb and flow of surf constantly redefine a beach. Viewed panoramically, it forms a collaborative narrative, and all beings which traverse its organic and inorganic matter contribute to its shared discourse. Both literally and metaphorically, these stories-in-motion open spaces for kinship and attunement, activating ecologies of pedagogical practice through an entanglement of self-in-relation to place. Walking the shore, one becomes a liminal conduit, experiencing, documenting, and storytelling.

Undeterred by the brutish centrality of human endeavour during the Anthropocene epoch (what Haraway, 2016 reinterprets as a consumptive and growth-obsessed Capitalocene), I respond to this provocation along the banks of the Lower St. Lawrence River. Seeking clues with and from an ecosystem that foregrounds the non-human and more-than-human, I weave walking with thinking and making in an a/r/tographic métissage. Thinking–walking (Truman & Springgay, 2016) and wandering while wondering mark a yearning for the kind of "wide awakeness" which demands attentiveness to the natural world (see Chambers et al., 2002; Chang, 2008; Guyotte, 2015; Osler, 2021; Osler et al., 2019). This practice creates liminal spaces for intentional and emergent pedagogies to intermingle, detour, and disrupt.

Arrival, in the middle

I situate this chapter in eastern Quebec, where I walk daily along a craggy, constantly shifting stretch of the Bas-Saint-Laurent in the company of amiable dogs and sometimes other humans. Sea birds thrust and swoop, effortlessly navigating Gulf thermals as they bicker territorially over the remains of crabs plucked from the cold St. Lawrence River. Taunting the few intrepid bipeds and quadrupeds that preserve along this route, cormorants and gulls flout its topography. But their relationship is not with land formed 450 million years ago, basaltic plates which left behind the stratum of a rock-strewn beach, laid bare by ancient glaciers, and softened by the sea. Instead, they hover over side swimmers, sea urchins, grey and harbour seals, a flotilla of kelp and algae, performing their own timeless, choreographed response to the rhythmic pull of wind and tide. A few kilometres beyond, Atlantic whales blow gustily as they breach and dive, moving in mammoth unison, past and sometimes through the charted shipping lanes.

Sounds carried on the wind intrigue the dogs, who pause, simultaneously alert to an unseen presence and, for an instant, to the myriad life forms that thrill and speak to them. Aware that I too have paused, they look back towards me, seeming to weigh the merit and constancy of our bond against the possibility of another, more mysterious kinship with beings that dwell in the sea. We map and trace our movements together, composing arc-like designs in the sand that intersect their imprints with my own, scribing our relation to one another and to the earth with our bodies. As we calibrate to meet new and invigorating elements, my senses quicken.

Memories of yesterday's trek still linger—the temporal conditions of light, sound, and scent were singularly different then, and stealthier. On that walk, we too performed differently as visitors. In the late afternoon sun, shadows cast by ancient spruce sinuously lengthened, creeping towards the water, quelling the dogs' spirited gait, camouflaging our return. The incoming tide came silently, lapping the shoreline in sheets, insistently pooling around familiar rock formations until they were obscured. Successive waves marked time, slowly re-designing the coastal scape in the spaces where water billows into the sand with every convolution of aqueous urging. A new line formed with each swell, and another, moments later. Further ashore, long fronds of sedge bent in homage to the close of day. Clouds massed upon the horizon.

Countless walks here comprise an entry point—arriving "in the middle" (Barney, 2019, p. 619) of the account to pause and reflect on my process and practice. *What is familiar? Is the tide coming in or going out? Is the wind shifting to the East?* Engaging with non-human and more-than-human elements has a synergistic effect, turning to deliberation of self-in-relation and becoming the foundation of this particular inquiry. My physical, affective, and spiritual intra-action (Barad, 2007) with this environment transforms into pedagogical provocation, aspiring to broaden and deepen understandings of time, place, and the ecologies which intersect here through a/r/tographic practice. More than simply interacting, I, too, am in the middle: at once a participant and an observer, my presence indistinct from any other material agency, co-constituting the environment as much as querying it through practice. Here, I gather and transpose these dialogic entanglements through art, following tentacular thinking along its geographic and temporal strands to arrive at Haraway's (2016) sympoesis or making-with.

Patterns of meaning-making

Grey and volcanic igneous rock, stratified ribbons of red and orange reef, scrub cliffs and granite boulders, sand, exposure, concealment, freshwater streams meeting salt, wild beach roses, swaths of rhizomatic beach grass, seaweed the colour of mustard, pink crab shells, and blue mussels in a Persian garden of tide pools. It is through this communion with animal, vegetable, and mineral, both environmental and historical, that one's self becomes (or becomes again) (Osler et al., 2019, p. 111).

In some of my paintings, I have tried to connect the lived experience of walking with place and time, situating myself amidst landmarks which are recognizable and trace to the history and community of my subject. If artmaking invites connection, so too do our bodies intra-act in relation to object and space, making meaning through and with mattering (Barad, 2003). This mattering incorporates gathering, sifting, and re-telling: co-constituting an assemblage of memory, encounter, exchange, engagement with feelings and immediate sensation. It is a way of filtering reality into forms which we can understand or adhere to, expressed through visual and spoken language. As Connelly and Clandinin (1990) relay, "humans are story-telling organisms who, individually and socially, lead storied lives" (p. 2). Considering the use of narrative, Bell (2003) placed importance on "the recovery and/or crafting of alternatives to some of the broader societal narratives which so profoundly shape [educational] experience [...]" asking how storylines and language mediate experience. "In what sense [do] storied practices attest to possibilities of honouring and renewing human ties and commitments to the rest of nature?" (p. 95). Grusin (2015) offers a counterpoint to assumptions predicated on human exceptionalism by challenging the separation from nature in the non-human turn: "the human has always coevolved, coexisted, or collaborated with the nonhuman—the human is characterized precisely by this indistinction [...]" (p. ix). In this light, and mindful of Haraway's (2016) guidance, "It matters what stories we tell to tell other stories with [...]" (p. 118), my perspective is of one agency among multiple agencies: human, non-human, and more-than-human, each of which entangles and are transformed by the experience. Visual and verbal literacies (Ruopp, 2019) narrate and participate in the evolving discourse of this space; multiple voices contribute to its becoming.

In this chapter, the relationality between self and walking with an environment is presented through narratives that emerge from these encounters, which I have termed *passages*. Passage "through" implies that a particular space is not a destination, but a waypoint. These markers are essential, albeit transitory and impermanent; moving through and then beyond them is fundamental to a journey. Nonetheless, there are encounters within the liminal spaces; pauses, detours, and diversions that occur along the way and, as with Deleuze and Guattari's (1991/1994) conception of "milieu," attentiveness, memory, and creation make the connections that imbue the route with new meaning. In the milieu, I have taken up here, the estuary of the Mitis River, a tributary of St. Lawrence, is a transitory space for human, non-human, and more-than-human entities, but also one which, through a lifetime of walks, blends familiar and temporary ecologies (see Figure 3.1). When we are mindful in our practice of how and why we traverse, we are open to gather moments that glow (MacLure, 2013) from our experience. These insights may not be wholly formed, but are rendered as "a pursuit of personally meaningful, fragmentary, situated and embodied understandings" (Lee et al., 2019, p. 682).

The encounters that are queried here unfold from walking as a way to abandon oneself to place and, by doing so, engaging in what might be described as "dialogic" walking, having a "conversation with landscape" (Chappell et al., 2019; Lund & Benediktsson, 2010). Offering

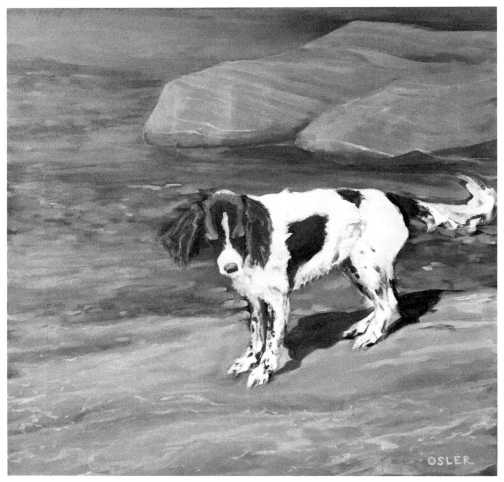

Figure 3.1: Patricia Osler. *Patterns of meaning-making*, 2019. Oil on canvas. Montreal. © Patricia Osler.

a way for us to navigate these exchanges, Haraway (2016) brings tentacular thinking and sympoesis to the entanglement of human, non-human, and more-than-human agencies across time and space, the real and the speculative, the reasoned and the felt, the preconscious and the conscious, the documented and the forgotten. These forces operate on each other, expressly or accidentally. When walking in any milieu, agencies that are transitory or temporary may be less noticeable with each passage; some will pass without a trace, while others will leave debris, the vestiges of a passage intentionally assembled or ascribed. The resultant fragments are collected, much like sea glass, to be spread out, sorted, and crafted into my anecdotes or images.

Walking aligns with a/r/tography by offering versatile approaches to inquiry (Barney, 2019; Irwin, 2006; Lasczik et al., 2021; Lee et al., 2019; Sinner, 2017). Moreover, a slow scholarship approach (Lasczik Cutcher & Irwin, 2018) allows for close observation: both the obvious and the abstruse are noticed and queried; senses, feelings, and wonderings are mindfully surveyed. Walking is also a provocation; a *dérive* from patterns of engaging with an environment—a way to "de-familiarize the habitual" (Truman & Springgay, 2016, p. 261). Building on the conception of milieu, Springgay and Truman contend that "[d]efamiliarization shifts the practice of walking from humanist ethnographic orientations [...], to one in which the categorical divide between body/place, human/nature is displaced with a new kind of radical transversal relation that generates new modes of subjectivity" (p. 263). Our human identities interpret and translate these relations into connections where none may have existed, critically considering the relationality of all agents within both temporary and enduring ecologies. It is this intentionality which transforms walking into pedagogies of practice. "The notion of pedagogy is implicit in de-familiarization in that there is an active effort to change a perspective" (p. 261). It is non-linear and often recursive work; epiphanies seem to shrink away the more energetically we scrutinize: "There must be something important there," or worse, "I feel like I am missing something." Intuitively, I sense a proximity to understanding, but it cannot be coerced into consciousness; dwelling in uncertainty requires patience. These vexing sensations are indicators of a dispositional shift—one can take comfort *in* the discomfort, for it is in those moments that practice is transformed by walking. Lee et al. (2019) contend that "[w]alking research engages a problem that can be solved by practice—an experimental engagement with the world" (p. 683).

I argue that "problem" is axiomatic for this engagement, for while immersion in any milieu brings its own rewards (simply by being present), walking as a disruptive practice will often provoke new connections and new queries akin to Basadur's (1995) notion of "problem-finding." Underlying all of my encounters with this remote landscape is a combination of long-standing curiosities, affinities, intensities, and the desire to respond to the many threats presented by agencies connected to its existence. Once again, Haraway (2016) suggests a way through: hope resides in configuring environmental threat in terms of its "consequences but not determinisms" (p. 31). This mindset acknowledges the peril of catastrophe while permitting alternate outcomes to emerge from collaborative action between human and non-human co-constituents of an ecology. Part of the work here, then, is to weave together threads from the past with the creative, anticipatory future-feeling Manning (2015) describes an alchemy that reveals moments that glow, the locus of learning. Equipped with this impetus and our curiosity, walking–wonderings about milieu and space (see Massey, 2005), we, as situated constitutive agents become, in Barney's (2019) words, "a mobile pedagogical site that is inherently dynamic" (p. 620), attuned and responsive to the process of mindful and embodied engagement within an environment. Summoning both theoretical and creative mobility, I engage in walking "with" to interrogate the temporal–spatial relationships in these transitory spaces.

My walkings and wonderings coalesce around three principal narratives, each entangling with agency across time and space. The first examines the human, non-human, and more-than-human relationships and elemental agents which entangle as they transit through or pause within these shoreline spaces. It seems that few actors intend to stay: birds, sea mammals, and ships all move with intention, *en route* to other habitats and feeding grounds or accessible ports upriver. In a similar manner, fragmentary evidence of voyagers recalls historical narratives—chronicles of the first human passage through the environment; this milieu is recognized and documented as an intermediate point on a seasonally travelled route. Narratives about identity and territory comingle as habitual crossings for humans and non-humans, signifying what I would call "transitory agency."

A second passage troubles conflicting transactional value: perceptions of and aspirations for this region, some to exploit and commodify, others to reaffirm historical connections and coexist harmoniously with the environment. Stark reminders of human enterprise appear in the form of wind farm installations, the transport of fossil fuels by surface rail and hydra-fracking for natural gas deposits. Earmarked as a source of energy to be extracted for use elsewhere, this region becomes merely instrumental, rather than essential in itself, by serving and sustaining interests disassociated with the local inhabitants and detrimental to the milieu. But not all human enterprise operates as exploitative; visceral affective affinity for and attunement to the environment spark emphatic counter-narratives. Allies are found in grassroots environmentalism and activism in an effort to signal the dangers posed by neglecting our collective response-ability (Barad, 2012). Even so, violent shifts in weather patterns may be interpreted as a response, a more-than-human resistance;the effect of invasive intervention seen in climate change. Although this place represents a familiar and compelling landscape to me, the nature of my conversation with it did not incorporate an incisive and critical lens until the potentially devastating impacts of the fossil fuel industry made reckoning unavoidable, particularly when an oil pipeline and supertanker port were imagined for a nearby village. As my research deepened, I felt increasingly protective of this milieu, affirming Truman and Springgay's (2016) correlation that "affective intensities in pedagogical encounters [are] complex, relational and likely felt before being cognized and named" (p. 264). This, in turn, propelled my own critical agency: affective response as an impetus towards thinking and making reflected the intensity of my connection to these emergent environmental threats.

To complete the triad of narratives, a third passage traces the rough shoreline near the estuary through ritualistic and focused walks at high and low tides. (Re)knowing a place and one's self in it through footsteps randomly performed, and through "making" with it, I gather and assemble ephemeral creations on the shoreline and respond artistically through digital or material constructions in my studio. Both in the walking and the making, pedagogies are activated, queried, and renegotiated within a milieu through transitory, critical, and creative agency and praxis.

Passage I: Transience

Where does the water flow through? Can you not hear it my relatives?
It flows through from that most beautiful place in the sky realm.
<div align="right">(Wilson Danard, 2015)</div>

A/r/tographic approaches offer the possibility for transitory agency, by listening for and serving as visible and vocal witness to all voices, identities and narratives, human and non-human as they intra-act, evolve, and transform through time and space. The land, sea, and air of this milieu serve as the setting where tensions between transience and permanence are enacted.

Human, non-human, and more-than-human actors have passed through perennially, marking their passage by leaving traces on the landscape and on human perception, to be gathered physically and affectively by walking and reified through artistic practice. Some of these tracings reflect seasonal migratory patterns that persist to this day, whereas human artefacts from the pre-contact era convey an impermanent, yet equally harmonious connection. By comparison, post-contact archives relate a gradual shift towards human settlement, disrupting the transitory agency of this milieu.

Each year, in early October, masses of snow geese overfly the estuary in aeronautical formations as they migrate south. On calm days, their plaintive cries are audible from first light until dusk as half a million birds navigate their flight path from the river. Gold and greying fields are blanketed in white while the flocks rest; their appearance heralding the imminent arrival of the first snow. Months later, as winter grudgingly subsides, the geese return to wetlands in the arboreal forests further north, establishing a pattern that corresponds with the land and the elements.

This rhythm of passage extends to human agents as well. Traversed by First Nations peoples for millennia in accordance with the seasons, on the south shore of the St. Lawrence River the contemporary landscape hosts a maritime farming community known as Métis-sur-Mer. Despite hagiotoponymic origins linking the region and its mighty river to a saint, there is little coincidence in the name of this village. It is believed to derive both from the Mi'gmaq word *mitis* (poplars) and from the Métis nation, aboriginal descendants of French and Scots settlers who colonized the region in the late seventeenth century (BAC-LAC.gc.ca). Interviews with representatives from the Lower St. Lawrence Heritage organization and with leaders of the local indigenous community contributed authentic, present-day contexts to the accounts of the first nomadic people who hunted, fished, and gathered in these territories: the Malécite/Maliseet (Wolastoqiyik Wahsipekuk), Bedekwe, Mi'gmaq (Gespeg, Gespapegiag), and the Cree-speaking Innu (Montagnais) communities. In the nearby village of Price, situated inland of the river and named for the colonizers who once traded and milled in this region, archaeological excavations have recently uncovered valuable aboriginal artefacts. These remnants of former indigenous encampments reflect the transitory movement of humans and non-humans moving eastward towards the Gaspé

Peninsula during fishing season, and northward across the river for the winter hunting season.

After European colonization, Indigenous identity was often concealed or sublimated between generations due to stigmatization (see Bouchard, 2006; Clément, 2007; Gélinas, 2007). While the degree of *métissage* (in this context, human interrelationships) provokes debate within the historiography, it was clear that the directives of the church and the conception of "French-Canadian" precluded any recognition let alone acceptance of native influence. Between sublimation and assimilation of cultures, Métis identity went through a process of what Bai (2003) describes as "normatization," a state of mind in which "[o]ne apperceives and apprehends the world in a certain way" (p. 45). In this region, indigenous peoples are in the process of reconstructing, reclaiming, and proclaiming their heritage (see Cajete, 2015). Environmental concerns, reconciliation, equity, diversity, and inclusion through multicultural and advocacy initiatives have cast post-colonial oppression, the unwarranted stigma associated with Métis status, into public scrutiny.

The advent of novel transportation and land use technologies shifted what was once a transitory space towards one of more established human habitation. With easier access to travel by sea and rail, the community of Métis-sur-Mer became a mecca for North American tourists, bracketing the period between two world wars with a boom in local construction. Multiple hotels, guest houses, and seasonal shops were built, transforming the rural village into a seasonal refuge from uncomfortably hot and crowded urban living. While it has since been revealed that the microclimate of the Bas-Saint-Laurent holds a significant quantity of ground-level ozone, it was commonly held that a trip around the Gaspé would bring the promise of health and well-being to city dwellers. However, with the rise in commercial air-conditioning and growing enthusiasm for travel further afield, tourist demand sharply declined in the 1950s, and one-by-one, the hotels closed and were torn down. Their legacy is marked today through oral histories and archived imagery, and by commemorative plaques erected throughout the village. Cottages and summer homes built on abandoned land now benefit from views once offered by hotel balconies and terraces—whitecaps, birds, and freighters, advancing almost imperceptibly across the horizon.

The shipping lanes are open from spring through late autumn, coinciding with the migratory patterns of cetaceans. More than a dozen species swim upriver from the Gulf, among them are blue whales, humpbacks, minke, beluga, fin, and right whales, nourished by a nutrient-rich confluence of the freshwater Saguenay, east of Quebec City. Various government, private, and grassroots organizations independently endeavour to track and warn large vessels during the peak periods of sea mammal traffic. Protecting seasonal migratory routes entails placing temporary restrictions on local fisheries, which covet the same waters for the limited season. Time, along with space, therefore, is also a transitory element, *when* things happen holds the same import as *where* things happen.

Passage II: Precarity

A dark bewitched commitment to the lure of Progress (and its polar opposite) lashes us to endless infernal alternatives, as if we had no other ways to reworld, reimagine, relive, and reconnect with each other, in multi-species well-being.

(Haraway, 2016, pp. 50–51)

For a province keen on exploiting significant hydroelectric resources, the waters of the Mitis region are not viewed as a potential source of profitable energy. Water, especially the hybrid salt and freshwater currents in this region of St. Lawrence has little marketable currency, except as a conduit for human transport or the expedient disposal of waste. These values are diametrically opposed to an indigenous ethos embodied in the water walkers, led by women activists who expressed their advocacy for the environment by walking the shoreline of major waterways. Under the guidance of grandmother Josephine Mandamin, the women added the St. Lawrence River to their pilgrimage before expanding further in the Four Directions Water Walk, aimed at "unit[ing] all the waters of Mother Earth" (p. 117), including the Pacific Ocean, the Gulf of Mexico, the Atlantic Ocean, and Hudson Bay. Through their example, they embody a kinship with the environment as something revered and precious. In her story, Anishinaabekwe walker Debby Wilson Danard (2013) reminds us that it is a symbiotic relationship: "water governs us; and women govern water as a sacred gift of life" not to be despoiled through toxicity or neglect. "The living web of life, human and otherwise, is interconnected through Mother Earth and her waters. The responsibility must be shared through family and community and the many Nations. Life within ourselves is dependent on the life outside ourselves" (p. 119).

Empathy for all the earth's ecologies is a necessary ingredient in confronting the human desire to extract, exploit, and commodify. Walking here brings a multisensory awareness of self-in-relation, the felt experience of a visual contradiction of colour, texture, and scale. Fields of yellow flax, set against a bucolic backdrop of densely forested blue-green hills, perform as a pastoral counterpoint in a landscape punctuated by dizzyingly tall white pinwheels generating electricity to an unseen power grid (see Figure 3.2). Turbines rotate massive blades with a pre-determined cadence, self-correcting for wind speed and direction to optimize power production and reduce wear on the machinery. In part, a plan for renewable energy as well as to develop underserved communities in rural Quebec, governments at all levels collaborated on a project to install wind farms on the hills and escarpments bordering the river. Their construction created years of needed work in the region, evidenced by convoys of oversized trailers with their entourage of safety vehicles. A network of new service roads and trails opened on expropriated farmland to build and maintain the wind towers, gradually closing off access by the public. For a few years, trespassers dared to stand beneath the towers, transfixed by the machinery, by the inversion of human proportion and the sonorous sweep of the rotor blades.

All pursuits for energy, however, do not aspire to the same ecofriendly aims as wind farms. Fossil fuel companies actively continue to explore and make claims in the region,

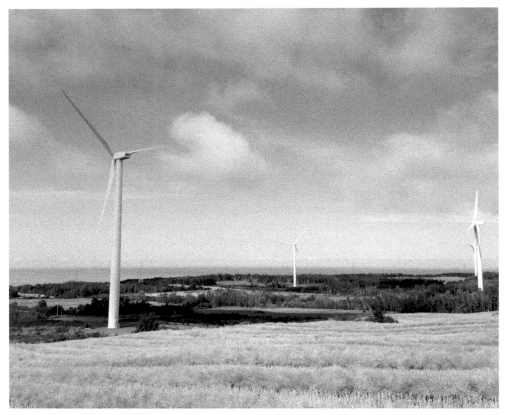

Figure 3.2: Patricia Osler. *Wind turbines*, 2019. Photograph. Montreal. © Patricia Osler.

seeking untapped pockets of natural gas to be accessed through fracking, despite the threat to existing aquifers that supply adjacent farms and municipalities. While prospecting presents another energy project it also presents a dilemma, weighing detrimental impact on the environment against economic benefit. The quest for new energy sources, therefore, makes for uneasy bedfellows in terms of sustainably abiding and cooperating with human and non-human agents in this region.

Further, human settlements constructed near the shoreline risk the repercussions of unchecked exploitation of the environment. Residences wedged on slivers of land between regional highways and eroding beachfront are exposed to the critical elements of weather and tide, which conspire on rare occasions to produce overwhelming surges (See Figure 3.3). In yet another striking example of climate change, extreme storms, known as *grandes marées*, wreak havoc in this community. In 2010, when the highest tide of the year combined with

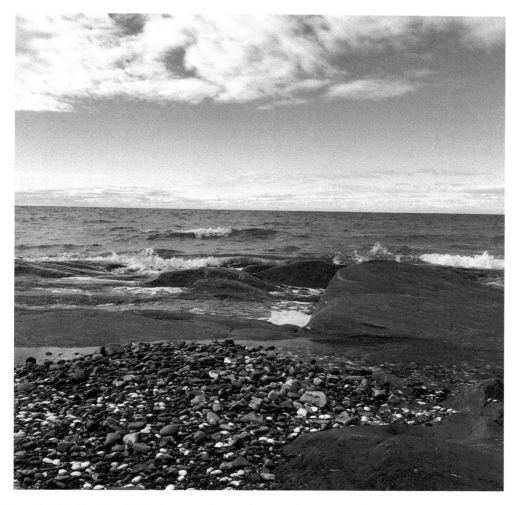

Figure 3.3: Patricia Osler. *The shoreline*, 2019. Photograph. Montreal. © Patricia Osler.

an unanticipated winter gale, homes flooded, shoreline was submerged and roads were overtaken by the sea, to the extent that some structures were left without foundation, tilting sharply and rendered derelict.

Thousands of kilometres away, the oil industry seeks its own pathway from the Alberta tar sands to market fossil fuels. Whether reluctantly or cunningly, suppliers have looked eastward to cobble together a series of existing pipelines and rail networks that would move the commodity across the continent to nearby Baie-des-Sables, Quebec or Saint John, New Brunswick. While emplacing the infrastructure would be difficult and costly, supertankers

destined for faraway refineries and markets could be filled in the environmentally sensitive Gulf of St. Lawrence or the Bay of Fundy.

Not surprisingly, substantive and even potentially catastrophic costs are hidden or ignored in the calculations. Studies paint a strikingly familiar picture of vulnerability, indicating that spillage is inevitable and a major spill, especially in winter, could not be recovered or even properly addressed (Drapeau et al., 1974). In the interim, the ecosystem would suffer from incalculable disruption. In lieu of oil, much ink has been spilled. Local voices join in the debate, raising the alarming question of whether this underdeveloped, underfunded region would (or should) be integrated as a throughway on a global petroleum exchange. Memories of the inferno at Lac Mégantic have escalated anxiety as local residents, glancing warily at freight trains travelling a few metres from, over, and under the main highway, consider limited options. In turn, local politicians look just as warily at the schedule of public meetings in order to negotiate a treacherous pathway through multiple opposing stakeholders.

With visible and invisible human interventions placed upon the landscape, walking with environmental concerns engages citizen science and response-ability (Barad, 2010). Being present, noticing, and probing further are all imperatives in advancing the discourse by working alongside congruent energies to express fears and hopes, support and resistance in verbal and non-verbal ways. Ontologies of power and energy—natural, physical, political, ethical, and creative are laid bare and queried through these pedagogies.

Passage III: Sympoesis

Shall I not have intelligence with the earth? Am I not partly leaves and vegetable mound myself?

(Thoreau, 1854/2004, p. 48)

In this part of the world, walking is an inexact process, much like walking with a/r/tographic approaches. The tide ebbs and flows twice daily, its pattern shifting by approximately 45 minutes each cycle, seemingly out of sync with the sun's convention. By night, the waxing and waning of the moon register the passage of time and regulate the relative strength of the tidal forces. Habitually walking the shore at the same hour is therefore unpredictable. Trajectories are altered: rock faces bordering the beachfront loom as obstacles now and again. Posted signs prohibiting shellfish harvesting contrast with myriad tiny holes bored into ancient boulders by a local marine biologist, intent on fostering snail habitats—a key indicator of the river's health. Once per month, the tides are at their lowest and it is possible to "walk out" to sea, wading through the shallows to explore what is normally hidden. Children with small pails collect their bounty: mussel shells, urchins, and the colourful flora and fauna of the interstitial spaces between shore and sea. Hip waders and sandals facilitate discovery in this new and yet familiar space with all its manifold wonders—human and non-human detritus deposited by the receding tide. The enterprise is unrefined but restorative;

there is a comfort in the uncertain process of exploring, examining, and wondering in these temporary ecologies (see Ingersoll, 2016).

Remarkably, some refuse is prized and transformed into works of art and craft. Ship bottles thrown overboard long ago metamorphose into treasured sea glass—reclaimed raw material for artistic undertakings. Driftwood of all shapes and size is re-imagined: sandcastle palisades, rustic furnishings, mirror frames, garden ornaments, and edgings. Reclamation and restoration inspired by the found-object reflect a human desire to collect and invent new meaning while salvaging traces of the past.

On a larger scale, the estuary's historic landmark, a lighthouse, reflects nostalgia for a time when sound and light had another kind of agency on the seas. First established as a navigational beacon, shielding ships from the perilous reefs, its encoded flashes once indicated a vessel's position on the river. Three flashes at Métis-sur-Mer, four further west, and two further east marked progress in either direction. A large foghorn safeguarded smaller craft when the fogbank came ashore. As technology progressed and ship-borne radar became ubiquitous, the lighthouse fell into disrepair, its lamplight dark and immobile in its mercury bath, severing one more connection to the past. By way of a multilevel cleanup project, various stakeholders collaborated in the safe removal of hazardous materials from the site, permitting renewed access as a public space. Forsaking proprietary considerations, memory, faith, and a communal sense of aesthetic purpose buttress the human, non-human and more-than-human equilibrium against entropy or oblivion.

Conclusion

Walking with and within this milieu reveals as much, if not more, about the researcher as the environment. Touching on the intersections of transience, precarity, and sympoesis induces me to bolster my research, situating myself alongside and within these narratives to arrive at meaningful walking pedagogies. Memories and assumptions are retrieved and examined with new insight: awareness and empathy for the agents which traverse and inhabit this region, attention to more mindful stewardship and sustainability practices on a local (and by extension, global) scale, and the purpose and meaning of my role and response-ability as human co-constituent. Thinking, making, and doing a/r/tographically is merely one form of response, but it answers Bell's (2010) charge that "we are implicated in what we know" (p. 97). Extending from these walking pedagogies, this implication involves a deepening commitment to this environment through presence, empathetic dialogue, and the exercise of visual and verbal literacies to reflect and respond to local and global concerns.

Resilient and unchanging components of the estuary, both physical and elemental, collaborate with the fleeting and ephemeral to form, reform, and transform matter, revealing stark realities and enigmatic narratives. This understanding combines with the need to acknowledge the consequences of human systems and interventions in this place, a microcosm of the fundamental environmental issues involving our planet as a whole.

Small-and large-scale thinking, making, and doing while walking with and through this transitory space shifts the impetus from appreciation to new knowledge and agency. Resonant and impactful pedagogies emerge through dynamic movement, assembling and examining textured images and stories of a lived experience.

Being mindful of the passage of steps traced, of time passing, of memory into story, of newness into decay and from a ruin into restoration, walking ecopedagogically balances exaltation with exhortation over concerns for environmental viability. If we grant that the spaces over which we travel, both literally and metaphorically, connect across time, space, and thought, we must acknowledge that it is through walking mindfully that the temporary ecologies we form can become vibrant, rich, and consequential to our work. Replicating the shift from Irwin's (2013, p. 34) "becoming movement" through "becoming-intensity" to the praxis of "becoming-event," a collaborative creative response engages and amplifies verbal and non-verbal voice. Through a/r/tographic approaches, we can at once celebrate aesthetic intuition and vitality while channelling and documenting the insights uncovered through walking ecopedagogically, revealing them through practice as we seek to (dis)empower those energies which are far-reaching and potentially determinant.

Ecopedagogy, for me, represents an amalgam of transitory, critical, and creative agency. Drawing upon the rhythms of repeated passages, even of mindful dwelling in stillness, cultivates both a kinship and a pedagogical provocation. Remote or proximal connections of time and place offer novel insights as emergent ecologies overlay those that are familiar, drawn into an ongoing relational narrative. My history here and my presence form part of this narrative by discerning and interpreting the multitude of dissonant human, non-human, and more-than-human agential voices through praxis. These ecologies of practice range between ephemeral, entropic assemblages and more permanent documents: value-laden, critical intersections of transience, precarity, and sympoesis. In the passage across liminal spaces between shore and water, familiarity and disruption, comfort and ambiguity, dynamic movement and serenity, creative agency and pedagogical provocation conjoin.

References

Bai, H. (2003). Learning from Zen arts: A lesson in intrinsic valuation. *Journal of the Canadian Association for Curriculum Studies, 1*(2), 39–58.
Barad, K. (2003). Posthumanist performativity: Toward an understanding of how matter comes to matter. *Gender and Science: New Issues, 28*(3), 801–831.
Barad, K. (2007). *Meeting the universe halfway*. Duke University Press.
Barad, K. (2010). Quantum entanglements and hauntological relations of inheritance: Dis/continuities, spacetime enfoldings, and justice-to-come. *Derrida Today, 3*(2), 240–268.
Barad, K. (2012). On touching: The inhuman that therefore I am. *Differences, 23*(3), 206–233.
Barney, D. (2019). A/r/tography as a pedagogical strategy: Entering somewhere in the middle of becoming artist. *The International Journal of Art & Design Education, 38*(3), 618–626.

Basadour, M. (2004). Leading others to think innovatively together: Creative leadership. *The Leadership Quarterly, 15*, 103–121.

Bell, A. (2003). A narrative approach to research. *Canadian Journal Environmental Education, 8*, 95–109.

Bouchard, R. (2006). *La longue marche du Peuple oublié: Ethnogenèse et spectre culturel du Peuple Métis de la Boréalie*. Chik8timich.

Cajete, G. (2015). *Indigenous community: Rekindling the teachings of the seventh fire*. Living Justice Press.

Chambers, C., Donald, D., & Hasebe-Ludt, E. (2002). What is métissage? *Educational Insights e-Journal, 7*(2), 1–4. http://einsights.ogpr.educ.ubc.ca/v07n02/metissage/pdf/whatis.pdf

Chang, H. (2008). *Autoethnography as method*. Taylor & Francis.

Chappell, K., Hetherington, L., Ruck Keene, H., Wren, H., Alexopoulos, A., Ben-Horin, O., Nikolopoulos, K., Robberstad, J., Sotiriou, S., & Bogner, F. X. (2019). Dialogue and materiality/embodiment in science/arts creative pedagogy: Their role and manifestation. *Thinking Skills and Creativity, 31*, 296–322.

Clément, S. (2007). *Guérison Communautaire en Milieu Atikamekw: L'Expérience du Cercle Mikisiw pour l'Espoir à Manawan*. Département d'Anthropologie, Université Laval, Québec.

Connelly, F., & Clandinin, D. (1990). Stories of experience and narrative inquiry. *Educational Researcher, 19*(5), 2–14. https://doi.org/10.2307/1176100

Courvelle, S., & Labrecque, S. (1988). *Seigneuries et fiefs du Québec: nomenclature et cartographie*. Faculté des Lettres de l'Université Laval (CÉLAT).

Deleuze, G., & Guattari, F. (1994). *What is philosophy?* (H. Tomlinson & G. Burchell, Trans.) Columbia University Press. (Original work published 1991).

Drapeau, G., Harrison, W., Bien, W., & Leinonen, P. (1974). Oil slick fate in a region of strong tidal currents. *Coastal Engineering Proceedings, 1*(14), 130. https://doi.org/10.9753/icce.v14.130

Garoian, C. R. (2014). In the *event* that art and teaching encounter. *Studies in Art Education 56*(1), 384–396.

Gélinas, C. (2007). *Les Autochtones dans le Québec Post-Confédéral: 1867-1960*. Septentrion.

Grusin, R. (Ed.). (2015). *The nonhuman turn*. University of Minnesota Press.

Guyotte, K. (2015). Becoming ... in the midst/wide-awake/in-between: An in-process narrative inquiry. *Narrative Works, 5*(2), 71–85.

Haraway, D. J. (2016). *Staying with the trouble: Making kin in the Chthulucene*. Duke University Press.

Heritage Lower St. Lawrence. https://heritagelsl.ca/

Ingersoll, K. (2016). *Waves of knowing: A seascape epistemology*. Duke University Press.

Irwin, R. L. (2003). Towards an aesthetic of unfolding in/sights through curriculum. *Journal of the Canadian Association for Curriculum Studies, 1*(2), 63–78.

Irwin, R. L. (2004). A/r/tography: A metonymic métissage. In R. L. Irwin & A. de Cosson (Eds.), *A/r/tography: Rendering self through arts-based living inquiry* (pp. 27–40). Pacific Educational Press.

Irwin, R. L. (2006). Walking to create an aesthetic and spiritual currere. *Visual Arts Research, 32*(1), 75–82.

Irwin, R. L. (2013). Becoming a/r/tography. *Studies in Art Education, 54*(3), 198–215.

Irwin, R. L. (2018). A/r/tography as practiced-based research. In M. Carter & V. Triggs (Eds.), *Art education & curriculum studies: The contributions of Rita L. Irwin* (pp. 162–178). Routledge.

Irwin, R. L., & de Cosson, A. (Eds.). (2004). *A/r/tography: Rendering self through arts-based living inquiry*. Pacific Educational Press.

Irwin, R. L, Beer, R., Springgay, S., Grauer, K., Xiong, G., & Bickel, B. (2006). The Rhizomatic relations of a/r/tography. *Studies in Art Education, 48*(1), 70–88.

Lasczik, A., Roussel, D., & Cutter-Mackenzie-Knowles, A. (2021). Walking as a radical act of inquiry: Embodiment, place and entanglement. *International Journal of Education Through Art, 17*(1), 3–11.

Lasczik Cutcher, A., & Irwin, R. L. (2018). A/r/tographic peripatetic inquiry and the Flâneur. In A. Lasczik Cutcher & R. L. Irwin (Eds.), *The Flâneur and education research: A metaphor for knowing, ethical actions and data production* (pp. 127–154). Palgrave Pivot. https://doi.org/10.1007/978-3-319-72838-4_6

LeBlanc, N., Davidson, S. F., Ryu, J. Y., & Irwin, R. L. (2015). Becoming through a/r/tography, autobiography and stories-in-motion, *International Journal of Education Through Art, 11*(3), 355–374. https://doi.org/10.1386/eta.11.3.355_1

Lee, N., Morimoto, K., Mosavarzadeh, M., & Irwin, R. L. (2019). Walking propositions: Coming to know a/r/tographically. *The International Journal of Art & Design Education, 38*(3), 681–690.

Library & Archives Canada. (2021). https://www.bac-lac.gc.ca/eng/discover/aboriginal-heritage/metis/Pages/introduction.aspx

Lund, K., & Benediktsson, K. (2010), *Conversations with landscape*. Routledge.

MacLure, M. (2013). Researching without representation? Language & materiality in post- qualitative methodology. *International Journal of Qualitative Studies in Education, 26*(6), 658–667. http://dx.doi.org/10.1080/09518398.2013.788755

Massey, D. B. (2005). *For space*. Sage Publications.

Manning, E. (2015). Artfulness. In R. Grusin (Ed.), *The nonhuman turn* (pp. 45–79). University of Minnesota Press.

Osler, P. (2021). Walking with and in-between: Interrogating tensions in a public garden space. *International Journal of Education Through Art, 17*(1), 141–150.

Osler, T., Guillard, I., Garcia-Fialdini, A., & Côté, S. (2019). An a/r/tographic métissage: Storying the self as pedagogic practice. *Journal of Writing and Creative Practice, 12*(2), 109–129.

Ruopp, A. (2019). Portrait of an a/r/tographer: Theory as conceptual medium. *International Journal of Education & the Arts, 20*(9). 1–16. http://doi.org/10.26209/ijea20n9/

Sinner, A. (2017). Cultivating researchful dispositions: A review of a/r/tographic scholarship. *Journal of Visual Art Practice, 16*(1), 39–60. https://doi.org/10.1080/14702029.2016.1183408

Springgay, S., & Truman, S. E. (2017). *Walking methodologies in a more-than-human world*. Routledge.

Thoreau, H. D. (1854/2004). *Walden*. Princeton University Press.

Truman, S. E. (2016). More than it ever (actually) was: Expressive writing as research creation. *Journal of Curriculum and Pedagogy, 13*(2), 136–143.

Truman, S. E., & Springgay, S. (2016). Propositions for walking research. In P. Burnard, E. Mackinlay, & K. Powell (Eds.), *The Routledge international handbook of intercultural arts research* (pp. 259–267). Routledge.

Wilson Danard, D. (2017). Be the water. *Canadian Woman Studies, 30*(2–3), 115–120.

Grounding

We Come From Walking

Shannon Leddy

I.
right foot
left foot

out of Olduvai Gorge

left foot
right foot
across one continent
and over to the next

and the next

right foot
left foot
along the landscapes where you live

trails worn over trails
layers of pathways
a palimpsest on the body of our mother

all those colonial layers
all that stratigraphy

here the sidewalk ripples in remembrance of the swamp
trapped between the street and the bedrock far below

there is the place in front of the pot shop
where there used to be a set of teeth
embedded in the pavement

until someone turned the building into an art gallery
and had the whole pavement removed

perhaps a hundred or two years before
a girl from Musqueam met her Sweetheart on this spot
unaware of the coyote bones
deep in the earth beneath their feet

where they lay silent and fallow still

II.
when Orpheus walked from
Hades Eurydice trailing
frailly behind
his only mistake was his lack of faith

taking his eyes from the horizon for only a moment

he looked
back and
lost his
way

III.
Deep before a rocking motion
Seeded you inside the safe close
dark of your mother's body

the rhythm of her
walking held her
mother's heartbeat

the rhythm of her heartbeat
held the pace of her mother's walking

the rhythm of your walking holds the heartbeat of your
mother

that first rocking that brought you to bear
in this
time in
this
place
is mimicked in your stride

the gentle bounce of the horizon
before your right foot left foot

forward

Chapter 4

Walking for Plant Re-Creation

Jun Hu

Using plants as a medium and as a theme, I, together with my graduate and undergraduate students at Hangzhou Normal University (HNU), have started to design art lessons for children as a part of art teacher candidate education as well as a reform platform for school art education in China. The work has gone through two phases with inspiring outcomes that extend the potentiality of a/r/tography applied as ecopedagogy.

The first phase started in June 2019 with the intention of developing an art-based natural education curriculum for city schools. It first took place in the natural environment of Phoenix Creek village 70 km from HNU and included a one-day field trip, "Plant Poem and Painting," created to help children learn about the biodiversity of plants by print-making different parts of plant materials on cloth. The field trip draws urban children closer to nature as they experience its magic and beauty.

The second phase started in July 2021 with the intention of creating site-specific art curricula for rural schools that are often in a disadvantaged position in art education. It first took place in Luding Bridge Primary School in Luding, Ganzhi Tibetan Autonomous Region, Sichuan Province, 2000 km away from HNU. This is a remote region at the east entrance to the Tibetan Plateau. Taking local agricultural products as an art theme, the curriculum taught pupils how to create emoticons and make stereoscopic picture books to tell their stories. The result was nine art lessons called the "New Legendary of Nine Treasures of Luding." The curriculum integrates art education into the rural revitalization project that seeks awareness of localized artistic creativity.

"Plant Poem and Painting" and "New Legendary of Nine Treasures of Luding" shared an art pedagogy based on the exploration of nature as a common ground. In "Plant Poem and Painting," ignored and unknown plants are often discovered, studied, and used as art media, while in "New Legendary of Nine Treasures of Luding," mundane agricultural products become the theme of pupils' artistic creation. Both projects are part of an effort to reform art education in a Chinese context. "Plant Poem and Painting" is focused on developing an arts-based field trip course for school children overburdened with academic study as they pursue alternative ways of learning in a natural setting, while "New Legendary of Nine Treasures of Luding" is focused on developing community-based art curriculum for schools in disadvantaged rural regions.

The projects employ a/r/tography (Bickel et al., 2011) by giving focus to artmaking, research, and teaching by volunteer graduate and undergraduate students at HNU, participating children, and myself, which blurs the boundary between the creator, researcher, and teacher. My students and I designed games as an impetus for art learning

among children. In the process, we experienced random opportunities to optimize a playful curriculum while orienting the games towards artistic creation. In doing so, teachers and learners become reciprocal partners in an open-ended playful game.

In this instance, the pedagogy is recreational and resonates with *Recreation in Art*, the semantic translation of "a/r/tography" in the Chinese language: Yi-You (艺游), with reference to the Confucian conceptualization of education, You-Yu-Yi (游于艺),[1] "Let relaxation and enjoyment be found in the polite arts" (Trans. Legge, 1861, Line 6) in the chapter Shu Er of the Analects. Given the focus on ecology, these projects are examples of ecopedagogy that may be understood as *recreation in plant re-creation*.

Context of education reform in China

Recreation in plant re-creation is my response to the current situation of education in China, which is going through deep crises, and simultaneously experiencing unprecedented opportunities. In ancient China, nature was regarded as a reference to reflective and reflexive contemplation. For instance, Confucian academies or Taoist and Buddhist temples preferred natural settings in serene landscapes to robust towns. Since poetry was a critical part of the holistic cultivation of a nobleman, landscape poetry was an integral part of education. As sensitivity to nature and landscape poetry was critical to learning, a village learner was not disadvantaged in the agricultural society of ancient China. As a popular poem by an unknown author (twelfth century CE) said, "still a peasant, In the morning, he might ascend the emperor's hall at dusk."[2] The 1000-year tradition of general examination by the royalty to select the most learned man for civil service of the kingdom had probably been the best system of fair education to promote social mobility before the late nineteenth century. However, industrialization has changed the educational scene of ancient China, especially since the Total Westernization Movement that took place in China in the 1910s. The introduction of western education embedded with the value of industrial functionalism has replaced an agricultural holistic perspective. Modern schools are eager to pass down a standardized set of knowledge, while individualized experiences are regarded as low performance if not irrelevant. This unfavourable situation for holistic education has been made even worse in recent decades because of the structural involution of Chinese school systems.

This involution has caused injustice in educational opportunities for rural students because it is often the case that the best students, best teachers, and the most well-funded schools are concentrated in cities. However, this does not mean that students in cities can all benefit from the system because the best educational resources in cities are concentrated in very few top schools. Since it is necessary to take private lessons in addition to school learning in order to compete, students are burdened with the off-campus study. Policy-makers have begun to take action to change the situation. In November 2016, eleven state departments issued *Opinions of State Department of Education on Promoting Field Trips for*

Primary and Secondary School Students,³ which requires that all schools manage three to five days of field trips in a school year for every student. The short field trip period may not be adequate to enhance the students' well-being. Nevertheless, as the saying goes—something is better than nothing.

Despite structural inadequacies, China is probably one of the very few countries in the world that take art education seriously. In November 2020, the General Office of Central Committee of the Communist Party of China (CPC) and the General Office of the State Council restated a policy first issued in 2015, *Opinions on Comprehensively Strengthening and Improving School Arts Education in the New Era*,⁴ which establishes arts education as core curriculum in schools for it enhances creativity that is critical to the nation's sustainable development. These policies have created a social environment for promoting art education as never before. As new policies relieve students of academic burden and emphasize art education, they also put a higher expectation on art educators. On this basis, I started to reform art education by exploring the potential of a/r/tography in enhancing students' well-being and creativity.

Phoenix Creek Village project "Plant Poem and Painting"

The one-day field trip lesson "Plant Poem and Painting" was designed in response to the opinion of the Department of Education in 2016 that enforces field trips. It was designed to replace an existing one-day field trip curriculum of natural education at the request of the owner of the Rose Farm, a private natural education camp in the Phoenix Creek Village, Tonglu County, an hour drive from HNU. In its five acres of land, there are fields that produce organic rice, vegetable, fruits, and 30 kinds of aromatic plants, as well as vast wild grassland where diversified flowers bloom all year round. In addition to the beautiful natural setting, there is a library, art studio, bakery, perfume workshop, etc. in three spacious dome buildings that provide convenience for indoor activities.

However, the owner of the farm was not satisfied with the original field trip curriculum and sought my support to upgrade it by artistic means. The original field trip curriculum focused on labour and skills of agricultural work, such as weeding, harvesting, planting, and some simple handicrafts. The owner tentatively asked me if it was possible to make a natural education more artistic. I believe artistic expression and physical contact with nature are mutually supportive and wanted to explore the potential of a/r/tography for integrating art education with natural education based on ecopedagogy. According to the Chinese philosophy of "Tao follows nature" (道法自然), only if a man knows the way of nature does he know the way of virtuous life and politics; and since the way of nature is beyond words, it must be expressed through poetry and arts. Thus, landscape poetry and painting can work as aesthetic markers of the cultivation of a nobleman in traditional Chinese education.

In the wake of that tradition, I brought with me five graduate and undergraduate HNU students to work on-site to develop arts-based natural education lessons for children aged

6–12. It took us around two weeks to develop a set of field trip lessons that could satisfy the need for a field trip that lasts five days. Among them, the one-day field trip lesson *Plant Poem and Painting* has since been applied by the farm with high popularity. The new field trip curriculum is art-based natural education for it enhances botanical knowledge through creative use of plants as art media. The curriculum is developed with three characteristics of a/r/tographic pedagogy: embodiment (Jevic & Springgay, 2008), group learning, and learner-centred, with artmaking, researching, and teaching intertwined.

Replacing repetitive labour with artistic creativity, and didactic lectures with embodied knowing, natural education is carried out during the process of artmaking and poem composition. The curriculum follows a series of eight activities. They are: (1) exploring the shape and colour of plants; (2) classifying plants; (3) plant calendar design; (4) plant collage; (5) knowing plants by names; (6) riddle poem composition; (7) plant-printing; and (8) interactive art show. The eight activities can be categorized into two phases of the curriculum: (1–4) Artistic display of achievements of embodied knowing of plants; (5–8) Artistic display of achievements in interdisciplinary (science, literature, and visual arts) study.

The curriculum starts with blind walking in nature, in order to open up more senses for an unfamiliar experience in a familiar place: curiosity is aroused and motivates students for further exploration. In activity 1, "Exploring Shape and Color of Plant," the child is asked to keep their eyes closed and is walked to a spot in the wild where he/she is required to search for ten different plants on that spot by touching and smelling. After all the children have found their plants, they compare (with open eyes) what they have found with another child. After comparing, each child goes out again to look for what he/she does not have but others have. Through the procedure of walking and searching while blinded, the tactile and smell senses of plants are enhanced. As they compare the found plants, they are always surprised by the diversity of plants in nature that they did not notice before. By comparing plants through sensory nuances, their knowledge of plants becomes embodied (see Figure 4.1). Activities like that prepare participants with newly acquired sensitivity to plants that will enable them to choose a plant as an art theme and to use found plants as art media for later artistic creativity.

Throughout the curriculum, the learning is learner-centred, for the teacher does not teach but facilitates the child's learning by designing games to enhance embodied knowing and arranging group learning to encourage interaction. For activity 2, "Classifying Plants," children are asked to categorize the plants they have found with the nuanced knowledge of the shape, texture, colour, and smell. For activity 3, "Plant Calendar," children make five sub-categories in each of seven major categories of plants to design a practical calendar (by choosing $5 \times 7 = 35$ most typical plants). As each child may have his/her own way to classify plants, they must discuss and coordinate in order to set up the rules of classification, which further challenges their ability to analyze and synthesize while working collaboratively (see Figure 4.1). At this point, it is time for the children to use found plants as art media in activity 4 "Plant Collage" to create images.

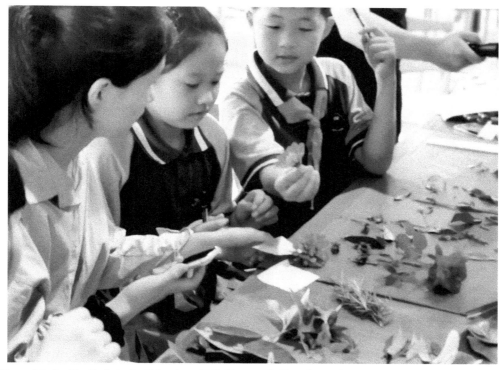

Figure 4.1: Jun Hu. *Students classifying plants*, 2019. Photograph. Hangzhou. © Jun Hu.

For activity 5, "Knowing Plants by Name," children are asked to search for information about unknown plants online. In actual fact, children have already acquired much-embodied knowledge of unknown plants by comparing and categorizing them, even though they do not know their names of them. At this moment, children are not content with knowing the names only, but are keen to know more about the botanical science of the plants, like whether they are poisonous or not, what medical effect they have, as well as their cultural implications and metaphoric meaning in poetry and painting. With new information and knowledge in addition to their embodied knowing, they use their knowledge of a chosen plant to create activity 6 "Riddle Poem Composition." For instance, a plant that looks exactly like Shy Grass (含羞草 Mimosa), but its petiole does not droop, and its feather-like leaflets do not close when a plant is touched, aroused children's curiosity. Children noticed seeds under its petiole in the first phase of the study. After searching online, they found additional knowledge that it is named Beads under Leaf (叶下珠, Phyllanthus). They created a riddle for the name of the plant: "Hiding a string of beads, it looks shy, but is not that shy."

Children then learned each other's riddles and searched for the appropriate plant. Then, in activity 7, "Plant-printing," children learn to do printmaking with plants as they respond

to the riddle poem. Children can print out abstract or representative images that indicate the texture, colour, shape, or simply their impression of the plants as they were poetically expressed in their riddle poem. For example, Xiangxiang, the 7-year-old daughter of the farm owner, composed the riddle poem: "Numerous small horns and sharp peaks, and the color of the ground hook is green." The answer to the riddle is Humulus (葎草). In her plant-printing, she expressed abstractly the characteristics of the plant (See Figure 4.2). The cloth printed with both the riddle poem and the painting is then exhibited in the activity 9 "Interactive Art Show." It becomes a riddle guessing party, to which visitors, including parents, are invited to compare and choose from a number of actual leaf samples, the right answer to the riddle poem. This is a proud moment for children who believe they have created a fun game that is both entertaining and enlightening for visitors, while the visitors are amazed by the poetry composed by the children and are learning new knowledge about plants.

An arts-based curriculum turns out to be much more fascinating to children than more natural forms of education, for children are exuberant all the time throughout the one-day course. It is the internal motivation that works in this arts-based curriculum, rather than the self-control promoted in the original curriculum. In the original natural education, physical labour and botanical knowledge learning were two separate orientations, and there were few surprises and no creativity in the learning process. However, an arts-based natural education intertwines artistic creativity, research and learning into a recreational activity, or recreation in re-creation (You-Yu-Yi), a/r/tography. As a result, students become more confident in artistic expression in poetry and painting, acknowledge diversity and individuality as a motivation for group learning, and master the basic skills of scientific research through observation and categorization. Those were not in the previous natural education curriculum.

In the playfulness of recreation in re-creation, new bonds are set up between humans and nature as embodied knowing integrated through science and art. In this way, a/r/tography bridges between physical and intellectual activity and encourages personalized and individualized creation. Thus, a/r/tographical encounters with ecopedagogy serve the purpose of the field trip: to be close to nature and to relieve the academic burden. It was the consensus of all participants after the workshop that a/r/tography has great potential in drawing humans closer to nature through art, and that the project has revived Chinese traditions in a contemporary context by enhancing holistic development and personal well-being through a/r/tographical ecopedagogical inquiry.

Luding Bridge Primary School project "New Legendary of Nine Treasures of Luding"

In the first phase of research, a/r/tography and ecopedagogy bring humans closer to nature through the embodiment of learning. In my second phase of research, I sought to develop a/r/tographical and ecopedagogical inquiry to enhance social justice through recreating

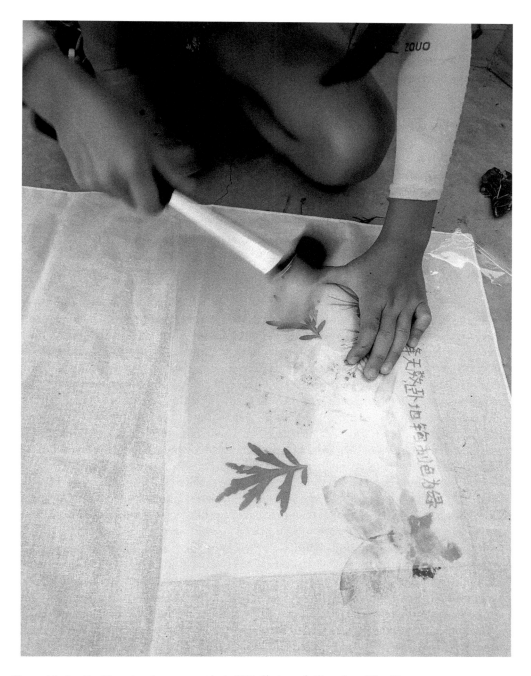

Figure 4.2: Jun Hu. *Xiangxiang hammers on plants*, 2019. Photograph. Hangzhou. © Jun Hu.

social ecology. The opportunity came to me in the summer of 2021 when I was asked by HNU to supervise a *support teaching* project. The idea of support teaching is to recruit volunteer university students to support rural schools in remote regions during summer vacation by offering free courses to students. Well-intended though as the project is, I have been criticizing its practice for years: the current support teaching in art subjects is not that supportive but potentially destructive, for the current pedagogy often lacks careful consideration and professionalism. Since support teaching is normally not organized by professional educators, but by political administrators, such as Communist Youth League Committee of HNU, propaganda rather than pedagogy is the concern of the organizer. From my professional perspective, its curriculum is often unfriendly to the learner and may have serious negative impacts.

In the past practice of support teaching by HNU, the art lessons were prepared by volunteer students who are usually under-trained and inexperienced in art teaching. The art lessons were typically chosen from an official art textbook. I often criticize this kind of support teaching for it is less about the cultivation of artistic spirit and capability than imposing an irrelevant knowledge of art. First, textbook-based art teaching ignores the fact that particular regions are very rich in local artistic culture as found in folk art and crafts, rituals, and festival celebrations. For example, in Luo-Chuan (洛川), a Miao ethnic autonomous region of Guizhou Province, where HNU has been supporting teaching for the past five years, there is excellent embroidery, traditional costumes, silver craft of ornaments and jewellery, the architecture of rain bridges and drum towers, at least two dozen seasonal festivals throughout the year, as well as rituals to celebrate weddings and to mourn the dead, let alone its beautiful landscape with terraced fields on the slopes of mountains. However, these are invisible to support teachers who base their curriculum on art textbooks.

Second, classroom art teaching ignores the fact that art is community-based in many regions where art is not for art's sake but has a purpose in human society. Art may be found in a mother's embroidery on her child's clothes that pledges good health, a girl's gift to her lover as a token of her love, or a hairstyle that identifies one's affiliation to a clan. However, classroom art teaching based on textbooks totally ignores these social aspects of art. I believe it is necessary to develop a localized and sustainable art curriculum based on local resources and local needs rather than teaching textbook-based art like a cultural invasion that may be destructive to the ecosystem of local education and local culture.

From July 2021, I lead a group of nineteen HNU graduate and undergraduate students as we travelled sixteen hours by high-speed train and coach bus to teach a summer camp to 50 pupils from grades three to five at Luding Bridge Primary School in Ganzhi Tibetan Autonomous Region, Sichuan Province. This is part of the Hangzhou-on-Ganzhi support programme under the umbrella of a national project based on the *Strategic Planning for Rural Revitalization (2018–2022)* (the CPC and State Council, 2018) that has made it mandatory that industrialized and developed regions in East China support the development of rural and underdeveloped regions in West China in a one-on-one manner at all levels of public administration. This is an unfamiliar economic and political practice to western countries,

but it has been proven efficient and successful in China. It is derived from the precursor project *Poverty Alleviation* that nearly 100 million people have been lifted out of poverty in this way during the past eight years, achieving the poverty reduction goal of the *United Nations 2030 Agenda for Sustainable Development* ten years ahead of schedule.[5]

As a socialist country, the Chinese government takes common prosperity (共同富裕) as a key indicator of political legitimacy, thus it is strictly enforcing the policy as its priority. Hangzhou city, one of the most developed cities in East China with a population of 10.36 million and a GDP of 1610.6 billion yuan (RMB) in 2020, has received the task to support Ganzhi, one of the most under-developed regions in West China with a population of 1.1 million and GDP 41.061 billion yuan (RMB) in 2020. During the short period of time from 2021 to 2023, Hangzhou is to invest huge amounts of capital, talent, and advanced technology to make Ganzhi prosper at all costs. This incredible undertaking is a serious political task, and failure will have a severe impact on the political career of Hangzhou municipal leaders. The focus of the support is on the economic development of the region, such as tourism, industry, and business, that comes with accountable numeral data, while educational and cultural support is normally taken as a necessary political gesture. I decided to build on this effort by experimenting with an educational reform initiative.

The school that we are working with is the best in the Ganzhi region and is one of the key primary schools of Sichuan Province. It has 1300 students in 30 classes and has 115 years of history. Yet, the school still does not have a specialized art classroom, which is the standard configuration in the primary schools of Hangzhou. While we began with 50 students receiving art lessons at a summer camp, the principal now regrets not sending more students to the camp as she now believes all students should benefit from such experiences.

The support teaching is unlike any other because it creates an ecopedagogy with the method of a/r/tography that respects the ecosystem of local culture, natural resources, and even politics. Instead of starting teaching immediately, I use the first three days for investigation in order to conduct research on local resources and needs. During the three days, we travelled to five villages in Luding county, visited the famous Luding Chain Bridge that dates back to 300 years ago, the new Dadu River Suspension Bridge that is 1100 m in a single span, and the construction site of Sichuan–Tibet Railway. We learned that Luding is now developing high-speed trains, has mild weather that produces delicious fruits and vegetables, and is a sacred place because the Red Army won a legendary victory here. We learned that the county is located in the mountain range between the Tibetan Plateau and Sichuan Basin, where there is a 6000 m drop from 7556 m at the peak of Gongga snow mountain to 1321 m at Dadu River in Luding county, which means the great potential of hydro-power and tourism in its scenic landscape. It is true that dams have been built, and Hailuogou National Park is a top tourist attraction, but local farmers as reservoir immigrants have received negligible compensation for the land they lost. Deprived of the most profitable businesses, Luding is left with little room for economic development.

On the fourth day, based on our preliminary research and discussion with local people, we agreed to develop a localized curriculum entitled "New Legendary of Nine Treasures

of Luding" five days later at an art show for the student's work (see Figure 4.3). Picking the nine agricultural products (treasures) that Luding farmers are most proud of, I divided the HNU students into pairs and each assumed one product as their theme. The nine products are cherry, pepper, yellow plum, golden chrysanthemum, apple, cactus fruit, fragrant peach, fig, and walnut. Each group taught five to six students to create emoticons for the product before making a five-pointed-star stereoscopic picture book that tells stories with the product playing the protagonist. This project benefits students by raising their self-confidence in creativity and their self-esteem because it is site-specific and community-based. It is site-specific because the nine products are the mainstay of Luding's economy. It is community-based because the products are their local pride and are closely related to the families of students in one way or another. Moreover, due to the rural revitalization plan, it is the duty of the Hangzhou municipal government to help the economic development of Ganzhi, which includes the promotion of Luding products in Hangzhou. This has linked up two communities between Hangzhou residents and Luding farmers, which means those products will be sold at a good price in Hangzhou that is strong in both purchase power and demand.

The pedagogy is a/r/tographic for it starts with an embodiment in the very beginning of learning and develops with recreational activities that encourage creativity through group learning and empower a learner-centred learning process for both HNU students–teachers and Luding pupils. When I supervised HNU students, I requested that they not use PowerPoint or another knowledge carrier but play equal partners with the pupil and try to learn from the pupil in their classroom teaching. This pedagogy is unfamiliar to HNU students. As an a/r/tographer, it is not to pass down knowledge of art, but to create an artistic expression of knowledge or to express the unknown through art. When this is conducted in classroom teaching, it often comes out of and is intensified by *reverberation* (Springgay et al., 2005, pp. 906–907), the reciprocal exchange between the teacher and the student as well as the reciprocal interaction among artistic creation, research, and teaching. The "New Legendary of Nine Treasures of Luding" exhibition of students' work illustrates how the nine groups shared some common ground in enhancing this a/r/tographic process:

1. All of the groups personified the agricultural product through an embodied way of inquiry into the product by touching, smelling, tasting, cutting, eating, etc. before further personifying the product with his/her own imagination based on the new experiences.
2. The student–teachers designed art games throughout the process.
3. There was successive development from the embodied knowing of the products to personification, to emoticon design, to story-making, and to picture books.
4. At the end of each day, there was an art show (one hour) of students' artistic expression where teachers and students shared with one another, until the fifth day when a general exhibition (one afternoon) was arranged for all interested parties.

I am happy to see the changes in HNU student–teachers, who have become more confident and are learning alongside primary pupils. Motivated by each other, they naturally enter

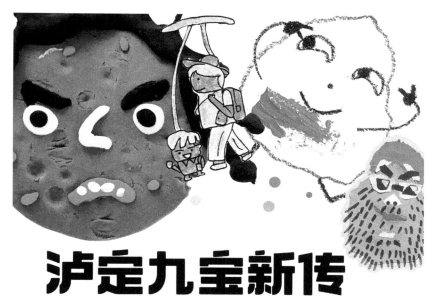

Figure 4.3: Jun Hu. *Poster of exhibition New Legendary of Nine Treasures of Luding at Luding Bridge Primary School*, July 27, 2020. Photograph. Hangzhou. © Jun Hu.

the state of open-ended a/r/tography, discussing and revising their teaching plan, capturing contingencies to re-orient the course towards creativity. For instance, in the Apple group, the varying degrees of redness of the apple are interpreted by children as personalities, for which they design three-dimensional emoticons such as Shy Red-faced Princess, Angry Red-faced Mother, Beaten Red-faced Warrior, Drunken Red-faced Man, etc. Each group personifies differently based on the characteristics of the product. For example, pepper is personified as bad-tempered, cactus fruit is gentle in the heart but plain looking, fragrant peach looks sweet and adorable but with strong will in heart, the double cherries are inseparable friends; golden chrysanthemum is the brave one who wards off evil, while the fig is the one who has crazy and unexpected ideas.

There are difficulties with personifying some products, but through group work, students always find a way to solve the problem. For example, the yellow plum lacks character compared with other fruits, but the student–teachers of the group came up with a lesson for identity enhancement by asking students to imagine "Who am I if I am the plum?" Through anthropomorphic self-portraiture, the group not only created emoticons for the plum but also learned a lesson about seeing the potential gem in a plain stone.

Walnut is just the opposite of plum, for its rough and irregular shell and its unique flavour of the flesh are too strong to be ductile in personification. The group started with an artistic inquiry through abstract expressionist group painting. Primary students began the action painting, scratching acrylic on paper with walnuts, at the rhythm of student–teacher's walnut music, tapping on a hard surface with walnuts. The absurdity of this activity ends up with students' extreme sensitivity to both the nut and the art of abstract expression. By masterly drawing and applying colour pigments, they successfully created a dozen of lively and vivid emoticons for walnuts.

Based on these preparations, students created nine stereoscopic picture books. The books are collapsible and take the shape of a five-pointed star when unfolded. Each point of the star is the work of a primary student, for there are five students in each group. Some books tell one story with five scenes in sequence while others tell five different stories, but each book is on the theme of one local agricultural product. There is one book that catches the eye of adults for it tells an inspirational story with five scenes: (1) A little Peach-man was a smart detector in the future world; (2) Who by accident dropped through the time door and falls into Luding county of today; (3) He chooses to be a history teacher because he knows where the history goes; (4) With his knowledge, he has easily made Luding prosper; (5) To honour his contribution, he is elected Chair of Luding Fruits Association by all fruits.

Walking to be continued

The two projects have expanded my vision of a/r/tography in developing an ecopedagogy that embraces walking (Irwin, 2017). Walking in a pedagogical sense enjoys contingency, is open to coincidence, and takes a natural way of being in this world. Thus, walking can

be physically and literally on foot, or may also be a metaphoric practice of touring around. Walking, as pedagogy informed by daily experience, is an open-ended curriculum that is not objective-oriented, but experience-based. It is like we simply appreciate the experience of walking itself when we take a walk. In the above two projects, I took the students' happy experience as a prior indicator of good teaching and do not care about the outcome; and I regard good teaching as an enhancement of that experience until it is so extraordinary that it entices an a/r/tographic craving for creative expression, inquiry, and sharing. To take a walk, we do not need a destination, and we can pause, meander, take a detour, and stop anywhere at any time, whenever we feel like we need to do so: in this sense, walking is pedagogical. In the Phoenix Creek Village project, blind walking in nature is the first step to open-children' senses so that they have surprise findings in nature: these ignite their curiosity to research, stimulate their motivation to express, and empower them with the capacity to create. Through eight activities, one after another, in a one-day field trip, students' sensitivity and motivation are increased until the art show and riddle party during the Plant Poem and Painting activity. In the case of the Luding Bridge Primary School project, it is the same except that each group developed its own way to reinforce the personification of the agricultural product until stories were well-developed.

Walking, as pedagogy, is informed by our confidence in this daily practice. We are seldom disappointed by taking a walk, whatever the weather is like because we are ready to accept any experience on the way. To me, this trust without reason characterizes walking in the pedagogical sense. In the Luding Bridge Primary School project, taking one-third of our time touring around Luding county is typical of a walking pedagogy in this sense. While I am relaxed during the tour, many of my HNU students were very anxious about not knowing what to teach, because they needed a sense of control with prepared art lessons. I keep consoling them with the Chinese idiom, "The cart will find its way round the hill when it gets there," but what I really believe in is that there will inevitably be something interesting whether there is a way around it or not. This is the receptive attitude of a walking pedagogy. It is like how we enjoy walking: Enjoy whatever comes to you without judgement. By touring the region at the beginning of the support teaching, I built upon what was learned locally to build a community-based art curriculum. I could not predict the curriculum in advance. So, I enjoyed visiting tourist attractions, construction sites, fields, orchards, villages, and government offices. I enjoyed listening to farmers, entrepreneurs, politicians, tourists, and teachers, and I enjoyed the landscape, street scenes, farmer's markets, wedding parties, and the food, taking in all the information without judgement. As it turns out at the end of the project, the tour made the support teaching "yield twice the result with half the effort" as commented by an HNU student. Actually, the output of the short five days of teaching was beyond my expectation, too. Without the tour, it is impossible for us to have a direct and personal feel of the needs and desires of varied parties in the local community.

Walking a/r/tographically and ecopedagogically invites us to keep an unbiased eye and to accept coincidence and a sharp eye for contingency because they are the sources of fun

and creativity in a walking pedagogy. As coincidence and contingency are unpredictable, it is the teacher's duty to build up kinship between humans and nature, and to build kinship between communities of different interests and values as coincidence and contingency emerge.

Notes

1. In full sentence of original text "子曰：志于道，据于德，依于仁，游于艺"(《论语·述而》), translated by James Legge (1815–1897) as "The Master said, 'Let the will be set on the path of duty. Let every attainment in what is good be firmly grasped. Let perfect virtue be accorded with. Let relaxation and enjoyment be found in the polite arts.'"
2. English translation of "朝为田舍郎，暮登天子堂" in *Poems by Child Prodigies* (神童诗) edited by Wang Zhu (汪洙) in Yuan dynasty.
3. English translation of 教基一[2016]8号《教育部等部门关于推进中小学生研学旅行的意见》official website of Central Government of China. http://www.gov.cn/xinwen/2016-12/19/content_5149947.htm
4. English translation of中共中央办公厅 国务院办公厅. (2015/09/28). 国办发〔2015〕71号《关于全面加强和改进新时代学校美育工作的意见》official website of Central Government of China. http://www.gov.cn/zhengce/content/2015-09-28/content_10196.htm
5. The State Council Information Office of the People's Republic of China. (2021). *Poverty Alleviation: China's Experience and Contribution*. Foreign Languages Press. https://www.chinadaily.com.cn/a/202104/06/WS606bd92ca31024ad0bab3be4.html

References

Bickel, B., Springgay, S., Beer, R., Irwin, R. L., Grauer, K., & Xiong, G. (2011). A/r/tographic collaboration as radical relatedness. *The International Journal of Qualitative Methods, 10*(1), 86–102.

Irwin, R. L. (2006). Walking to create an aesthetic and spiritual currere. *Visual Arts Research, 32*(1), 75–82.

Irwin, R. L. (2017). *Maple Jazz:* An artist's rendering of currere. In M. Doll (Ed.), *The Reconceptualization of Curriculum Studies: A Festschrift in Honor of William F. Pinar* (pp. 93–102). Routledge.

Irwin, R. L., & de Cosson, A. (Eds.). (2004). *A/r/tography: Rendering self through arts-based living inquiry*. Pacific Educational Press.

Jevic, L. L., & Springgay, S. (2008). A/r/tography as an ethics of embodiment: Visual journals in pre-service education. *Qualitative Inquiry, 14*(1), 67–89.

Legge, J. (1861). The Analects: Shu Er in Chinese Text Project. https://ctext.org/analects/shu-er

Springgay, S., Irwin, R. L., Leggo, C., & Gouzouasis, P. (2008). *Being with a/r/tography*. Sense.

Springgay, S., Irwin, R. L., & Wilson Kind, S. (2005). A/r/tography as living inquiry through art and text. *Qualitative Inquiry*, *11*(6), 897–912.

The State Council Information Office of the People's Republic of China. (2021). *Poverty alleviation: China's experience and contribution*. Foreign Languages Press. https://www.chinadaily.com.cn/a/202104/06/WS606bd92ca31024ad0bab3be4.html

Grounding

Lessons From the Forest

Cathy Rocke

Walking in the forest has taught me many things over the years. I have often reflected on reciprocal relationships found in nature and how that can help us to understand healthy human relationships. Like the tree and flower in the picture, the delicate flower benefits from the shade of the tree to produce beautiful blooms. The moss on the bark of the tree finds a place to grow and thrive. The ground cover helps to retain the moisture for the tree. Is there wisdom in observing how nature sustains beauty? Do we all have something to contribute to society based on our unique characteristics? How can we draw on the diversity found in humankind to make this world a better place?

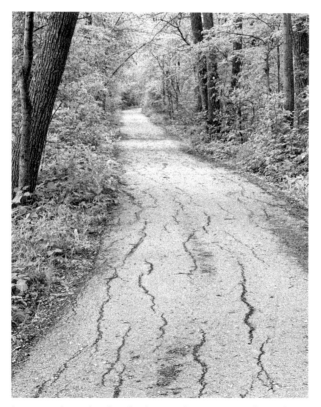

Figure G5.1: Cathy Rocke. Fort Richmond park path. Photograph. Regina. © Cathy Rocke.

Chapter 5

Walking to Where the Grid Breaks Up: Accessing the Aesthetic

Valerie Triggs and Michele Sorensen

"Walks are like clouds," writes Hamish Fulton (in Careri, 2017, p. 135), an artist whose art form is the walk. Clouds are fleeting, unrepeatable, and often considered the perfect example of inherent meaninglessness. If we see form or images in clouds, we are often expected, John Durham Peters (2015) argues, to think that they are "nothing but figments in the eye of the beholder" (p. 255) and in this understanding, "nothing quite divides subject and object like clouds" (p. 255). For John Constable, JMW Turner, and Claude Monet, however:

> Clouds were gorgeous studies of color, mood, light and wind, meticulously documented by date and hour, contingent portraits of the sky's whims and emotions [...] saturated with water and with meaning that humans never put there [...] but also with meanings that they did.
>
> (Peters, 2015, p. 258)

For example, clouds are full of meaning for farmers, pilots, sailors, and picnickers. Peters argues that finding images and meaning in clouds is not only a lazy afternoon pastime; being able to read signs in the atmosphere is an urgent skill for human survival. In fact, our basic experiential "conditions of walking rely on looking, hearing, scanning, and taking one's bearings from the sky and the horizon" (p. 81). However, these conditions do not so much emphasize differences in individual events. Instead, clouds, like walking, do away with misguided divisions between subject and object and instead, open space between what presents, and what remains unpresented (Figure 5.1).

Walking, like clouds, poses particular problems for art. The atmospheric logic of both defies the grid logic. Grid logic, as described by Peters, is focused on rules of perspective including a geometrical discipline of point, line, and plane, and an atmospheric logic, of the systems of streets and structures of colonial settlement. Furthermore, clouds are difficult to render because of their fleetingness and lack of edges: "Bodies without surfaces" (Damisch in Peters, 2015, p. 256).

Hubert Damisch puts /cloud/ between slashes to indicate that the cloud is not only a representation but also a signifier whose object is found exactly at the point where it escapes. Damisch was most concerned with painting and how it sought an alternative to the grid of linear perspective. For him, /cloud/ was a sign of the ways in which the modernist emphasis on representational surface miss "painting's paradoxical combination of the ephemeral and the material" (in Jacobus, 2006, p. 221). While the art object is

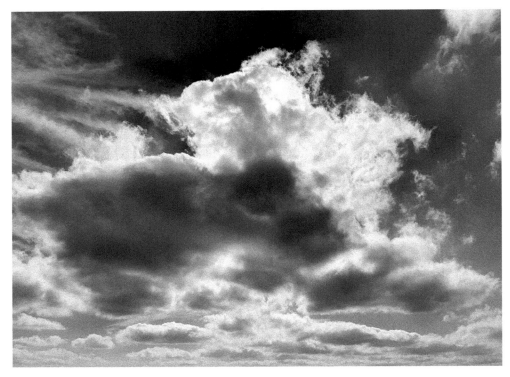

Figure 5.1: Valerie Triggs. *Clouds*, 2020. Photograph. Regina. © Valerie Triggs.

what presents, it is not all of the art object (Robbins, 2002). For Damisch, /cloud/ negates solidity and shape but also "contains the paradox of form which signifies itself" (in Jacobus, 2006, p. 222). There is an unlimited depth to each surface of difference. This means that the cloud, like the walk, can't be pointed at directly and when we access either, we are never completely accessing them. When one moves into clouds things become foggy and when one moves into the walk, they realize they are included in the walk and the walk starts to be about oneself—but elsewhere. Even the most local and descriptive walks can inspire delight in engaging part of walking without claiming to contain all of walking. For Damisch, this is /cloud/: art creating a thinking space, art thinking. Letting go of the subject–object distinction makes room for knowledge that is described in its omission and distinguished in its capacity to differ.

Peters describes how scientists have tried to make atlases of cloud types as "a project with built-in frustration" because "clouds resist ontology" (p. 260). So do walks, we suppose. As anyone who has tried to recreate a walk knows, failure is built into one's expectations of duplication and certainty. Clouds and walking necessitate a more creative ontology that is

not so much about realizing one reality amongst others but rather that ideas and experiences are contemporaneous with the material world, not separate. Drawing on Peters's (2015) ideas about clouds, we speculate that the notion that walking could be art is a test of the limits of art. This kind of art does not have to resemble things to bear significance and yet it favours observation of the world in all its reclusive detail. In walking, art is not just the domain of the recordable but is expanded to include traces of other processes such as sound, bodies, thought, gravity, clouds, and their surfaces of unknowable depths. Walking resists mappings of grid coordinates, which are grids of grouping and subdivision according to similarities and differences and rather, requires one to think in divergent ways. It also provides the means of doing so. Walking is immediate; its meaning is right there on the surface, but one only knows something of it as the walking moves them away.

We are two university professors, one of Mi'kmaq, Lebanese, Danish ancestry and the other of Mennonite settlers/refugees of war forebears. In this paper, we share the work of four students currently studying in a variety of educational disciplines and levels of university research, each of whose lineage we did not probe and each of whom has served as research assistants (RAs) between January to May 2019 in our Social Sciences and Humanities Research Council of Canada (SSHRC) funded international a/r/tographic research project aimed at telling transnational stories of cultural, artistic, and educational significance across local, regional, and international routes of significance. Whitney is a teacher on maternity leave from her classroom position in a local school and completing her thesis in a Master of Education programme (now graduated). Nicole is an undergraduate teacher education student in Arts Education (now graduated); Tom is a Ph.D. student in Adult Education and Human Resource Development and Sheena, also a teacher, is working as a Nation Builder Advocate with Treaty 4 Education Alliance and studying in a Ph.D. programme in Education Curriculum and Instruction. These RAs were asked to undertake an a/r/tographic project in which they initiated a regular walking practice as a form of artmaking, and despite its fleetingness and lack of edges create a shareable mapping of the walking art events in both a visual and written way.

We also asked the RAs to consider, in the walking and/or the subsequent shareable components, the University of Regina mission statement *peyak aski kikawinaw*, which in the Cree language translates to being one with Mother Earth. We anticipated that this university focus might lend itself to some understanding of global–local implications of walking, as well as the immediate particular social, cultural, political, and geologic contexts. We wanted to design the experience as a curriculum inquiry that anticipates how walking not only stimulates thought in certain places but also provokes broader modes of an ecological and transnational curriculum study, one that ignites the complex and uncanny connections between walking in particular places, and the feel of an echo of what Timothy Morton (2013) might describe as the essence of a certain unity that is one's self.

A/r/tographic research attends to the ways in which artmaking carries the potential for affecting one's practices of research and teaching (Triggs et al., 2014), as well as one's practices of living in the midst of various commitments and interests (Irwin, 2008).. A/r/tography is a

"methodology of embodiment" and its activity is always "engaged in the world" (Springgay et al., 2005, p. 899). The text and images rendered by the RAs in this research are thinking spaces; each informs and shapes the other and no space is too small or too large. In pulling alongside layers of other material correlates for the experience of the learning self, such as clouds and walking, the text and images begin to produce theory just as /cloud/ does for Damisch (Bois et al., 1998). It is here that walking is both delimited and localized, where walking both eradicates and adds to itself.

We draw extensively on the scholarship of Francesco Careri, a professor of architecture who researches and teaches an approach to teaching through walking. We also reference media and political theorist Brian Massumi and ecological philosopher Timothy Morton, both of whom situate art as providing access to feeling the aesthetic dimension of life in which bodies of all kinds, including those that are not human, affect one another in unpredictable and indeterminate ways. One of the most significant aspects of our research assistants' work involves ways in which the art form of walking seems to channel the earth's more-than-human pedagogical force (Ellsworth, 2005; Triggs, 2020) in its offering of potential for responsive repositioning. This channelling, according to Massumi and Morton, is apparently what all art does. Each of the RA participants seems to have a desire to re-engage with the world through the realm of the aesthetic, to reconfigure themselves in relation to the physicalities and sensations of places they are moving through. They are willing to be vulnerable and to accept not only what seems readily evident but also to be attentive to a sense of coexistence with life as not already fully known, or even fully knowable.

When the RAs presented us with their images and texts, we began the process of arranging, organizing, and fitting together to see if we could find forms of thought that appear just where they disappear. As researchers, we wanted to discard the divisions between subject and object and think in terms of fields in which things displace slightly allowing theory to take place (Bois et al., 1998). Damisch (in Bois et al., 1998) explains field according to Luding Wittgenstein's description as the possibility of structure rather than settling on either a form or a structure. Damish claims that art is the medium with which to work in that possibility of structure. In this research, we chose to engage Damisch's /cloud/ thinking by dealing with difference and continuity simultaneously. We wanted to find where difference differs, compelling thought—where cloud is in contact with itself, where walking effaces itself in the walking, and where RAs recapture the feel of the walking as it affects itself. As a/r/tographic research tends to emphasize, we looked for where stability and movement were phases of the same and where a person's text and image seemed to constitute the other. We selected some concepts arising from the texts and images—concepts with thought room for potentially furthering the movement and making begun in this project. They are *Points of Departure, Into the Void, Listening for Life-flow,* and *Practicing Relational Responsibility*. In this chapter, we will expand briefly on how these trajectories might be relevant and significant for provoking new tales of an ecological and transnational curriculum.

Points of departure: Whitney

Whitney writes about points of departure. Walking in the park has an uncanny sense of being, and having been, a point of departure to other times in which she has walked this same park in different seasons. It evokes a sense of being stuck as well as a sense of coexisting with the park's cyclical processes. Her images and writing involve family and children with whom she loves to walk (Figure 5.2).

Damisch (in Bois et al., 1998) argues that while art's major work is one of departure, it must be a contorted departure. Only a slight warp is required for things to differ, and at that point, he claims they gain their function as theoretical objects. Whitney's writing hints at the complexity of feeling a measure of loss of oneself to the predefined grid of motherhood intensified in the absence of her own mother's motherhood, as well as in the day-to-day busyness of mothering. Perhaps this is a point of departure into feeling grief, which might be as Morton describes, "the photograph of an object buried deep inside you" (2013, p. 18), or of a certain innermost season, which "every so often

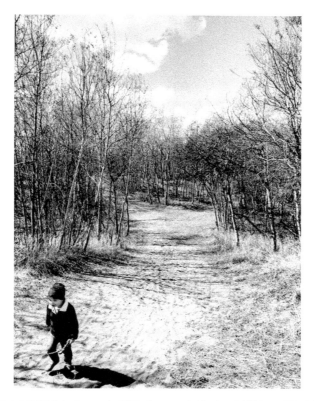

Figure 5.2: Whitney Blaisdell. *Walk in the woods*, 2020. Photograph. Regina. © Whitney Blaisdell.

releases its photons into the bloodstream" (p. 18), as Morton describes grief as doing. He claims grief is the trace of something that isn't you, the record of a non-human world, a sound perhaps from another place and time, qualities you've lost in your moving and living.

These aesthetic traces "sparkle with absence" (p. 18), still capable of contortion and taking one elsewhere. Whitney is sensitive to the non-human forces on her walks. She makes cyanotype images with her toddler son, an age-old method of exposing photographs in sunlight, which requires sensing and aligning with other forces at play, such as the movement of the sun and the play of the shadows.

Winter, for Whitney, is a participant in the walk, one that maintains its own agency, similar to the sun in the cyanotype process (Figure 5.3). The little fragments of non-human intrude, Morton writes, but are "much more delicate, so much more childish, so much more just pure twinkling, than anything else" (2013, p. 18). Winter compels Whitney

Figure 5.3: Whitney Blaisdell. *Cyanotype image*, 2020. Photograph. Regina. © Whitney Blaisdell.

to points of departure, or, at least, to become more intimate with its unknowability. Whitney writes:

> Winter mutes everything for me. "I can't take the kids with me. Too cold." He doesn't argue. The cold bites and threatens and shrinks my skin and pulls away from me and I am grateful. I walk, and I don't have a child tied to my front. There's no stroller. My hands are in my pockets, not holding my toddler's hand. I am not pregnant. I can stand the cold and they cannot, and this is Winter's greatest gift. The cold allows me to go out, be alone.

Winter intimates its otherness in a way that bears witness to our own limits. Attentiveness to it involves "playing back and forth in relation to the other" (West, 2010, p. 239), a way of bringing the other into one's presence, a way of letting go of what one thinks they know, and a way of letting be, in an absence of complete knowability. It takes repeated walks in the park to realize there are spaces in the grids of everyday expectancies and to realize how very deeply we crave contact with earth forces (Ellsworth & Kruse, 2011). Careri (2017) describes walking as:

> The pleasures of finding new paths and new certainties, of building thought with your own body, acting with your own mind. Casting doubt on the few certainties you have just managed to put together thus far [...] encouraging you to reinvent everything, from scratch [...] your own place in this world [...] and start to remember that space is a fantastic invention with which you can play, like a kid.
>
> (p. 14)

Walking, like cloud studies, puts one in touch with a world already at play in which the transformations of one part of the world are in the midst of responding to another part: air, wind, light, sky, sorrow, and organizing thought from which new thought can occur.

Into the void: Nicole

Points of departure are significant for the other participants as well. Nicole is attuned to the potential of moving into what she describes as the void, a place from which she feels that her unitary sense of self might not actually return. She writes:

This.
 This was me, and sometimes still is….
I relate to this.
Do we need to fill the void?
Or be **F R E E**
Let's see how I feel.

Her research focus is mental health, and she understands the sensation of literally pulling back from a point of departure where one might attune too tightly to an entity that is not the self and lose oneself in the midst.

In thinking-walking alongside /cloud/, there is a return to the question of form. Damisch writes "Cloud is a body without a surface but not without substance [...]. Although it has no surface, cloud is visible" (Jacobus, 2006, p. 219). Clouds are visible aggregates of "minute particles of water suspended in the atmosphere" (Forster in Jacobus, 2006, p. 219), which might lead us to recall that on a walk we are a visible aggregate of walking. Walking is movement that suspends and flows through the form and substance of walking and like cloud, it is not space so much as matter that occupies space, changing in split-second adjustments of gradient and intensity.

Walking is both real and abstract because we walk with the form of walking, and we walk through the form. The form, Massumi (2008) argues, is a launch pad, or a point of departure for art and if we were only to see the actual form of walking, we would not know walking. In walking, the form is the way a "whole set of active embodied potentials appear in present experience" (Massumi, 2008, p. 4). Walking makes it difficult to address form in terms of art, "because each time that it operates the interaction produces a variation, and the variations are in principle infinite...the interaction is distributed in time and space and never ties back together in one particular form" (p.2). While Damisch argues for a focus on topology instead of centuries of geometric perspective, he also acknowledges that there *is still* a geometric grid which compels certain things and not others. One may, in fact, lose their bearings amidst the rules of convention. Sometimes it's hard to know if it is the grid that is one's real life. Damisch (in Robbins, 2002) explains that when the grid exceeds its frame, in any art, it consumes the world around it. Perhaps it is in the void of the geometric surface that Nicole feels she might lose herself.

Going outside boundaries involves risk of course. The infinite in any direction evokes a degree of terror. After her weeks of walking, however, Nicole suggests one should not be afraid of the void. "You cannot worry about the what-ifs but live in the present. Be mindful of your surroundings and be mindful of yourself. Listen to your body's needs." Walking provokes an awareness of the irreducibility of things to perception, or relations or uses, and instead, offers sensation of the ways things affect each other in a region out in front, the place into which walking launches us. The walk, like clouds, becomes a language for inner activity: darkening here, lightening elsewhere, heaviness here, and transient weightlessness. What counts is not what something represents, but rather what it transforms. This region is the aesthetic dimension (O'Sullivan, 2001; Massumi, 2002, 2008; Morton, 2013, 2019). It is where things affect each other (Morton, 2013), where there is the feeling of the openness of closed form (Massumi, 2002), where potential for the next variation is available, and where one is also in the midst of a new point of arrival, as Whitney suggests. There is a kind of silence here. This sense of distance and openness felt under an open sky actually provides a temporary refuge for poet John Clare who describes his anguished depression as "under a cloud" (in Jacobus, 2006, p. 224). Communicating

weather-related moods seems common in walking experiences where clouds, for example, express what the geometry of language cannot.

In a poem written about John Clare, clouds and sky evoke the feeling that "the sky might be in the back of someone's mind" (Ashbery in Jacobus, 2006, p. 226). This sense of openness may indicate a more relaxed mode of observation being made temporarily possible—the opposite of a clouded mind. However, /cloud/ may also provoke the so-much-to-be-seen-as-too-much. Nicole does not seek to shut down the fullness of the aesthetic with all of its unknowable potential for destruction and creation. "Live with it," she writes, "filling the void with one's body and perhaps filling one's body with the void." To be in an encounter with the void is to already have ventured forth, to be in the midst of filling the void with one's body. It's a moment of suspension where one might not know if things are at an end or a beginning.

Walking moves Nicole forward, filling the void outside and inside with an expanded range of felt potential rather than the stasis of allowing the call of the unknown to paralyze her (Figure 5.4).

Figure 5.4: Nicole Gebert. *Not afraid of the void*, 2020. Photograph. Regina. © Nicole Gebert.

Listening for life-flow: Tom

Tom has a purpose in his walking. He is listening for the void, the sky at the back of the mind, that place where the everyday grid of order and partitions, power, and control, the realm of the everyday, gives way to carry him into other times and places. As he moves, he is receptive to sensations: the gurgling of water, the reflection of sunshine, the scent of water, pine, and ice, and the sound of the wind.

Each sensation evokes feeling and as Massumi (2008) writes, "a thing felt is fringed by an expanding thought-pool of potential that shades off in all directions It's like a drop in the pool of life making ripples that expand infinitely around" (p. 11). At the limit, every appearance, as Massumi (2008) claims, is at a crossroads of life. At the limit of living what appears isn't just a drop or a pool, but a whole ocean, with calm stretches and turbulence, ripplings that cancel each other out and others that combine and amplify, with crests and troughs, killer surf-breaks and gentle lappings at the shores of other situations ... the fact that experience comes in drops doesn't mean it can't also come with "oceanic" feeling (p. 12).

Massumi explains further that when the body is in motion, it does not coincide with itself. It coincides with its own transition: its variation. In motion, the body is in an immediate unfolding relation to its "own nonpresent potential to vary" (2002, p. 4). In the course of everyday life, Massumi claims, "we march habitually and half-consciously from one drop of life to the next; we don't attend to the ripples" (2008, p. 11). Rather than letting moments appear with all of their force, the moment falls back from the ripple that might extend it and instead, "it closes in on itself" (p. 12). As a result, it appears "so paltry a thing that we just pass on to the next thing" (p. 12). Art helps one see that the emphasis in everyday experience is different and what one usually thinks of as insignificant background, slips behind the flow of action. Activities in everyday life, like walking, disappear into their functioning. Art, however, provokes an uncanny sense of déjà vu that indicates a "moreness to life" (Massumi, 2008, p. 6), a feeling that things around us go on, that the non-human will continue in some form or other, long after its connection within us. It presents the moment's relation to the flow of life itself, its dynamic unfolding, and the fact that "life is always passing through its own potential" (p. 6). This background is the dynamic, ongoing relational flow of life that often gets lost in the living.

Tom writes that he feels desperation. Like John Clare, he feels a necessity to get away from the minutiae of everyday living where consumerism and greed seem to predominate. While Tom provides a map of his pathways, he finds that walking in the materialities of unstructured space rescues him (Figure 5.5).

Careri (2017) seems to agree:

If we want to gain "other" spaces we have to know how to play, to deliberately get out of a functional-productive system in order to enter a non-functional, unproductive system. You have to learn how to lose time, not always seeking the shortest route, letting yourself get detoured by events, heading towards more impenetrable paths where it is possible to

Figure 5.5: Tom Janisch. *The Thaw*, 2020. Photograph. Regina. © Tom Janisch.

"stumble," maybe even to get stuck, talking with the people you meet or knowing how to stop, forgetting that you were supposed to proceed; to know how to achieve unintentional walking, indeterminate walking.

(p. 14)

Careri's challenge resonates with Gilles Deleuze and Félix Guattari's idea of making oneself a *body without organs*, where one can feel more than a limited set of habits and movements

and access "the wilderness where the decoded flows run free, the end of the world [...] and the eternally renewable product of alienation from the civilized world" (Deleuze & Guattari,1983, p. 192).

Deleuze and Guattari are, perhaps, claiming that every actual body has a dimension that is a virtual collection of potentials and to make oneself into a *body without organs* is to actively experiment with oneself to draw out and activate these virtual potentials. They are aware, however, of the dangers of plunging too deeply into the depths of groundlessness and explain that one is to consider this a way of thinking rather than solely as an endpoint, as Nicole in our study seemed to realize. Expressed in another way, Massumi (2008) draws from his translation of Deleuze to argue that to really perceive, to fully perceive, you have to "cleave things asunder. You have to open them back up" (p. 12), give them back their ripples. This is what art can do: "It can take a situation and potentially open the interactions it affords" (p. 13), providing the "background feeling of what it's like to be alive, here and now, but having been many elsewhere and with times to come. Art brings that vitality affect to the fore" (p. 6).

Practising relational responsibility: Sheena

Sheena chooses to walk paths near or on the TransCanada trail that runs through the Qu'Appelle Valley approximately 45 minutes north-east of the city of Regina, Saskatchewan. This is not her first experience with the art of walking. For the past seven years, Sheena has been engaged in what she calls *Treaty Walks* which she defines on her website, as "a hike, a stroll, a field trip with Treaty on the mind" (Koops, 2011, 2019). She is thinking most specifically about Treaty 4, which is an agreement between Queen Victoria and the Cree and Saulteaux First Nations signed in 1874 at Fort Qu'Appelle. Honouring her participation in the Treaty relation is uppermost for Sheena and it seems that part of this engagement for her involves what Careri (2017) describes as an "ongoing discovery of a hidden order we can observe as it comes to life beneath our feet and the perspective [it] afford[s] us, the possibility of constructing a meaning and a coherent shared story-route" (p. 15). Sheena walks alone or with other people or with her horse. She also feels that in walking she is walking with the land and each of her participants is teaching her. Sheena wants to continue to learn about the "promises kept by Indigenous peoples to share the land and the promises broken and twisted by settler colonials to be good neighbours, giving back in proportion to what we were, what we are taking from this land." "It is here," Sheena writes in her artist statement, "I am learning the language, the spirit and intent of Treaty" and where she has come to see the practice as "embodied Treaty mindfulness through movement." Sheena walks in rural areas and not on the colonial grid. Perhaps, like Hamish Fulton (in Careri, 2017), she is drawn to the periphery, to places without edges, and does not want to know how to walk in urban space; she heads out on the frozen ice, the prairie trail, past the closed road. There is danger in walking beyond the grid:

rocky sections, collapsed roads, risk of frostbite, and no immediate contact for assistance. She is sensitive to guidance from her horse, from the weather, from markings on the ground, and from frozen leaves and flowers.

Students from White Bear First Nation lead her on one of her walks. They point out burnt spots on the land, markings from a sacred fire that burns for four days for wakes. They teach her that the land is used as a textbook; one needs to learn how to read it. In any loss, indeterminate arrival sparkles. Sheena pauses at the buffalo rubbing stone where the land is telling her a story-route of the buffalo who would have walked around the stone, rubbing it smooth and indenting the ground around it. She is convinced that the future is retrievable somewhere in what was jettisoned out of dominant-recorded Canadian history, and simmering, suspended in the land, defiant of the colonizing tools of gridlock.

For Sheena, being a Treaty partner involves walking the land central to this agreement. We think that *Treaty Walking* seems to resonate with what Careri might describe as "a sort of automatic writing in real space capable of revealing the unconscious zones of space, the repressed memories" (Careri, 2017, p. 27) of the land. *Treaty Walks* use the body, one's sense of possibility of movement, the strength of arms and legs and forward propulsion into what one does not already know. There is no cutting into the earth's crust, no ploughing, no path longer than the one her body can follow in a certain period of time. Engaging the body, as Careri describes walking artist Richard Long as doing, Sheena seems to be exposing herself to "the changes in the direction of the winds, in temperature and sounds" (p. 129) and this means moving in "keeping with a rhythm and a direction" (p. 129). They might offer Sheena ways of experiencing how the indeterminacy and vitality of the land is also the container of our being. In the topographic wrinkles of the Qu'Appelle valley, spaces of transit are rediscovered, ancient paths in continuous transformation. It is here, the *Treaty Walks* make possible a going beyond divisions of grids and settled space, where in walking the land, which is the main concern of the Treaties, can offer its own presence—one to learn from, but only by moving through it. Careri writes:

> Walking as an aesthetic tool lends itself to attending to and interacting with the mutability of spaces so as to intervene in their continuous becoming by acting in the field, in the here and now of their transformation sharing from the inside in the mutation of these spaces.
>
> (p. 25)

Rather than walking to apply systematic logic to the study of everything, there is an embodied sense of the inextricable links between atmosphere, land, and light.

Sheena's *Treaty Walks* are ways of walking to "stumble on the other" (Careri, 2017, p. 17). Careri argues that one way to approach conflict between differences is to walk with a non-belligerent greeting, to walk towards the other, human or non-human, "disarmed,

unthreatening, reaching for an embrace" (2017, p. 17). This also includes decisions to stop in places, to construct a material space of encounter among diversities where slight experimentation with the walk offers new points of departure for thinking. Sheena photographs one such encounter where her accompanying students discuss how one might harvest trees such as the Black Ash for building and carving. She realizes later that her camera lens was dirty when she photographed the walk and she writes that the resulting photo of their space of encounter is cloudy, "perfectly evocative, like a dream" (Figure 5.6).

Sheena's walking practice intervenes itself to investigate the walking, reinvigorating one's awareness of "background" on which to read the form of the land that would "otherwise appear homogeneous, deprived of a complex evolutionary dynamic and therefore of life itself" (Careri, 2017, p. 69). In the transient character of /walk/, which we are appropriating and refashioning from Danish's /cloud/, one might rediscover an anthropically altered field that yet escapes complete human control, and which is reabsorbed in its changing assemblage in matters of the void where things affect and alter one another.

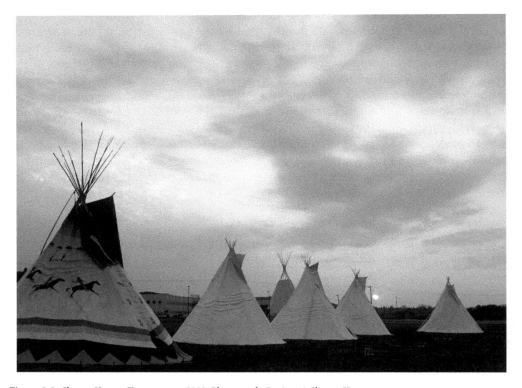

Figure 5.6: Sheena Koops. *Treaty sunset*, 2020. Photograph. Regina. © Sheena Koops.

An eco-curriculum of /walk/

We have presented an interpretation of parts of the RA's journeys as recorded in images, poetry, and writing. Our sharing of this work might be interpreted as a cartography that evokes sensation of places and aims to share experiences in moving them into a nearness of the here and now, but which also takes them beyond the visible to address the "entire body's presence in time and space" (Careri, 2017, p.125). The research trajectories of these art journeys that we have highlighted offer spaces to think about a pedagogy that attends to the ripples of life's moments, one that intentionally designs for accessing the realm of the aesthetic in the making of art and self. Perhaps our basic conditions of *currere* (Pinar, 1975) in curriculum rely on taking one's bearings from the journeying, a skill needed as much now as ever. The curriculum /walk/ is drawn to the epistemological rupture that self-affirms in next steps that do not coincide with themselves but are in immediate unfolding variation. To manifest an object for thinking and theorizing, it may be important to begin with little things that no one pays much attention to and then try to enter another system by means of the walk, finding the swerve in the movement that provokes thinking related to the unlimited depth of every surface. The point is, as Careri (2017) claims, in relation to his teaching through walking:

> How to designate a direction but with extensive openness to indeterminacy, and to listen to the projects of others [...] continuously adjusting, reading the ripples, seeking zones with gusts and avoiding doldrums [...] finding the energies in the territory and the people that inhabit it that can take an indeterminate project forward in its becoming [...] in which the project can grow, change.
>
> (p. 15)

Most importantly, Careri argues, "If we have a determinate project, it will fall to pieces at the first gusts of wind. There are definitely greater hopes of achieving an indeterminate project" (p. 15).

It seems the more elaborate a given plan, the more it will be pockmarked by disintegration. Rather than giving up in the midst of "the impossibility of analysis of shape set against methods of measurement" (Curtin, 2002, p. 64), English professor Mary Jacobus (2006) notes that even clouds have directional tendencies; clouds travel on what is known to meteorologists as "streets" (Jacobus, 2006, p. 224). Damisch (in Curtin, 2002) argues against letting the indeterminacy of clouds overtake all sureties or knowledge offered by linear perspective and rather to find space for thinking in the tension of the relationship between /cloud/ and grid, that "require each other in terms of exclusion and dependency; place-lessness defined against place" (Curtin, 2002, n.p.). Offering an analysis of /cloud/ and grid, Damisch (in Curtin, 2002) claims that European painting "thrived on [the grid], transgressing the laws it gave itself" (n.p.), and notes that in some ways, this left the traditional points of view intact and preserved the regime of perspective. JMW Turner was

an anomaly in this understanding, according to Damisch (2002). A specific characteristic of Turner is his "delight in seeing only part of things..." (p. 188) and his striving to maintain mystery. We consider how clouds challenge our thinking about walking with Massumi's (2002) description of art as a "good example of art's autonomous process of bringing an enveloping self-variation into its own truly singular expression" (Massumi, 2002, p. 174). In the creative events of re-situating, the repetitions of one step in front of the other consist in the walk, self-showing itself as a way of thinking. Walking thinks.

What seems most important for a curriculum of /walk/ is attending to how walking is modified rather than how it exists. The reality of walking is always hidden, slightly mysterious, thus a curriculum of /walk/ is not just an act of planning. Like the walk and clouds, curriculum is also an act of creation, one that involves assembling contradictions and transforming these, in aesthetic relationships. The grid or form of curriculum cannot be grasped independently of the walk because walking disappears in the course of walking. Yet walking also makes the walk appear and reappear, reactivating new points of departure. A curriculum of /walk/ is an inquiry into the possibilities for movement and locality, an inquiry that holds the feeling that something always escapes us—amidst which, there are full spaces of thinking and indeterminate paths through which to depart.

Acknowledgements

We wish to thank our research assistants, Whitney Blaisdell, Nicole Gebert, Tom Janisch, and Sheena Koops, for allowing us to work with their writing and images. To make meaning is always to mistranslate. We have tried, however, to bring their work into our own current areas of study, while at the same time remembering that our work does not displace or usurp what is currently underway in each of their research paths, nor does it attempt to completely summarize the exciting directions in which each of them are moving.

We would also like to thank the Social Sciences and Humanities Research Council of Canada 2020 for funding this research titled "Mapping A/r/tography: Transnational storytelling across historical and cultural routes of significance".

References

Bois, Y., Hollier, D., Krauss, R., & Damisch, H. (1998). *A conversation with Hubert Damisch* (Vol. 85, October, Summer, pp. 3–17). MIT Press.

Careri, F. (2017). *Walkscapes: Walking as an aesthetic practice* (2nd ed.). Culicidae Architectural Press.

Curtin, B. (2002). A theory of /cloud/. *InVisible culture: An electronic journal for visual culture.* https://ivc.lib.rochester.edu/a-theory-of-cloud/

Damisch, H. (2002). *A theory of /cloud/: Towards a history of painting* (J. Lloyd, Trans.). Stanford University Press.

Deleuze, G., & Guattari, F. (1983). *Anti-Oedipus: Capitalism and schizophrenia (R. Hurley, M. Seem & H. R. Lane. Trans.)*. University of Minnesota Press.

Ellsworth, E. (2005). *Places of learning: Media, architecture, pedagogy*. Routledge.

Ellsworth, E., & Kruse, J. (2011). Inhabiting porosity. Wordpress blog post 01.06.2011, *Friends of the Pleistocene Founded in 002010*. https://fopnews.wordpress.com/2017/11/06/porosity/

Irwin, R. L. (2008). Communities of a/r/tographic practice. In S. Springgay, R. L. Irwin, C. Leggo & P. Gouzouasis (Eds.), *Being with a/r/tography* (pp. 71–80). Sense.

Jacobus, M. (2006). Cloud studies: The visible invisible. *Gramma: Journal of Theory and Criticism*, 14, 219–247.

Koops, S. (2011). *Treaty Walks*. http://treatywalks.blogspot.com

Koops, S. (2019). A1. As long as the grass grows: Walking, writing, and singing treaty education. In E. Hasbe-Ludt & C. Leggo (Eds.), *Canadian curriculum studies: A metissage of inspiration/imagination/interconnection* (pp. 2–10). Canadian Scholar's Press.

Massumi, B. (2002). *Parables for the virtual: Movement, affect, sensation*. Duke University Press.

Massumi, B. (2008). The thinking-feeling of what happens: A semblance of a conversation. *Inflexions 1.1 How Is Research-Creation*, May, www.inflexions.org

Morton, T. (2013). *Realist magic: Objects, ontology, causality*. Open Humanities Press.

Morton, T. (2019). *Being ecological*. MIT Press.

O'Sullivan, S. (2001). The aesthetics of affect: Thinking art beyond representation. *Angelaki: Journal of the Theoretical Humanities*, 6(3), 125–135.

Peters, J. D. (2015). *The marvelous clouds: Toward a philosophy of elemental media*. University of Chicago Press.

Pinar, W. F. (1975). *The method of currere*. American Educational Research Association.

Robbins, C. (2002). Surface. *The Chicago school of media theory: Theorizing media since 2003*. https://lucian.uchicago.edu/blogs/mediatheory/keywords/surface/

Springgay, S., Irwin, R. L., & Wilson Kind, S. (2005). A/r/tography as living inquiry through art and text. *Qualitative Inquiry*, 11, 897–912.

Triggs, V. (2020). Thinking pedagogy for places of the relational now. *Oxford Research Encyclopedia*. https://doi.org/10.1093/acrefore/9780190264093.013.1422

Triggs, V., Irwin, R. L., & O'Donoghue, D. (2014). Following a/r/tography in practice: From possibility to potential. In K. Miraglia & C. Smilan (Eds.), *Inquiry in action: Research methodologies in art education* (pp. 253–264). NAEA.

West, D. (2010). *Continental philosophy*. Polity Press.

Grounding

Walk, Walking, Walker

Gloria Ramirez

Walk, walking, walker
Through the Andean Mountains, harvesting wood, Grandpa Julito
From town to town, carrying goods, Dad
Every year, for seasonal activities on warmer lands, the whole family, and the animals
Everyday, carrying meals, mom
Walk, walking, walker

On each step I carry the legacy of my ancestors.
Their gentle contact with the land as they stepped on it barefoot.
Their fast pace as they hurry to get home before dusk.
Their slow motions carrying their *azadon*
Their rhythmical movements as they dance
I close my eyes and hear their steps, they have carried me here today

My feet hold the memory of the places where I have been
The compacted soil of the house where I grew up
The terracotta soil of the fields that gave us food
The refreshing water of the creeks along the roads, the pebbles, the rocks, the sand
The grass of the open fields where I run free
The mountains I climbed with Dad
The hardness of the paved roads and sidewalks of cities around the world

Walk, walking, walker
Across forests to feel the presence of nature by my side, with me, within me, to learn from it
From one plaza to the other, hand in hand with friends,
To create friendships, memories, to find love
Up the mountain to be enveloped by the wind and give my eyes a chance to hug the world
Along paths, alone, to meditate, ponder, and reflect
Walk, walking, always, walker me

Chapter 6

Don't Move! Desired, Hairy, and Forbidden Surface Encounters in (Motionless) Walking With Alpacas

Biljana C. Fredriksen and Isabel Scarborough

Introduction: Lotta's Kisses

This text is written by Biljana and Isabel; however, to be able to address the first author's personal experiences with her alpacas, we have decided to write with a singular (Biljana's) voice. Isabel is silently present in the text, contributing from a distance (Illinois, USA) with her anthropological understanding of the Indigenous people of Aymara and Quechua in South America and their relationships with alpacas. Biljana is an art and craft teacher/teacher educator and a-r-tographer. Voices of the eight alpacas are represented through photos and narratives from shared environments of their and Biljana's farm in southern Norway.

When people ask me why I keep alpacas, there are many different answers to this question. Curiosity and fascination for these extraordinary gentle and social animals might have been a part of me for a long time, but it was first experienced when I became a farm owner that living with alpacas was even possible. I remember the hand-made hat from Bolivia, knitted in alpaca fibre with tiny alpaca profiles walking around a hat-bearing head, that my son got from Isabel ten years ago. When she handed him the hat, she told us how precious alpacas are considered to be in Bolivia, the country of her ancestors, both because of their delicate fibres and their gentleness in their environments. Back then, I had never met an alpaca. Today, they wait for me every morning.

I like to believe that Lotta and I have a connection, some kind of platonic love (see Figure 6.1). It often feels like her teddy-bear coat is screaming for my hug – but I am gradually learning to listen more to her needs and less to my own. My (human-centred) desires continuously strive to drown hers. As much as the visual texture of her body calls for my embrace, I know that she dislikes human touch.

> When Lotta is looking at me intensively, I sense that she wants to greet me properly. I immediately stop moving and try to stand as motionless as possible, and I close my eyes. I can hear her breathing as her face is getting closer to mine. Then, I might sense her pleasant popcorn-like smell. Soon, I will feel her warm breath as she closely sniffs my face. If I am still motionless, I might also feel her whiskers slightly brushing my cheeks, and sometimes even the tiny hairs of her nose touching the tip of mine. I get filled with joy every time she does that. But sometimes, if the first interface between our faces is a pinch of straw from the hay supply, she often carries in her mouth, I might jump unintentionally, and she will shy away.

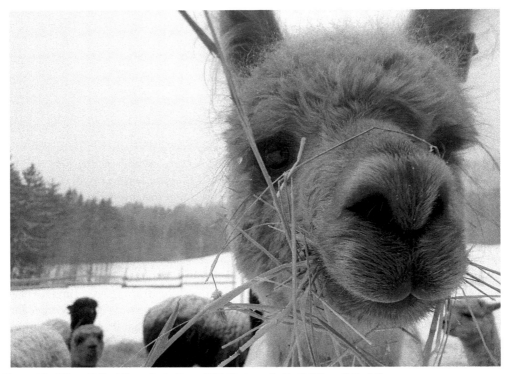

Figure 6.1: Biljana C. Fredriksen. *Lotta kisses*, 2020. Photograph. Bø. © Biljana C. Fredriksen.

The deer that graze on the other side of the fence would probably also shy away if I tried to touch them. My alpacas are halfway between domesticated and wild animals. They question my humanness and invite me to the process of rewilding myself—"rewilding my heart" (Bekoff & Louv, 2014)—which is about accepting the forces of nature that are a part of myself. Paying close attention to the intensity and diversity of the alpacas' forms of touching their environments challenge me to consider my own ways of touching, affecting, and caring for the more-than-human while moving together with them. The concepts of movements, touch, agency, and care are central to this article. The main question it addresses is: *What can acts of touching and abutting, motivated by the alpacas' individual and the species' specific preferences, teach us about more-than-human agency?*

Alpacas as species

Alpacas are one of the four camelid species that originate from South America, the Andes mountain range. They are domesticated and no longer exist in the wild (Bromage, 2019). In

the 1980s, the first alpacas were exported from Peru, Bolivia, and Chile to the United States, Canada, Australia, and New Zealand. The first alpacas arrived in Norway in 2005, and there are about 3000 alpacas in Norway today.

In appearance, alpacas seem to have more in common with sheep than with camels, but they are more intelligent than sheep (Bromage, 2019). They stand out because of the fine fibre of their coat and other physical, biological, and psychological characteristics. Alpacas are known for their sustainable treatment of natural resources. Their padded feet, toothless upper jaws and unique digestive system make them extremely gentle on the ground (Bromage, 2019). Indigenous Andean communities have for centuries appreciated alpacas for their special connection to the land (Cáceres Chalco, 2016). Alpacas are assigned a special place in a model of ecological complementarity where different ecosystems are perceived holistically as a single universe (De la Cadena, 2016; Murray, 1985). Alpacas move with changes in the landscapes and know the rhythms of the bogs. Paying careful attention to their grazing management teaches the people of Aymara and Quechua when the land is getting too dry, when they need to create channels to irrigate the peat bogs, and generally how to treat the land with care.

Indigenous Andean people see alpacas as part of the landscapes and manifestations of the spiritual world (De la Cadena, 2016; Murray, 1985). Quechua communities in highland Peru believe alpacas are in relationship with the universe. Miniature figures of alpacas are placed in homes and stables to protect the animals and people from harm, and to ensure fertility and wealth (Allen, 2016). In parts of Peru and Bolivia, Aymara and Quechua peasants hold ceremonies where they "marry" two alpacas, and alpaca newborns (called cria) are adopted into a human family (Loayza Huamán, 2015) not as pets, but as family members.

Alpacas are highly social animals who tend to bond successfully and imprint with whomever they assume belongs to their herd, and they develop complex and nuanced relationships with them. Their "gregarious social instinct" (Matthews et al., 2020, p. 2) secures connections to their herd, but however valuable it is, it may also fire back on them. They can "almost literally 'die of a broken heart' if kept without company of their kind" (Bromage, 2019, p. 19). Alpacas are kind, companionable, and respectful, but are also aware of their status as prey animals (Bennett, 2006). Since big cats and humans are alpacas' most significant predators, "they are keen observers of human behaviour," able to learn human language and how to trust humans (Bennett, 2006, p. 38). They can enjoy human company, but they "do not make good pets in the conventional sense" (Bromage, 2019, p. 19).

The eight alpacas

Fredrik and Jørgen, 6 and 7 years old geldings, arrived at my husband's and my farm in February 2020. They amazed me with their different personalities and independence from humans, and I wondered if encounters with a young alpaca could lead to a

closer relationship with me. A few months later, my husband and I purchased a pregnant mare, Siri, and her 1-year-old daughter, Lotta. Siri was relatively old (10) and had her own mind that she was not willing to change, but Lotta has shown me how curious and affectionate alpacas can be. Even though Lotta was a giant for her age and sex, she was extremely gentle and vulnerable, but her mother, for some reason, constantly reprehended her, especially after her little brother, Leonardo-Leo, was born in June 2020. As I was spending a lot of time with the alpacas and intensively reading about them, I found out that Leo needed a friend of the same age to grow up with (See Figure 6.2). That is why my husband and I got Sara (4-year-old) and her newborn son Raphael-Rapha in July 2020. At the same time as Leo got a friend, Lotta also got a girlfriend, but even though Sara was a kind mare, her and Lotta's personalities did not seem to match very well. We got Sally (9 months old) in May 2021, both because Lotta still needed a girlfriend, and because I could not resist Sally's amazing red-brown colour.

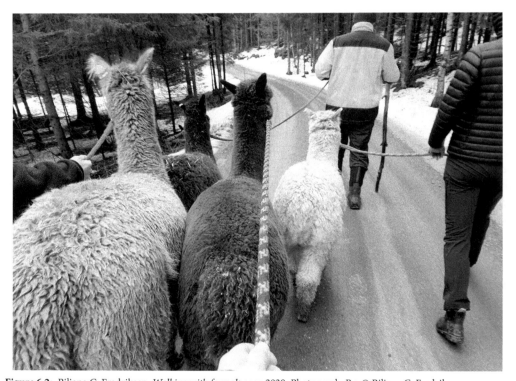

Figure 6.2: Biljana C. Fredriksen. *Walking with four alpacas*, 2020. Photograph. Bø. © Biljana C. Fredriksen.

People commonly generalize species unknown to them, but each individual has unique subjectivities and alterity (De Georgio & De Georgio-Schoorl, 2016). Acknowledging animal subjectivity concerns their personal preferences, ideas, past experiences, genetics, upbringing, cultural/herd differences, and agency. Through the process of slow co-becoming with my alpacas, I am gradually learning to notice how each of them feels and makes choices, and I try to imagine how they think, but I can never know for sure. Still, it is possible to share perspectives from an individual of another species if we are willing to "extend our subjectivities" (Despret, 2008, p. 135). Such extensions of subjectivities seem to work the other way around too when animals understand us better than we understand them (Despret, 2008).

Theory and methods: Ecopedagogical perspectives in a more-than-human approach

Education is deeply grounded in the ideas of humanity (Pedersen, 2010) which obscures equal relationships between humans and other species. Post-human pedagogy "aims to reveal alternative perspectives of how we can understand human–animal relationships in education" (Lindgren & Öhman, 2019, p. 1201) and achieve more harmonious ways of living with our companion species. The "animal turn" recently developed in academia (Young & Rautio, 2018) welcomes more-than-humans into research and is an act of "'ecologicalisation' of knowledge" (Bastian et al., 2017, p. 1). It is also a "step away from the modernist dismissal of nature and nonhumans as anything but resources" (Bastian et al., 2017, p. 2) and a step towards acknowledging animals' agency.

Research with other-than-humans demands careful attention to their forms of being (van Dooren et al., 2016, p. 16) and that they are included in the notions of social justice and social inclusion (Taylor & Pacini-Ketchabaw, 2019). In research with companion species, ethical commitment requires care for their well-being (Krzywoszynska, 2019), but in order to know how to care, one has to become aware of their needs. Trying to understand those who speak an unfamiliar language demands patience, determination, and responsibility for one's own misunderstandings. Including alpacas in my research makes me ethically responsible, and taking their agency seriously makes both them and myself vulnerable (Taylor & Pacini-Ketchabaw, 2019). Lindgren and Öhman remind us about the importance of "critical examination of underlying human desires, projections and interests when valuing and categorising nonhuman life forms" (Lindgren & Öhman, 2019, p. 1206).

Co-production of knowledge with more-than-humans depends on a more flattened power balance between humans and non-humans, and, recursively, the co-production of knowledge is also a driving force behind equalization of power among them (Bastian et al., 2017). Indigenous Andean communities acknowledge alpacas as their teachers and muses. In a Finish art-and-inter-species project called "Alpaca Oracle," humans ask alpacas for help and advice about "the present state and future prospects of life on Earth" (Keski-Korsu, 2014). In a similar manner, I am trying to be open to what my alpacas might teach me.

The significance of touch, compassion, and movement

Touch is for humans the most subjective sense, "deeply personal and impossible to […] share with others, as one can do with sight and hearing" (Stenslie, 2010, p. 80). For humans, tactile and haptic explorations are important for orientation in the world, and close contact with other individuals, like holding and hugging, is important for emotional development. I have observed how young alpacas press their bodies tight when walking through unfamiliar places, how mothers and babies cush (lay in a specific camelid way with all of their feet under their bodies) close one to another, and how alpaca boys play by pushing, jumping, and biting. So, they do touch each other, but the act of touching seems to have different meanings to them than to humans.

Humans usually understand touch as compelling (Puig de la Bellacasa, 2017), but touching alpacas is inappropriate and can be harmful to them (Bromage, 2019). They are wary of catching and grabbing, even if it is meant to be only a friendly cuddle (Bromage, 2019). They can learn to tolerate touch, but tolerance is not affection (Bennett, 2006), and respect for humans might be lost during the process. Especially young male cria should not be touched because of their predispositions for the development of "Berserk Male Syndrome" (BMS) (Bromage, 2019) which is "the end result of a series of confusing and negative interactions with humans beginning with the breakdown of the normal standoffishness […] to humans" (Bennett, 2006, p. 332). A young cria that shows signs of BMS becomes imprinted to humans and starts treating them in the same way that he would treat other alpacas: spitting, biting, kicking, rearing, and so on. Rehabilitation from BMS is impossible (Bromage, 2019) which often leads to the elimination of the animal. The concept of BMS implies that something is wrong *with the alpaca*. Bennet (2006), however, suggests another term for the same condition: "The Novice Handler Syndrome" (NHS). She turns the focus on humans, proposing that "humans play the major role in the creation of this problem" (Bennett, 2006, p. 332), which is particularly a problem with new alpaca owners, such as myself.

Compassion, care, and affection

Compassionate contact with nature is a pathway to the improvement of human–nature connectedness and fostering of pro-environmental attitudes and behaviours (Petersen et al., 2019). Transcendental experiences with nature can lead to life-changing experiences, but small experiences can also have a large impact. "Care for ecology begins with doing what we can in the microsphere of our lives" (Stake & Visse, 2021, p. 113). In many species, caring for their young ones is necessary for survival, but emotions, moods, and intentions can also be shared across species. The Biophilia hypothesis asserts that humans "are born with an innate attraction to other species because of our common ancestry" (Taylor & Pacini-Ketchabaw, 2019, p. 3).

Care is related to affection. We *want to* care for those we feel affection for, and affection depends on closeness. In that sense, when we know a more-than-human individual personally, such intimacy can lead to enhanced ecological awareness (Morton, 2018). Truly caring for another, in a way that our own habits and actions are put at risk, represents a movement towards increased multispecies environmental justice (Taylor & Pacini-Ketchabaw, 2019) because it can motivate us (humans) to reduce our imagined and enacted power over other species. Reduction of our power can make us aware of the mutual interspecies vulnerability (Taylor & Pacini-Ketchabaw, 2019)—of how much we depend on each other. Bekoff (2013) promotes empathy and compassion across species as a central force of species' interconnectedness. "With empathy, we not only understand, but we feel the other's health, well-being or emotional state" (Collins & Collins, 2017, p. 112). Still, we have to remember that understanding another being is never truly possible, especially if the other differs from ourselves in ways that we have no capacity to comprehend (Broglio, 2011, p. xvi).

Movement, action, and agency

The sense of touch provides access to qualities hidden inside materials, subjects and objects (Fredriksen, 2011), but sensing through touch demands more physical activity than seeing. It is "the first-person perspective" that provides access to the understanding of one's interplay with the world (Stelter, 2008, p. 61). The inner will to act (Merleau-Ponty, 1962) is embedded in human biology (Fredriksen, 2011) and is possibly even greater in species whose lives depend on the ability to move quickly to escape from predators (Fredriksen, 2020). Self-movement of an organism is fundamental for life and "is at the root of (our) sense of agency" (Sheets-Johnstone, 2011b, p. xx). Ordinary thinking in more-than-humans unfolds in terms of movement—kinetically (Sheets-Johnstone, 2011a). Alpacas' movements express their thinking and their agency. This also means that encounters between them and humans can be viewed as more than interaction but intra-action: the concept of intra-action implies that each of the actors (human or non-human) simultaneously act upon one another and constantly impacts what can emerge during the ongoing process (Barad, 2007). In new materialism, agency is also assigned to objects and matter (Lenz Taguchi, 2010).

Since movements of *animate species* coincide with their emotion, cognition, intersubjectivity, and communication (Sheets-Johnstone, 2011), alpacas' movements can uncover their thoughts, desires, needs, feelings, and forms of communication. I might be able to "read" their movements, but they are much better interpreters of my agency through their intense observations of human behaviour (Bennett, 2006). Thinking with other animals is possible through "corporeal thinking" that takes place "in the no-man's-land between humans and animals" (Broglio, 2011, p. xviii), and attuning movements across bodies is a form of trans-corporeality that "reveals the interchanges and interconnections between various bodily natures" (Alaimo, 2010, p. 2).

Methodological approach: A/r/tography and ecopedagogical walking

In the present global contexts of the COVID-19 pandemic, human vulnerability is evident. Microscopic co-habitants of our planet are making significant impacts on our lives. The new contexts urge us to pay extended attention to ecological entanglements among species and welcome them into research, requiring imaginative, creative, courageous, and radical research approaches (Jickling & Sterling, 2017).

This anthology is framed by ecopedagogical walking as an approach where acts of walking facilitate "relational aliveness" in more-than-human worlds (Triggs et al., 2014, p. 23). As an a/r/tographic endeavour, walking with my alpacas, invited me "to move and be moved in search of meaning, conceptually, artistically, physically and relationally" (Lee et al., 2019, p. 681), and by doing so, explore the relations amongst the alpacas' bodies, snow, trees, water, and my own body.

Walking is an active, free-will action of moving, changing perspectives, attuning, and an opportunity to get closer to someone or something. Ecopedagogical walking is framed by a/r/tography as a living inquiry where the a/r/tographer remains aware of the complexities of the process, cultivating "the art of attentiveness" (van Dooren et al., 2016) and "arts of inclusion" (Tsing, 2010), and welcomes the unexpected. I found myself implicated in "messy entanglements" (Malone, 2020, p. 60) with members of species I was just getting to know through gentle and meditative roaming together "in the spirit of slow scholarship and the subsequent spaces for wonder" (Cutcher & Irwin, 2017, p. 1). As biosocial-becomings (Ingold & Palsson, 2013), the alpacas and I were, and still are, in the process of co-becoming.

Common worlding can be represented through everyday stories that are constructed on the basis of multispecies ethnographic encounters (Taylor & Pacini-Ketchabaw, 2019). A number of everyday stories have been collected and captured by photo and video during the year of roaming with alpacas. Those stories that affect the most are often those that deviate, "diffract" from what is expected (Malone, 2020). The most surprising stories from Fredrik's, Lotta's and Leo's surface encounters are chosen for this text in order to address relation between movements, touching, emotions, and care.

The Alpacas' encounters with more-than-humans: Touching snow and water

> In March 2020, I learned from Fredrik and Jørgen that sleeping outdoors can be pleasant, even when it is snowing. As the spring approached, the snow was interchangeably melting and freezing. I was worrying that they might hurt themselves if they slipped on ice or mud, but what worried Fredrik the most were tiny streams. On one of our first spring walks with halters and ropes, my son was leading Jørgen in front of Fredrik and me. When Jørgen stepped over a narrow stream, I followed him, but was stopped by an inert weight at the end of my rope. Fredrik had stopped a meter before the stream and started to stamp his feet as if he was preparing for a line-dance.

Don't Move! Desired, Hairy, and Forbidden Surface Encounters in (Motionless) Walking with Alpacas

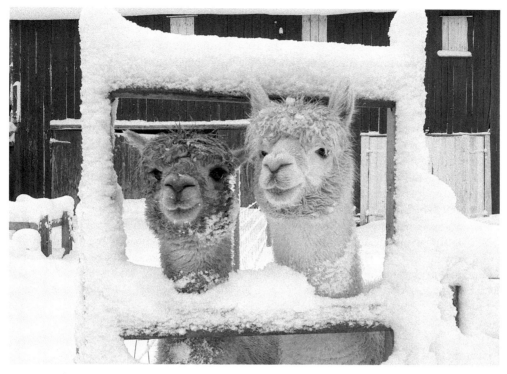

Figure 6.3: Biljana C. Fredriksen. *Jorgen and Fredrik love snow*, 2020. Photograph. Bø. © Biljana C. Fredriksen.

I gently pulled his rope and at the same time I sensed my right foot sliding in mud. I looked down and moved a step to the right, and at the same moment sensed a massive 70 kilogram projectile pass my left shoulder. With all his legs curled under his body as if he was trying to push in the air, Fredrik made sure to avoid getting any water on his feet. I realized how lucky I was not to have stood in his way. This incident taught me to focus my attention on the alpacas when I am with them.

A week later, the snow had almost melted and water gathered in tractor tracks on the country roads, making oblong ponds. With the fresh experience of Fredrik's flight and imagining his fear of water, I was worried if he would be willing to walk between the ponds. I walked very slowly with full attention to his body language. He suddenly fell on his front knees. His hind legs followed and he ended up in a cush. Then he started to crawl, left knee, right knee. I observed him curiously. Why is he crawling toward the pond when he does not like water? Bit by bit he ended up in the pond with his whole body. As his soft coat absorbed all the pond water, he dropped his neck and dipped it in the soft mud.

Merging with trees but not with ropes

Our alpacas are kept on leashes when we walk, not because they would run away, but because they could run back home. The rope connects the pair of walkers, helping them move in a similar direction, but the walking speed, time for explorative stops, and the rhythm of trans-bodily movements are far from constant and regular. The walks are affected by the changing landscapes, objects, growths, road bumps, and everything else we come about, including the ropes. Most of our alpacas hate when a lead rope touches their bodies. Their response to such unexpected touch is to kick with their hind legs, disregarding whom they might hit. Consequently, I learned that I had to adjust my movements in relation to the ropes.

On one of our spring walks, Fredrik started to press his body between small fir trees. I struggled to follow him through the narrow spaces and avoid rope lashing. At first, I was so occupied by my own body, the rope and the trees that I did not realize that Fredrik was trying to walk over the trees. To do this, he was looking for relatively small "Christmas trees" with thin and flexible trunks so that he could bend them while walking over them—and scratch his belly. He did not mind that some of the branches touched or even hit him when they bounced back. Still, he responded anxiously if the lead rope touched his back or made a loop around his neck during his chaotic tree-merging motions that I was desperately trying to adjust to.

Human touch

We waited patiently for the birth of our first cria. Although Siri was an experienced mare, I panicked when it seemed that her cria was stuck, and I called our neighbour, a sheep farmer. He pulled Leo out, and when we realized that he was not breathing properly we held him upside down and massaged his chest as I read in a book. We may have stayed close to him longer than it was necessary.

We were all enchanted by this little creature that, soon after his birth, could cush, run, and roll. He approached people curiously and behaved as if "he was the star of the show" (Bennett, 2006, p. 335). Already one day old, he started to play (or fight) with my son's leg as if it was a neck of another alpaca. As he grew older and I read more about alpaca behaviour, we tried to avoid touching him and we moved away if he tried to bump into our legs. Still, we could not resist watching and adoring his every step—and he probably sensed that.

As his desire for play grew stronger and there was no other cria to play with, he bothered his 1-year-old sister, Lotta, and his interest in playing with people increased. When he was a month old, I started to worry about the development of the NHS. We, therefore, bought Sara and her son Raphal, who was three weeks old at the time. When Leo and Rapha gathered, they immediately became best friends, and Leo's slightly intimidating behaviour was reduced. A year old today, he still gets close to people and sometimes jumps on those

Don't Move! Desired, Hairy, and Forbidden Surface Encounters in (Motionless) Walking with Alpacas

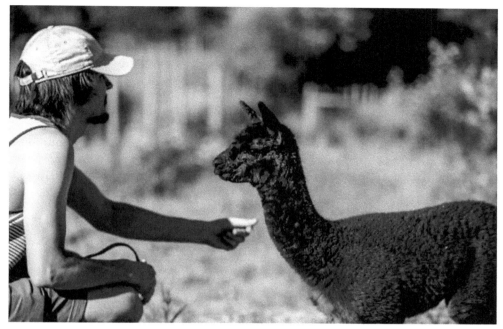

Figure 6.4: Ada Marlene Vrolijk. *Biljana's son with baby Leo*, 2020. Photograph. Bø. © Ada Marlene Vrolijk.

who are not paying attention to his signs (upright tail, charging position, or clicking sounds). However, Leo does not kick if a lead rope or a human hand touches his back and even seems to like being scratched on his neck.

Discussions: What did my fellow alpacas teach me?

In this section, I am returning to the main question: *What can acts of touching and abutting, motivated by the alpacas' individual and the specie's specific preferences, teach me about more-than-human agency?* The section is divided into two parts: The first part deals with the alpacas' encounters with their physical environments. The second part deals with their encounters with humans.

The alpacas' embodied encounters with materials in their environments uncovered their desires, fears, expectations, and past experiences. When Fredrik approached the fir tree, he had already measured its size and the thickness of its trunk. Since Fredrik, unlike the other alpacas, usually chooses fir trees, he has possibly found out that the structure, texture, flexibility, and other qualities of a fir tree are most appropriate for *his* needs. In his choices of trees, Fredrik also considers their placement in the landscape

and size in relation to the size of his own body. He seems to know if there is enough space between the trees for him to pass, but he does not include my body in his calculations.

A bit similar to our donkey, Fredrik has strong opinions and expresses them with big movements so that his agency cannot be ignored. His movements can be understood as meaningful on behalf of his need to survive (Sheets-Johnstone, 2011a, p. 455). When he jumped over the stream, he may have assumed that it could be dangerous, even though this seemed quite ridiculous from a human's point of view. On the other hand, the pond of motionless water did not scare him. Was water "less alive" and less dangerous when it was not moving? I have experienced similar distinctions in my horses' reactions to the movement of water, branches, and even leaves. As if moving water is capable of taking action, having her own will, Fredrik seemed to assign agency to water, in a manner that a new materialist researcher might do.

If I acknowledge the alpacas as animate beings with their own agency, should I also acknowledge their ways of assigning agency to elements in their surroundings (running water, ropes, and humans)? I suppose it was the specific focus on the alpacas' sense of touch that actualized the issue of the alpacas' understanding of agency. Touching between the alpacas' bodies and elements of their environments was only possible through the alpacas' movements or movements of the elements, materials, or more-than-humans. Alpacas seem to be very aware of their own motion and being in charge of their own movements. On the other hand, they are skeptical of movements that seem to aim for touching their bodies. They seem to assume that what moves have power, and what has power can choose to hurt them, as a rope around their neck could. They seem to consider the elements of Earth as "driven by agents, acts and events" (Grosz et al., 2017, p. 132) as in Barad's (2007) performative ontology. Similar to the agency of running water, human relocation in space and arm movements can be scary for alpacas. To gain alpacas' trust, one must move softly, slowly, and calmly—always!

Loving from a distance

When Leo was born, my human desire to show affection and care to this little vulnerable being through touching, petting, and hugging was strong. Afraid that our inappropriate behaviour could cost him his life, I managed to refrain from touching him, but my family and I often watched him, and there was no doubt that he was aware of his capacity to affect human bodies through his movements (Sheets-Johnstone, 2011a).

As a novice alpaca owner, I should listen to alpaca experts, but as a researcher, I am critical of human-centred literature. I suppose that Leo's condition is neither his fault, nor mine alone, but a result of many interrelated aspects of our co-becoming: Leo's biological predispositions, imprinting to humans (due to the problematic birth), size of his herd, and absence of other cria to play with, as well as my inability to treat him more like a family member than a pet, as people of Aymara and Quechua would have done (Loayza Huamán, 2015).

When I, through empathy, try to sense his well-being and emotional state (Collins & Collins, 2017, p. 112), I cannot comprehend that I lack the capacity to truly understand a non-human individual (Broglio, 2011, p. xvi). Similarly, Leo is probably not able to understand that humans are different from alpacas. When non-human animals imprint on people, it is believed that they assume they are like people, but it is more likely that they assume that humans are like them. Therefore, Leo treats humans as alpacas. I am struggling to grasp that what looks like Leo's affection for humans might actually be disrespect. I must be fully present and deeply mindful when I am with Leo, so he does not enter into a position to behave inappropriately (jump on me, push me, and hurt me) which would lessen his chance to develop into a lovable, respectful stallion.

Unlike Leo who gets close to humans, his sister, Lotta, shies away with small, minimal movements from a human. She is curious, follows me around to observe what I am doing, and often sniffs my face which is an alpaca's way of establishing social connections (Matthews et al., 2020, p. 14). Lotta has taught me the most about affection and care without touching. I now understand that her contempt towards touching does not mean that she is not affectionate, intelligent, and capable of attaching to people—she simply does not express this through touch (Bennett, 2006). I have known that alpacas do not like human touch, still, it is taking so much time to fully accept that. Knowing something with the mind is different from knowing it with the whole body. Forms of deep, embodied thinking unfold through intuitive and immediate movements (Sheets-Johnstone, 2011a). It is only when I am fully present and move mindfully and respectfully with my alpaca herd that I truly learn from them. Transforming habit-driven movements and actions—and changing my paths of agency—is not easy. It took time to train my arms to hang and do nothing.

The concepts to touch, move, and affect are metaphorically connected and akin to embodied experiences (Lakoff & Johnson, 1999) of care and compassion. It is only when we are close to someone that we can touch him or her—this applies both literally and metaphorically to humans, but not to alpacas. When I am appropriately close to my alpacas, I should not touch them physically but I can touch them emotionally—love them from a distance. The process of accepting this has been a journey of de-centring my humanness (Malone, 2016, p. 394). I have become aware of my human urge to connect feelings of affection to acts of touching and of my ignorance that these might not belong together for other species. The alpacas' resistance to touch has taught me that true compassion with these species requires that I care for them in the way *they* need to be cared for. In times of social distancing (due to the pandemic), my alpacas have taught me that respecting someone's need for distance *is* a form of caring.

Final words

Living with my alpacas is an ongoing ecopedagogical journey. They have taught me about touchless caring, motionless walking and the potential agency of water, ropes, and other objects and materials. They are "ecological agents" in my life (Bastian et al., 2017, p. 3). If

we consider the condition of the global ecological system, roaming around with alpacas is a very small form of being ecological. However, a big pedagogical advantage of the process of becoming ecological is that such a process is not reversible: Once a person has acknowledged the existence of beings other than themselves, there is no way to "un-acknowledge" this (Morton, 2018, p. 128).

Taken-for-granted discourses embedded in education make it impossible to suddenly turn to post-human thinking in education (Lindgren & Öhman, 2019), but we can hope that new insights derived from encounters with more-than-humans can nudge, push, and destabilize the human-centred positions, little by little. Compassion with more-than-humans has the capacity to pull us out of ignorance. Caring for more-than-humans can "foster a more just and equitable society" (Stake & Visse, 2021, p. xiv). Compassion for non-humans can help us reconsider what it means to be a human in the present context and motivate true care for our environments.

References

Alaimo, S. (2010). *Bodily natures: Science, environment, and the material self*. Indiana University Press. http://ebookcentral.proquest.com/lib/ucsn-ebooks/detail.action?docID=613606

Allen, C. (2016). The living ones: Miniatures and animation in the Andes. *Journal of Anthropological Research, 72*(4), 416–441.

Barad, K. (2007). *Meeting the universe halfway: Quantum physics and the entanglement of matter and meaning*. Duke University Press.

Bastian, M., Jones, O., Morre, N., & Roe, E. (2017). Introduction: More-than-human participatory research: Contexts, challenges, possibilities. In M. Bastian, O. Jones, N. Morre, & E. Roe (Eds.), *Participatory research in more-than-human worlds* (pp. 1–15). Routledge.

Bekoff, M. (Ed.). (2013). *Ignoring nature no more: The case for compassionate conservation*. University of Chicago Press.

Bekoff, M., & Louv, R. (2014). *Rewilding our hearts: Building pathways of compassion and coexistence*. New World Library.

Bennett, M. M. (2006). *The Camelid companion*. Racoon Press.

Broglio, R. (2011). *Surface encounters: Thinking with animals and art*. Oxford University Press. http://ebookcentral.proquest.com/lib/ucsn-ebooks/detail.action?docID=819531

Bromage, G. (2019). *Llamas and alpacas: A guide to management*. The Crowood Press.

Cáceres Chalco, E. (2016). *Sistema económico Indígena Andino: Funcionamiento y lógicas desde la perspectiva del Runa en el Sur Andino. [Indigenous Andean Economic System: Workings and logic from the perspective of the Southern Andean indigenous]*. Abya Yala.

Collins, R. G., & Collins, T. M. (2017). Imagination and empathy—Eden3: Plein Air. In M. Bastian, O. Jones, N. Morre, & E. Roe (Eds), *Participatory research in more-than-human worlds* (pp. 107–126). Routledge.

Cutcher, A. L., & Irwin, R. L. (2017). Walkings-through paint: A c/a/r/tography of slow scholarship. *Journal of Curriculum and Pedagogy, 14*, 1–9. http://dx.doi.org/10.1080/15505170.2017.1310680

De Georgio, F., & De Georgio-Schoorl, J. (2016). *Equus lost? How we misunderstand the nature of the horse-human relationship—plus, brave new ideas for the future.* Trafalgar Square.

De la Cadena, M. (2016). *Earth beings: Ecologies of practice across Andean worlds.* Duke University Press.

Despret, V. (2008). The becomings of subjectivity in animal worlds. *Subjectivity, 23,* 123–139.

Fredriksen, B. C. (2011). *Negotiating grasp: Embodied experience with three-dimensional materials and the negotiation of meaning in early childhood education.* The Oslo School of Architecture and Design.

Fredriksen, B. C. (2020). More-than-human perspectives in understanding embodied learning: Experience, ecological sustainability and education. *FORMakademisk, 13*(3), 1–23.

Grosz, E., Yusoff, K., & Clark, N. (2017). An interview with Elisabeth Grosz: Geopower, inhumanism and the biopolitical. *Theory, Culture & Society, 34*(2&3), 129–146.

Ingold, T., & Palsson, G. (Eds.). (2013). *Biosocial becomings: Integrating social and biological anthropology.* Cambridge University Press.

Keski-Korsu, M. (2014). Alpaca Oracle. http://www.artsufartsu.net/alpaca-oracle/

Krzywoszynska, A. (2019). Caring for soil life in the Anthropocene: The role of attentiveness in more-than-human ethics. *Trans Inst Br Geogr., 44,* 661–675.

Lakoff, G., & Johnson, M. (1999). *Philosophy in the flesh: The embodied mind and its challenge to western thought.* Basic Books.

Lee, N., Morimoto, K., Mosavarzadeh, M., & Irwin, R. (2019). Walking propositions: Coming to know a/r/tographically. *International Journal of Art & Design Education, 38*(3), 681–690.

Lindgren, N., & Öhman, J. (2019). A posthuman approach to human–animal relationships: Advocating critical pluralism. *Environmental Education Research, 25*(8), 1200–1215. https://doi.org/10.1080/13504622.2018.1450848

Loayza Huamán, S. (2015). Cuestión de identidad entre los pastores de llamas y alpacas en las comunidades alto andinas de Vinchos. [Identity issues among the shepherds of llamas and alpacas in the Andean highland communities of Vinchos.]. In E. Cáceres Chalco (Ed.), *Tejiendo las bases teóricas del sistema medico indígena andino: salud e interculturalidad desde los Andes. [Weaving the theoretical base for the indigenous Andean medical system: health and interculturality in the Andes].* Universidad Nacional de San Antonio Abad.

Malone, K. (2016). Theorizing a child–dog encounter in the slums of La Paz using posthumanistic approaches in order to disrupt universalisms in current "child in nature" debates. *Children's Geographies, 16*(4), 390–407.

Matthews, P. T., Barwick, J., Doughty, A. K., Doyle, E. K., Morton, C. L., & Brown, W. Y. (2020). Alpaca field behaviour when cohabitating with lambing ewes. *Animals, 10,* 1–18.

Merleau-Ponty, M. (1962). *Phenomenology of perception.* Routledge & Kegan Paul.

Morton, T. (2018). *Being ecological.* Penguin Random House.

Murray, J. V. (1985). The limits and imitations of the "Vertical Archipelago" in the Andes. In S. Masuda, I. Shimada, & C. Morris (Eds.), *Andean ecology and civilization: An interdisciplinary perspective on Andean ecological complementarity.* University of Tokyo.

Pedersen, H. (2010). Is "the posthumanism" educable? On the convergence of educational philosophy, animal studies, and posthumanism theory. *Discourse: Studies in the Cultural Politics of Education, 32*(2), 237–250.

Petersen, E., Fiske, A. P., & Schubert, T. W. (2019). The role of social relational emotions for human-nature connectedness. *Frontiers in Psychology, 10*, 1–6.

Puig de la Bellacasa, M. (2017). *Matters of care: Speculative ethics in more than human worlds.* University of Minnesota Press.

Sheets-Johnstone, M. (2011a). Embodied minds or mindful bodies? A question of fundamental, inherently inter-related aspects of animation. *Subjectivity, 4*(4), 451–466.

Sheets-Johnstone, M. (2011b). *The primacy of movement.* John Benjamin.

Stake, R., & Visse, M. (2021). *A paradigm of care.* Information Age.

Stelter, R. (2008). Learning in the light of the first-person approach. In T. Schilhab, M. Juelskjær, & T. Moser (Eds.), *Learning bodies* (pp. 45–64). Danmarks Pædagogiske Universitetsforlag.

Stenslie, S. (2010). *Virtual touch: A study of the use and experience of touch in artistic, multimodal and computer-based environments* [Doctoral dissertation]. The Oslo School of Architecture and Design.

Taylor, A., & Pacini-Ketchabaw, V. (2019). *The common worlds of children and animals: Relational ethics for entangled lives.* Routledge.

Triggs, V., Irwin, R., & Leggo, C. (2014). Walking art: Sustaining ourselves as arts educators. *Visual Inquiry: Learning & Teaching Art, 3*(1), 21–34.

Tsing, A. (2010). Arts of inclusion, or how to love a mushroom. *Mānoa, 22*(2), 191–203.

van Dooren, T., Kirkesy, E., & Münster, U. (2016). Multispecies studies: Cultivating arts of attentiveness. *Environmental Humanities, 8*(1), 1–23.

Young, T., & Rautio, P. (2018). Childhood nature animal relations: Section overview. In A. Cutter-Mackenzie-Knowles, K. Malone, & E. Barratt Hacking (Eds.), *Research handbook on childhood nature* (pp. 1211–1237). Springer.

Grounding

mosom Calls

Shauneen Pete

We woke up that morning knowing that we were called
Silently, we packed our water, salmon, and tobacco
We sat in the Jeep for a few minutes saying nothing
"I know where we are going"
It wasn't so much a message, but more of a deep knowing
It was, and I respected the understanding.

We walked northward along the trail
Until we knew, we were almost there
We stopped walking at the same time, smiled at the same time to one another
We turned and stepped over the log that lay beside the path
We are near, we paused, listen …
"*nosisim*" that voice reverberated, just a notch above silence.

"*nosisim*, do you hear me?"
I nodded and walked toward the grandfather
He was ancient beyond imagination, expansive and very tall
I placed my hands on him and smiled
There it was, the deep—ooooom, a low vibration
I placed my forehead against him, eyes closed listening.

Grandfather, I am thankful for all that you have seen
I am thankful that you called to us
"Look about you" he said, and we did
Seeing how his roots spread out across the forest floor
Some roots turning upward becoming other trees, reaching upward
All relatives, all related to this one.

"Hmmm, nois*ism* are there others that can hear us?"
Yes, *mosom* there are some that hear but many have forgotten how
We teach our grandchildren that this way of knowing is real and powerful
We bring them to the land and invite them to listen, they hear you
They offer their tobacco and salmon, and we pray together
They will know that we are relatives to one another.

mosom, I teach my students that this way can be theirs again too
They learn that dominant education norms remove them from this way
I challenge them to walk the land and listen
They tell me that sometimes they are overwhelmed with listening
They are changed and teaching others to accept your gifts
mosom, Kininaskomitotin

Chapter 7

An A/r/tographic Inquiry of Yo/haku and Warm Freeze: Returning to Land and Relationship During the Pandemic

Koichi Kasahara, Nanami Inoue, Mika Takahashi, Chiaki Hatakeyama, Yukito Nishida, Takeshi Kawahito, Naoko Kojima, Kanami Ban, Seisuke Ikeda, Momoka Kiyonaga, and Kanae Shimoji

The coronavirus, which began spreading at the end of 2019, caused various changes and disruptions in society that have also influenced art education. These shifts have created opportunities to re-examine and question our relationship with the land and others in an increasingly complex and difficult situation. In this chapter, we share a/r/tographic walking inquiries conducted by a group of artists/researchers/teachers (practitioners) during the pandemic that culminated at the Art Bay Tokyo Olympic Pavilion. Specifically, we offer the concepts of the marginal space of "yo/haku" and "warm freeze" as a way of coping with the disconnect that emerged due to the pandemic, providing concluding questions as guides for further inquiry.

For the past few years, Koichi Kasahara has worked on a/r/tographic research through walking practices in his graduate school (Kasahara et al., 2022). He believes that the fusion of walking and a/r/tography can be a living inquiry, in which the meaning of places and events emerge through one's experience, and new possibilities of meanings and existence are generated through artmaking, writing, and conversation in community. Such creative "intra-actions" (Barad, 2008, p. 128) reshape our understanding and relationship with materials, land, and others. In this chapter, we investigate the way in which our relationship and understanding of others and land have been impacted by the restrictions imposed by the pandemic through various lines of artistic inquiry. A/r/tography can be a methodology that supports our understanding of our lives and our progress in a changing world as arts educators (Triggs et al., 2014). As Japanese art educators from across Japan, we share the following Japanese examples of our a/r/tographic experiences during the pandemic.

A/r/tographic inquiry during the changing situation of COVID-19

In the myriad complex issues that arose due to the pandemic, we may have become numb to these changes, making it difficult to determine a focus of research. LeBlanc and Irwin (2019) state that a/r/tography is an effective approach in these situations where it is difficult to define questions in advance as follows:

> [A/r/tography] is framed by a continual process of questioning where understandings are not predetermined and where artistic contexts, materials, and processes create

transformative events, interactive spaces in which the reader/viewer/audience can co-create in meaning-making.

(p. 1)

Rather than conducting research for the static reproduction of knowledge, research through a/r/tography explores what is not yet known by playing with and re/writing meaning, fusing ideas of production and thought (LeBlanc & Irwin, 2019). The Art Bay project is an inquiry into the consciousness and life of graduate students and the societal conditions during the pandemic. With an emphasis on change, the characteristics of a/r/tography are suitable to explore this complex situation.

A project at the Olympic pavilion of Art Bay Tokyo (ABT)

This project was carried out across six classes from October to November 2020. The classes were held remotely, and the final exhibition was held at the ABT, the Olympic pavilion in the bay area of Tokyo. Due to the pandemic, various social functions including the Olympics were temporarily cancelled, giving us an unexpected opportunity to exhibit at ABT. We began by discussing these changes to individuals and society, sharing about our lives, emotions, and feelings since the pandemic began. For many in Japan, the postponement of the Olympics had become symbolic of the disruptions to daily life caused by the pandemic. Walking around ABT and other familiar places, we began to see various margins of unused space and time in the metropolis that emerged due to the pandemic. Attending to these margins through our artmaking, we began to refer to these spaces as "yohaku" (余白) in Japanese. Starting from the "yo/haku" (余/白) with a slash as a shared theme, students visited and walked around the unfamiliar ABT, then around familiar cities and universities, expressing their feelings and concerns, thinking with members, creating their own questions, and conducting artmaking, using the concept of "yo/haku" to inquire into what was happening around them to develop an ecological concept of "warm freeze" (see Figure 7.1).

Semantically, "yohaku" means margins or emptiness such as the white space left on the paper after writing, drawing, or printing. It is a peripheral remainder, an ambivalent space, place, or time that has the potential to express something. This word is composed of two Chinese characters, "yo" and "haku." "Yo" means remainder or excess. "Haku" means white, brightness, pureness, honest confession, nothing, and untainted. Based on these meanings, ABT, as a large, white building made for the commemoration of a big sporting event, could be regarded as a representation of "yo" and "haku," symbolizing the excess of economic power and pure expression of celebrating human achievement. However, under the pandemic, economic excess has come to be seen as wasteful or useless. Instead, the temporary cessation of economic development has prompted a reconsideration of our relationship with humans and non-humans that has been given over to uncontested economic desire. Since we do not

Figure 7.1: Mika Takahashi. *Warm freeze: Flyer for the project exhibition*, 2020. Flyer. Tokyo. © Mika Takahashi.

know what kind of potential is contained in the "yo/haku" of these disrupted spaces, the "/" in the middle is inserted to tentatively suspend meaning.

"Yohaku" is also an important feature in Japanese art, a blank space created around the object being depicted. This is also called "ma," the Japanese concept of "being and becoming, existing in between" (Gillard, 2018, p. 141) and is both space and time in the middle. Sinner et al. (2018), who conducted an a/r/tography project with students, note that

> [r]eferring to the interval between two markers, in our practice, ma is somatically constructed by a deliberate, attentive consciousness to what simultaneously is expressed, repressed, or suppressed between two structures…*ma* is a space where freedom (of thought, self, object and so on) is possible.
>
> (pp. 1–2)

Ma is a place of meaning-making where "being/existence" and "nothing" are relationally possible at the same time.

Takayama (2020) suggests that the pandemic revealed many flaws in systems that operate under the conditions of modern rationalism. The pandemic-induced shift to online learning in higher education has removed many "margins" (yohaku) of learning. The "margins" (yohaku) are

> the possibilities for accidental moments of learning; for instance, during a casual conversation with a professor or classmates as they walk down the corridor after class or as they continue to talk over lunch or drinks about the ideas and books introduced during the lectures.
>
> (Takayama, 2020, p. 1344)

These accidental moments of learning only occur when the structure of learning is kept relatively "loose," allowing students to spontaneously explore "meandering sense-making work" (p. 1344). Takayama emphasizes the importance of such marginal spaces for education. Individuals, societies, time, and space in suspension can be seen as variations of "yo/haku," beings/existences and situations in "ma," a space of possibility. Experiencing the "yo/haku" created by the difficulties of the pandemic, we sensed and noticed something warm. How did the contradictory concept of freezing and warmth work with yo/haku? What did the concepts open to us?

Walk un/familiar places

Our university is in the western part of Tokyo, and ABT is in the eastern bay area, about 25 km away from the university. ABT is an unfamiliar place to us, surrounded by large commercial buildings, TV stations, and Olympic facilities and stadiums. Our group met at ABT, listened to the details about ABT from the staff of the Tokyo Metropolitan Government, and walked around the area with Professor Ryoji Namai of Musashino University, who coordinated

the exhibition. Later, each of us walked around the town where we live and the university campus for a long time. Lee et al. (2019) state that:

> [a]s an embodied, immediate and tangible process, walking opens up a range of possibilities and potentials for embracing sound, smell, emotion, movement and memory into our explorations, illustrating the sensuousness and the capacity of walking as artistic, research and teaching practices.
>
> (p. 688)

Employing walking methods as a/r/tographical inquiry, we explore, re-sense, recognize, and re-create our ecological relationships during the pandemic (see Figure 7.2). By walking in two un/familiar places and exploring a/r/tographically, we highlight what these difficult times have brought forward and how we might create knowledge and action for the present and future.

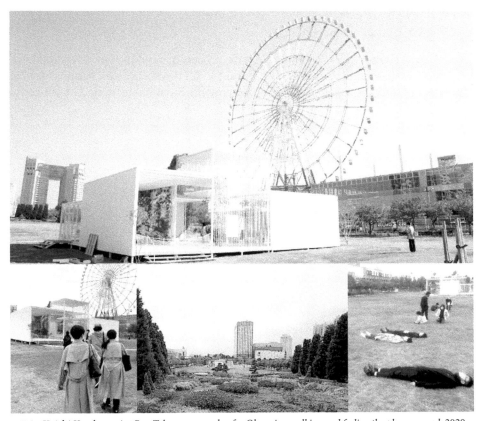

Figure 7.2: Koichi Kasahara. *Art Bay Tokyo, new garden for Olympics, walking and feeling the place around*, 2020. Collage. Tokyo. © Koichi Kasahara.

A/r/tographic inquiries by graduate students

The following is a series of inquiries created by ten graduate students in the master's programme and a discussion of what was produced or generated through this project.

Gazing at something that exists in the margins: Nanami Inoue

> The grass entangled in abandoned bicycles.
> The stains on the wall from my childhood.
> Graffiti in the classroom.
> A deserted, photogenic spot.
> The beauty of the slanting sun shining through the blinds...
> These are the things and state that excluded my and other interventions.
> The photographs remind me of the meaning of the situation and what it should be for the objective.

I wanted to overwrite empty spaces through the process of painting. However, looking back on the process of making the work, I did not want to fill it with my own actions (see Figure 7.3). There is a period known as the blank space brought about by the period of self-restraint.

Figure 7.3: Nanami Inoue. *Tracing the remained forms: Photo taken at the bicycle parking lot, prototype drawing with colour*, 2020. Collage. Tokyo. © Nanami Inoue.

Figure 7.4: Nanami Inoue. *Gaze at*, 2020. Oil on canvas. Tokyo. © Nanami Inoue.

Despite the absence of what should be, time has not disappeared but continues to flow. What is yo/haku for me is not yo/haku for others. There is my yo/haku that is being filled in by something through my work. I was trying to find something that existed in that yo/haku for me (see Figure 7.4). I needed to trace the passage of time that seemed to be yo/haku.

Escape from everyday life and the possibility of yo/haku: Mika Takahashi

The time I spent exploring was the only time that I could escape from my already fixed schedule, pursue the direction I was interested in, take pictures of things I was interested in, and have the freedom to think and act as I wished. If I had not walked, I would not have stopped to think about the yo/haku which might have been treated as a meaningless yohaku. Even if they are out of my or anyone else's perception, many things and people are always moving in unrecognized places (see Figure 7.5). The pandemic has changed society, but nothing has changed for me. Our daily lives are more routine than ever before, and the environment that forces us to stay at home unless we have something to do is monotonous and brings no change to us. I have fewer opportunities to encounter the unexpected.

Figure 7.5: Mika Takahashi. *Mask fallen*, 2020. Photograph. Tokyo. © Mika Takahashi.

Window art-connecting hearts: Chiaki Hatakeyama

This April, I started living in a new place. Since then, my graduate school classes have been online, and my communication with friends has always been through ZOOM and SNS. Some of my classmates, whom I casually talked to at the beginning of this project, were the first people I met in person. What is the meaning of the connection between people? There was constant light rain on the day I explored the Odaiba area where ABT is located for the first time. The white walls and glass walls of the ABT were impressive (Figure 7.6). The inorganic and empty space seemed to represent the emptiness of what we have lost due to the pandemic.

Connection: Yukito Nishida

Although there were some inconveniences in my life during the self-isolation period, what I felt more than anything was freedom. I was able to spend my time as I wished, creating artworks, editing videos, and cooking. However, when I looked around, I found that many people were tired of the "Corona" and self-isolation. When we discussed the

Figure 7.6: Chiaki Hatekeyama. *Drawing on glass walls of ABT*, 2020. Photograph. Tokyo. © Chiaki Hatekeyama.

pandemic restrictions during our classes, there were many students who had negative feelings.

Hatakeyama invited me to work and exhibit together. Hatakeyama was aiming for a direct/physical/offline connection with the visitors through the exhibition. Some of the other students' inquiries had similar intentions. Initially, I was thinking about the theme of

"heart during the pandemic," but as I planned the joint exhibition, I began to think more about connection. However, during the exhibition, I avoided interacting with the visitors even when they were interested in the works. Other students may refer to connection as interactivity or sharing of time and space. For me, connection is a result. Each visitor's drawing leaves a trace on the window, and as a result, they are connected as a single work of art.

For people to live in society, they have no choice but to interact and connect with others. However, for me, this is a connection as a means or a result, not a purpose. On the other hand, people living in society, especially many of the friends, lovers, and family members who came to ABT, probably consider connection itself as their purpose. My visitor-participation exhibition happened to incorporate them as part of the structure of separated/consequential connection.

Exploring the garden: Takeshi Kawahito

About five years ago, I moved to a city closer to my workplace. The city I started living in is a mix of offices and houses, with tall buildings and narrow skies. However, plants were very visible even in the city with little space to spare. The park near my house functions as the city's yohaku, where trees and other plants are incorporated into the urban space, and the undergrowth and weeds along the streets peek out from the cracks in the asphalt. Gradually, I began to take photographs of these plants and use them as aids for my drawings.

In many cases, weeds annoy humans. The space created by weeds is different from the yohaku planned by environmental designers. This yo/haku can be described as interrupted human will. In the past, humans embraced yo/haku that sometimes interrupts human will in various forms of expression. These spaces do not necessarily depend on human will, and there are also forms that are created and emerge there (see Figure 7.7). Using plants as a clue, I attempted to give value to yo/haku through a series of drawings, which suddenly interrupted the human will and continue to float around without meaning.

A house and art for people to enjoy: Naoko Kojima

The day I went to ABT for the first time was sunny and the sun was shining so brightly that it was almost dazzling the light reflected inside. I was impressed to see parents and children taking a walk in the area. I chose home as a concept because home is the central place of life in a pandemic. It is a meaningful theme for me, as 2020 was a period in which I spent a lot of time at home. Furthermore, when I thought about it from the perspective of the human body sculptures that I have been creating since my undergraduate days, one idea

Figure 7.7: Takeshi Kawahito. *Painting through creative inquiry*, 2020. Photograph. Tokyo. © Takeshi Kawahito.

that came to mind was to use stainless steel and mirrors as a barrier around the human body sculptures to reflect the surrounding scenery and themselves.

The question I asked myself throughout my work was, "Can I make children happy through my work?" It was suggested at the ABT meeting that there are not many things that children can play with freely around ABT (see Figure 7.8). The window on one side of the work is a peephole, like a kaleidoscope. When children look at their own reflection in the work or put their hands close to it, they can see their own body reflected in the sparkling world and see how it is infinitely expanding.

Inquiring about the relationship between place and memory: Kanami Ban

I usually return home during long university vacations. This year, however, I have not been back since the beginning of the year. Not being able to return or see the people I wanted to see became a burden for me. Agoraphobic traveller and photographer Jacqui Kenny uses Google Street View to take screenshots of her journey home and posts them on Instagram. This practice reminds me that I could visit my parents' house from a distance. As I typed the

Figure 7.8: Naoko Kojima. *Kaleidoscope games*, 2020. Photograph. Tokyo. © Naoko Kojima.

address of my parents' house into the search box, I remembered the appearance of my parents' house and its surroundings. The window of my room on the second floor, the parking lot where my parents' car was parked, the chestnut tree across the street. I thought about each of the elements that made up the building as I reflected on my memories. When I saw my parents' house on Street View, I could see the building and its surroundings more clearly than I expected. However, the image of my parents' house was slightly different from the image I had in my mind. The house I remembered had my parents' car parked in the parking lot as if the family was home together during the holidays. However, the photos on Street View were probably taken on a weekday when the house was empty. I tried to see the hydrangea by the front door, but there was an obstacle that prevented me from seeing it. When I zoomed in, the image quality was too rough to see the details. The tree, whose branches were pruned last year, is still spreading its branches. What I see there is indeed my parents' house, but it was photographed by someone I don't know, from a perspective other than my own.

Based on the discrepancy between the information on Street View and the image in my memory, as well as the experience of walking around ABT, I created a map of what visitors felt when they visited ABT (see Figure 7.9). I wanted to know what would happen if I put together a map of what people felt and what they found when they visited a place at that time. Intentionally, I looked at it online from a remote location, forming my experience and memory of ABT and thinking about this displacement.

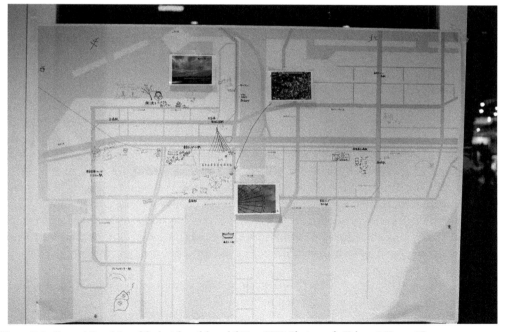

Figure 7.9: Kanami Ban. *Map of the last day of the exhibition*, 2020. Photograph. Tokyo. © Kanami Ban.

Rhythm and reflections on the sense of time: Seisuke Ikeda

Since early May 2020, I have been stopping in front of flower shops more and more. I bought flowers to put in vases, bought insectivorous plants, and in June I planted indigo seeds in a planter. I had never done anything like this before, and I decided to grow them by gathering information on the internet about when to replant and how often to water them. I was worried about the indigo for about a week after planting the seeds, but when the buds started to appear all at once, I was excited and took many pictures. Fortunately, they grew well and put on lush green leaves.

As I walked around ABT, I strongly felt that the distance between parks and buildings and the width of the roads were wide and deserted. At the same time, the flow of time seemed to slow down somehow. I could see parents and children leisurely playing in the park and the blue sky above, and I felt a sense of peace from the scenery that I don't usually see in my daily life area. On the other hand, a little further away from the park, I could see the Bayshore Route of the Metropolitan Expressway. Several large trucks were passing by, and I felt a sense of movement that contrasted with the time I felt in the park. This juxtaposition of slow and fast time may be a characteristic of the area around ABT.

I filmed the indigo for about seven hours while I was sleeping and played it back in fast motion. I found that the stems and leaves were moving more often than I had expected. When I filmed the crossroads that I could see from outside my window for a long time and played it back in rapid rotation, I found that the movement was much more hurried than that of plants (see Figure 7.10). I created images that contrasted the movements of nature, such as plants, clouds, and tides, with the movements created by human activities.

Exploration by drawing, exploration by sprain: Momoka Kiyonaga

I realized that I was able to do some things only because my life was changed by the pandemic. This spring, I entered a graduate school. On the day I moved, a state of emergency was declared, and I returned to my parents' house without living in my new house in Tokyo. I participated in an artist-in-residence project and experienced things and met people I never would have if not for the changes of the past pandemic months. I wanted to adapt to the crazy days of change by looking forward to big changes. I was curious about "2m" as a key word during the pandemic. It is a distance that has come to be focused on as an interpersonal distance to avoid infection, but we are rarely aware of "2 m" in our daily lives. I wanted to understand not only what I perceive as "2m," but also what others perceive as "2m," so I did a live painting.

I connected eight brushes together to paint from a distance. Some people thought of ways to paint together. The children suggested paper airplanes and water guns as methods. The conversation about "2m" often evolved into something else entirely. I felt that the area where ABT was located was devoid of anything superfluous and that the presence of the residents

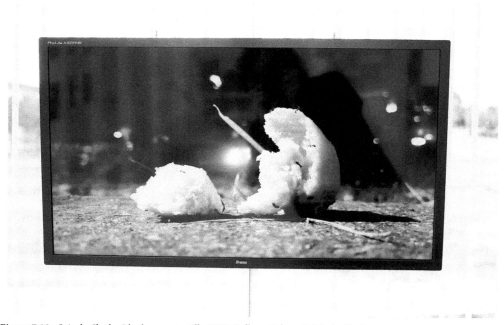

Figure 7.10: Seisuke Ikeda. *Rhythm movie stills*, 2020. Collage. Tokyo. © Seisuke Ikeda.

was rare, so I wanted to meet them. One day, I saw many bicycles parked in the bicycle parking lot of an apartment building and felt the presence of the residents. Excited by this discovery, I was walking around when I fell down a hill and sprained my foot. The next day, I went to the hospital and found many residents there. The injury was not intentional, but it became an opportunity to get involved with local people and see the land from a different perspective.

Re/discovering the year 2020 in the camera roll: Kanae Shimoji

In April 2020, I was in my hometown on Miyakojima Island. I spent four months there until July when in-person classes started. Having left the island after graduating from high school, I had occasionally returned home for a week or two, though I have not been able to spend much time in my hometown since then. As I spent more and more time without my family and relatives, I had more and more time to think about the place where I was born and raised and the connections between myself and others. As my classes and part-time job continued to be online, I searched for the everyday life I had lost in the photos on my cell phone. Photos of my relatives gathering before the pandemic, photos of my grandmother seeing me off at the

entrance when I returned home a few months ago, the everyday life before 2020, and the new everyday life now. While I had been focusing on the changes, by looking back at the photos on my cell phone, I was able to see the things that had not changed.

ABT is a pure white building with glass walls, and if I stay in the room for a while, I forget the existence of the glass and feel as if I was outside. As if I lost sight of the boundary between inside and outside, I felt that this sense of ambiguous boundaries was similar to the relationships between people online. I would like to create this sense of ambiguous boundaries with others, to find points of commonality and differences, and to create an exhibition that brings together people who would not normally be connected.

Two pairs of the most important photos of the participants taken before and after the pandemic of 2020 were collected and displayed on the glass of ABT. The photos were collected via Social Networking Services (SNS). As the days went by, a variety of photos were collected. Gradually, the glass was filled with photos, and as a result, the existence of a transparent wall of glass was highlighted. Goto (2009) describes this method as drawing out a small narrative element by seeing the photograph. By seeing with the photograph, sociological imagination is exercised, and the larger social correctness hidden behind the photograph is imagined and read. The distanced individual's visualized stories were assembled utilizing SNS, and the collective images and awareness on what important or wonderful things that remain unchanged even in a pandemic emerged.

A warm freeze within the yo/haku of urban space and time during the pandemic

Students reflected on the state of their personal lives before and after the pandemic and explored their connections with society and the world by walking through an unfamiliar ABT and surroundings. What did their inquiries bring to light?

The students used yo/haku as an opportunity to create the keyword "warm freeze." This "freeze" refers to the cold-blooded and heartless aspects of the pandemic that brought people's lives and their hopes to an abrupt stop or cancellation. However, the students found a possibility of warmth in this situation.

Aspects of excessive economic activity that were frozen by the pandemic have made people skeptical of economic activities that were sometimes prioritized over life and ethics. For many, such freezes became opportunities to re-examine and change their lifestyles and values. Our inquiries into what is still important and essential as a response to the pandemic reminded us once again of the significance of human, non-human, and more-than-human life and warmth. Some students felt the warmth as/through human communication and engagement while others became attentive to a different flow of time and space latent in the environment. This awareness and discovery emerged through intra-action and negotiation with human and non-human existence during the pandemic. A pandemic is not only a crisis but also an opportunity for us to rethink our way of life and the world. "Warmth" is our finding through this inquiry.

Figure 7.11: Kanae Shimoji. *Photos on glass wall*, 2020. Photograph. Tokyo. © Kanae Shimoji.

Coexistent and exclusive beings/existences that we never noticed before

Walking through the city filled with silence turned our eyes and ears to the existence of things we had not noticed before. Attending to these details meant relativizing and unfixing a binary

perspective of the subject–object relationship of human beings and the city (nature and things). Even in the absence and disengagement of human interaction, time kept flowing and plants were growing. When anthropocentric assumptions around the constancy of the everyday city are relativized, the yo/haku in the urban spaces become an inverted trace of human existence for the city and the world. It is a gap and an opportunity for the emergence of non-human coexistence and exclusivity that is latent in the city. Holland (2016) insists that the possibility of non-humans can be "partners in a shared activity with humans" (p. 79) as follows:

> [T]he natural world is as communicative and social as any concrete jungle. Elephants grieve over the bodies of their dead, darkness conveys to us a concern for what cannot see, and leaves change in autumn, warning us of colder weather. Although the environment does not use words, it does "speak to us."
>
> (p. 79)

Some students were conscious of non-human existences such as plants which had been less visible before the pandemic. Awareness of non-humans in this inquiry shows the inevitable situation of intermingled ontology of non/humans in the world. This awareness was brought through the experiences and sensations as "an embodied, immediate and tangible process in the process of walking inquiry" (Lee et al., 2019, p. 688). This walking inquiry, as it were, opened our senses to perceiving the invisible and hearing the sounds of the non-human, enabling access to the potential for an ecological perspective.

A/r/tography as a methodology for living in ambiguous dis/continuity

In these pandemic circumstances, we may be numbed to the perception of ambiguous dis/continuity. The daily routine of sitting at a desk for long periods of time with our eyes and ears focused on a screen and our sense of smell suppressed by masks severely restricts physical sensations. This blockage of our senses incurs a gradual and inexplicable sense of loss and lack within us. By walking around the city, the university, and ABT, and by opening up our physical senses to tracing and confirming rather than burying and reclaiming loss, lack, and the irreversible, we accept displacement and absence as it is while engaging and confronting them through art. Such artistic engagement is an act of re-territorialization (Deleuze & Guattari, 2013/1987) through walking, exploring, drawing, and confirming what our daily lives were once forcibly de-territorialized by the pandemic.

Knowles and Sweetman (2004) propose a method that expresses visualized individual stories based on photographs and constructed new meanings. In this practice, students developed various approaches to think about ambiguous dis/continuity: using the architecture and context of ABT as a metaphor for this situation, utilizing SNS and photographs and tried to think about what has changed or has not changed, by glass wall drawings, live paintings and map making, they tried to think and create a connection with/

among audiences. These collective attempts are a form of re-territorialization involving audiences. We are forced to move forward despite feeling paralyzed under these ambiguous situations. The a/r/tographic inquiries of the students offer methods for moving forward, projecting oneself while exploring a world that is doubly alienated from reality and certainty in this difficult time.

Exploring with others

Under a pandemic, it is difficult to have a direct connection with people. Some students felt something was lost or missing, compelling some of them to work collaboratively. Some created works nurtured a sense of fun for children and allowed participants to interact by drawing. The difference in the idea of human connection was apparent. Painting explorations with visitors also examined dis/continuities before and after the pandemic with participants who would not normally be connected through SNS. In the time of the pandemic, when people all over the world have experienced isolation and many other challenges, we realize the need to collaborate with many people. Through art, we can create new methods and practices as we inquire into living through adversity.

Ecology beyond non/human boundaries

It is necessary to refer to this practice from the aspect of "*onto-epistem-ology*" (Barad, 2008, p. 147) in which the relationship between humans and non-humans is newly located. In this collaborative inquiry, various means of art as/for inquiry played a crucial role of apparatuses that "are material (re)configurings/discursive practices that produce material phenomena in their discursively differentiated becoming" (Braidotti, 2013, p. 138). As Braidotti (2013) stated, post-human theory "can also help us re-think the basic tenets of our interaction with both human and non-human agents on a planetary scale" (pp. 5–6). The student's inquiries, within time and space, were enacted through an arts-based and collaborative body and "material-discursive practices" (Barad, 2008, p. 128), re-explored, re-questioned, and (re)configured the unconscious framework of their recognition of relationship and categories of human and non-human natural things. It made the students recognize that "'[h]umans' are part of the world-body space in its dynamic structuration" (p. 147) beyond individual selves and opened them to a new visibility and view for ecology in/after the pandemic era and for a post-human perspective.

Questions for people living together in a pandemic era

Finally, if what their inquiry has produced is not a set of conclusions, but rather questions to be shared, we share the following questions to begin a new inquiry:

- *What potential differences in our thinking and behaviour does a pandemic bring to the surface?*
- *How should we deal with the human-centred perspective after realizing that the importance of the non/human, recognizing coexistence and exclusivity simultaneously shape our world?*
- *What are the frozen and warm things, materials, relationships, and beings/existences that can be seen in a "yo/haku" life?*

The pandemic restricted our customary and ordinary behaviours. The yo/haku we sensed and recognized in this pandemic era made us realize that time flows differently when we notice the unnoticed existence of non-human nature. Access to online technologies contributed to sharing our memories. Walking outside, meeting, and engaging someone became a more valuable and fresher act. Such shifts encouraged us to live in our world in a way that sought to reconnect relationships between humans and environment, and human and non-human. It is not easy to notice that which we have not noticed before, nor to recognize our unconscious presumption and world-view. Our a/r/tographic inquiries through walking while questioning yo/haku in this pandemic era nurtured a pedagogical practice that recreates our ecology by focusing on an inclusive ontology not limited to predominant epistemology.

The Tokyo Olympics was held with almost no spectators, so we could not watch the games in person. However, this unexpected exploration of yo/haku at the Olympic Pavilion ABT created an Olympic memory for us and became a "warm freeze" for our lives and inquiries, in the middle of a pandemic with no end in sight. The inquiry for us is still continuing.

Acknowledgements

The authors would like to thank all participants and collaborators in this a/r/tographic inquiry. This work was supported by SSHRC 890-2017-0006 and JSPS KAKENHI (JP18H01010, 20KK0045, JP18H00622, JP21K00233).

References

Barad, K. (2008). Posthumanist performativity: Toward an understanding of how matter comes to matter. In S. Alaimo & S. Hekman (Eds.), *Material feminisms* (pp. 120–154). Indiana University Press.

Braidotti, R. (2013). *The posthuman*. Polity Press.

Deleuze, G., & Guattari, F. (2013). *A thousand plateaus* (Bloomsbury Revelations). Berg. (Original work published 1987).

Gillard, Y. (2018). Beginning in the middle: My liminal space of "MA". In A. Sinner, R. L. Irwin, & T. Jokela. (Eds.), *Visually provoking: Dissertations in art education* (pp. 140–150). University of Lapland Press.

Goto, N. (2009). Visual methods and sociological imagination: Seeing, researching, and narrating. *Japanese Sociological Review*, *60*(1), 40–56 [in Japanese].

Holland, L. M. (2016). Reconsidering the "Ped" in pedagogy: A walking education. In *PES Yearbook 2016: Featured Essay* (pp. 74–84). PES.

Kasahara, K., Morimoto, K., & Irwin, R. L. (Eds.). (2022). *Walking a/r/tography: A journey of art and education through walking inquiry*. Academic Press [in Japanese].

Knowles, C., & Sweetman, P. (Eds). (2004). *Picturing the social landscape: Visual methods and the sociological imagination*. Routledge.

LeBlanc, N., & Irwin, R. L. (2019). *A/r/tography. The Oxford research encyclopedia, education (ocfordre.com/education)* (pp. 1–21). Oxford University Press.

Lee, N., Morimoto, K., Mosavarzadeh, M., & Irwin, R. L. (2019). Walking propositions: Coming to know a/r/tographically. *International Journal of Art & Design Education*, 38, 681–690. https://doi.org/10.1111/jade.12237

Sinner, A., White, B., & Hu, J. (2018). *"Ma" and the space in-between: A China-Canada pedagogical exchange*. 5th Conference on Arts Based Research & Artistic Research, Liverpool (pp. 1–17).

Takayama, K. (2020). Japanese nightingales (uguisu) and the 'margins' of learning: Rethinking the futurity of university education in the post-pandemic epoch. *Higher Education Research and Development*, *39*(7), 1342–1345. https://doi.org/10.1080/07294360.2020.1824208

Triggs, V., Irwin, R. L., & Leggo, C. (2014). Walking art: Sustaining ourselves as arts educators. *Visual Inquiry: Learning and Teaching Art*, *3*(1), 21–34.

Grounding

Luu amhl goo'y gyalk ganiis ["I Am Happy Outside Always"]:
Ecopedagogical Interconnectedness to Indigenous Knowledge

Sheila Blackstock

The land allows us to be a guest during our time on Earth. We come from different fires as we say in our nations, denoting different cartographies, cultures, practices, ceremonies, and languages. Our allies walk among and with us on this Earth, each bringing their cultural backgrounds to share. If we are lucky, we gather around a common fire that each brings us at different times, moments and situations … to share amongst a sharing circle to unpack the things done in the past, to unearth the truth, to create understanding, and to break the cycles of colonization of the past. I share these thoughts on ecopedagogical movements and moments to start a conversation of self-determination with neighbouring nations and allies.

Walking allows me to focus on the movement of my body and everything outside of myself …. This is where great moments of reflection and inspiration occur. There are moments of walking when the greatest things have happened. Perhaps, by sharing a walk, silence, nature, or something that comes to us by the four directions …. Yet can take the shape/form/notion/feel of something that makes us feel transformed….

In times when nothing seems to make sense—get outside, walk and keep moving, keep walking[…]and breathe in mother earth and breathe out the things weighing on your mind so you can get back to your heart. I welcome you to join me on a walk along the lakeshore this early spring morning.

At daybreak the rising sunrays slowly permeate the surface of the lake triggering the crisp morning mist to slowly rise and seep into the forest. The stillness of the air and the quiet brings the anticipation of grounding, clarity and healing….

The mist coming off the lake seems to signal nature's awakening like an orchestra for the senses, as waterfowl begin to stir in the reeds at the water's edge, morning birds chatter to one another as the minutes pass more of natures' reverberations join in the morning serenade; my senses and spirit start to become renewed, and the pressures/schedules that permeate my mind lessen with every step … being interconnected to the land, my heart takes over once again as we are taught by our Elders.

Mother Earth's sounds are not only audible they are sensed by the fresh, but cool spring air also as I breathe in, breathe out … and continue along the snow-covered path. I amble along the path today for solace in the forest; each area provides a different and yet beautiful experiential canvas of mother nature. As I round a peninsula along the lakeshore the ducks become visible on the water's surface as the mist rises above the waters and the sound and feel of my footsteps along the lakeside trail accentuates the splendour, peace, and relief of being back in the forest. I move with my trusty hiking companion—a

Labrador pup, past marsh areas, and ice-covered patches like a weathered quilt with holes on the surface of the lake. Every moment of movement while being in nature, on the land, waters, and territories are lessons of how to be in nature taught to me by my mother and to us by Mother Earth.

These moments create memories in nature and also strengthen my heart spirit and ways of being. Walking is the bush on the lands, and paddling the waters is a spiritual realm of tranquillity; enjoying the essences and sounds of Mother Earth, it comes with a reciprocal responsibility through our Indigenous teachings passed on through oral teachings. These *movements and moments* in the bush [on traditional lands] are layered onto the memories from my youth and contribute to the knowledge of learning from nature. Lessons taught to me to learn nature's cues like weather pattern changes of dark clouds rolling in over lakes are cues to ice cap waves on lakes and linkages to water movements. These movements, senses that become a heart catalogue of understanding of how to be in nature, sense patterns, learnt as a form of survival and to enact a *respectful land ethos*.

It's the moments of walking on snow in the north and learning from my mom how the sound of your footprints on the snow can give you a sense of the air temperature. When walking in the winter, as you breathe in the air freezes in your nasal passages; walking along snow-laden paths your snow boots feel like they are sticking to the snow. These signs signal a near minus 40-degree Celsius temperature.

This knowledge is shared in moments of time, for example, taught to us through experiential and relational learning from the forest, our Elder, our parents, through kinship ties are embedded in Indigenous ways of knowing and being. *These moments are familiar to me growing up in rural northern communities, and I draw from my memories when I feel disconnected from my path, the land, the earth*—I strive to get back to my heart and be grounded reflecting on my wise mother's words. *She gently says, "get outside, listen to the earth, be grateful for all of nature and respect its beings—when you do this You will find peace and purpose."* A disconnection occurs through the necessities of work, and the mind being crafted, shaped, strengthened, and yet when stressed and overwhelmed, I look to the lessons from the heart, from moments in nature and my mother's wisdom continues to guide me. When I am within our territory, more lessons come my way, more time in the forest *and shared stories from our Elders. Our territory was mapped by our ancestors through territorial markers that other nations came to know.*

Although Eurocentric processes actualized through colonialism demark town sites through cartographic means, we came to know our territory through experiences on the land, waters, and mountains ... Does decolonization mean the obfuscation of maps and the honouring of traditional territories and thus self-determination?

As I walk along the game trail that nestles and frames the shore of the high-elevation lake, I reflect on what is meant by ecopedagogical moments on the land and these territories of which I am a guest. I reflect on the words of Elders noting *"reconciliation is not our work as Indigenous Peoples…it is the work of our allies, and those that came after us,"* and yet we guide our allies as we walk our journey on Turtle Island. I continue to

walk as I do heart work […]letting all our relations before me, with me, guide me in the bush[…]."

The moments and movements of walking create footprints of ecopedagogical moments, on Mother Earth. Each movement of walking during our lifetime creates coordinates of the four directions—spiritual, emotional, physical, and mental well-being moments of time of which we are guests, only here on Mother Earth for a short time. With every season, the "senses" of being in the bush evolve and change like the quiet of cool Fall evenings when the trees are still and the leaves have fallen … the lake is still, and the birds are quiet … as everyone prepares for Winter with/on Mother Earth …. only footsteps … no geographical boundaries … seeking self-determination.

T'ooyaxs'y'nii ("I thank you").

Chapter 8

Making Oddkin With Plantly Relations as Wayfaring
Through Colonial Legacies

April Martin-Ko

Anna Tsing (2015) asserts: "As contamination changes world-making projects, mutual worlds, and new directions emerge. Everyone carries a history of contamination; purity is not an option" (p. 27). Through my walking practices, I contemplate complex layers situated within the land on which I wander, where Indigenous understandings of land are entangled within a history of colonization (Marker, 2018; Watts, 2013). In specific terms, my inquiry takes place on the unceded shared traditional territories of the Musqueam, Squamish, and Tsleil-Waututh peoples. Tuck et al. (2014) note that understandings of Indigenous knowledge of land, be they "green" or "urbanized" are storied and not static: "landscape is more than simply a container for human history. It is the mind of reality shaping the stories of time and space" (Marker, 2018, p. 453).

I engage in walking practices, which include focused conscious walking in the neighbourhood surrounding my home. On these walks, I endeavour to engage with my environment through careful sensory attunement and utilize photography and sound recordings to document these practices, with the purpose of further inquiry through a/r/tographic engagement with photography and textile practices. A/r/tography as practice-based research denotes continual movement and active positioning around inquiry. Knowledge creation emerges through this aspect of living inquiry; moreover, through practices that involve engagement with materials, movement, places, writing, and reflection which allow for examination around the taken-for-granted, hence new perspectives to come forth. Finally, these emergences are dynamic and continuously unfolding (Springgay & Irwin, 2008). During the walking practices that were a part of this inquiry, I noticed the consistent and far-reaching presence of the plant, English Ivy (*Hedera helix*). This extraordinary non-human finds a way to grow with, on, and around almost anything through its octopus-like relations. These noticings had me reflecting on Ivy as a colonizer and the damage it does to Indigenous plants, "many current ecological problems—including threats to native plants—are an important legacy of colonialism, which was a multispecies project involving the settlement of plants as well as animals and people" (Mastnak et al., 2014, p. 365).

Ivy embodies excess, takes over and strangles other plants. Its reach seems unstoppable. It covers buildings with fervour, gripping to surfaces with strong suctioning; it takes over almost any space it encounters, human-made or natural. English novelist Penelope Lively (2017) notes that if humans vanished from cities like London, the Ivy and foxes would rapidly take over "swarming and consuming" (p. 54). Its excess and reach seem unstoppable; it has contaminated many of our forests and native plants here on the west coast of Canada,

strangling them to death. Invasive plants are usually escaped garden ornamentals and have originated in biodiverse ecosystems; moreover, they were vigorous over growers to survive under their original conditions. Within milder environments they become plants that don't share and starve others for soil and sunlight, hence a monoculture emerges, and the plant enacts colonization (Kallis, 2014, p. 11). Ingrid M. Parker (2017) notes that the iconic golden rolling hills within parts of California are made up of 84 per cent of species introduced by the Spanish who colonized the area. Like English Ivy, these plants are aggressive competitors dominating the landscape creating a situation devoid of biodiversity (p. 155). However, like everything mixed up in contaminated worlds, I was interested in how and why English Ivy might have held importance to settler populations and why the plant made its way to these lands. Efforts to understand the intricacies of attachments and the histories of Ivy were not attempts to justify or erase its colonizing properties, but to highlight the complexities within these encounters.

Ivy has a long history as a mythical and sacred plant in several European traditions. For the Irish, it was said to protect a home from evil, was considered a fertility plant, and would bind you and your partner through fidelity, hence it was often carried by young women at weddings. It was also linked to inspiration and was often worn by poets as a crown ("ivy tree," n.d.). During the Victorian period, people readily referred to Kate Greenaway's (1884) *Language of Flowers* to bestow secret messages to loved ones and Ivy carried many of these ancient meanings, such as fidelity and loyalty (p. 23). Ivy was also used medicinally as it "was said to help dysentery, jaundice, and intestinal parasites among other uses. Topically, leaves and berries were applied to heal infected wounds, burns, and even for ear infections" (Noveille, 2015, n.p.). These various reasons connected to the plant's enduring value may illustrate why some settlers decided to pack it along with them when coming to North America.

Drawing upon Misiaszek (2020), I contemplated how my walking practices and inquiry with Ivy might think with ecopedagogies where this approach "problematizes our ways of knowing (i.e., epistemological frameworks) the world as well as how we understand and act toward the rest of Earth" (p. 24). In addition, as Kimmerer (2013) notes, being and acting differently in the world through centring ecological perspectives entails examining intertwined, difficult and knotty histories. Doing so might push us forward to unlearn past models and become open to "learning the grammar of animacy" (Kimmerer, 2013, p. 48). It is only through these efforts one can initiate and "counter socio-environmental violence and devise transformative actions" (Misiaszek, 2020, p. 26) regarding local and planetary sustainability.

Thinking ecopedagogically with these scholars, how could I "make" with Ivy to uncover an ecopedagogical understanding of place that reflected Ivy's own complex histories? Would this lead to an understanding of being with place through wayfaring? In that, "The perceiver–producer is thus a wayfarer, and the mode of production is itself a trail blazed, or a path followed" (Ingold, 2011, p. 12). Renderings emerged through textile practices in conjunction with walking by activating Haraway's (2016) "tentacular thinking" (p. 30)

as a way to "think-with a host of companions in *sympoietic* threading, tangling, tracking" (Haraway, 2016, p. 31).

Through felting and weaving enactments of disruption were performed on and with the plant. Folding/unfolding, cutting, stripping, poking, layering, and intertwinement emerged as poignant a/r/tographic processes and renderings. Furthermore, these "makings" produced relations denoting "*oddkin* and unexpected collaborations" (Haraway, 2016, p. 4) and established storying metaphorically and materially. In turn, this inquiry attempts to recognize within a "partial perspective" (Haraway, 1988, p. 583), thinking and being with materials in conjunction with the non-human, and more-than-human within places, is tangled and matted together with complexities that sit within legacies of colonial violence. These are modest offerings, but my hope is that they might contribute to the larger conversation acknowledging a planet presently in peril and facing an uncharted future. Donna Haraway (2016) states: "The tentacular ones make attachments and detachments; they make cuts and knots; they make difference; they weave paths but not determinisms; they are both open and knotted" (p. 31). I was eager to explore this concept of "tentacular thinking" (Haraway, 2016, p. 30) materializing it through literal work with textiles that included felting and weaving holding ideas of "*tentare*—to feel and to try" (Haraway, 2016, p. 31).

Sharon Kallis (2014) is a Vancouver artist who works with unwanted natural materials, many of which include invasive species like English Ivy. Kallis (2014) engages with these materials and asks us to rethink our relationship with these plants through "making." She notes: "We can look for ways that our production/consumption relationships can simultaneously broaden in creative thinking and shrink in geographical scope to refocus on local ecology" (p. 9). She also pushes us to think beyond binaries and dualistic thinking: "invasive plant=bad, instead what if these species could be useful for something?" (p. 9). How can we look at ways to transform how they exist within our environments through material transformative practices, which could also speak to ways of living well together? How could these artistic endeavours provoke resistance to extractive thinking and being and, in turn, translate to other ways we might examine how to "do differently" concerning our relationship with this planet? Do these actions contribute and gesture towards a postcolonial reality?

Kallis (2014) provides an example of a collective project that included problem-solving the disposal of mass amounts of English Ivy that had been removed from a forested site. She found that after the Ivy's removal, areas of the land were left susceptible to erosion. Usually, commercial netting would be utilized to tackle this problem; however, Kallis felt the issue of unused removed plant material presented the opportunity to "make with" the Ivy. Furthermore, she felt this would be a way to highlight concerns about invasive plants and erosion, the material carrying the message through artistic means. Kallis (2014) and those she was working with from the Stanley Park Ecological Society, located an area that could illustrate this erosion and utilized this site to engage in public artmaking of "nets" through knitting and crocheting with the removed and leftover Ivy (p. 13). By engaging in this

artmaking within a public site they displayed how their embodied and material practices were connected to what had happened to the land, and how this artistic practice was also connected to ideas and enactments of restoration. When the knitting and crocheting "performance of making" was complete, the nets were moved and lain in the areas of the park where the Ivy had been removed and erosion was present (Kallis, 2014, p. 14). This type of "making with" Ivy produced actual biodiversity: the knitted Ivy nets that were placed on the forest floor composted and the area is now overgrown with native plants like miner's lettuce and salal (Kallis, 2014, p. 14). Art and community-engaged practices such as these present transformative ways to think and do with invasive and colonizing plants and highlight the interconnected complexities of gesturing towards a postcolonial reality.

In my efforts to think diffractively (Barad, 2007) with these offerings, and through a/r/tographic inquiry I wanted to see where my embodied and material encounters with English Ivy could take me. Would experimental artistic textile practices bring me to places of deeper understanding around relations with place and plants? In turn, would inquiries unfold as a conversation between the plant and the making?

Textile work has been prominent in both my artistic practice, as well as through my work in educational settings with young children. In addition, textile work is connected to family, to kin (Kind, 2004; Robertsson & Vinebaum, 2016). Textile creation is often associated with women's work and is passed down generationally. Many of those who are taking up "craft" today see fibre work as a way to mobilize politicized examinations of gender (Robertson & Vinebaum, 2016, p. 5). As I look to "make kin" in new ways, it felt appropriate to engage in a practice that was passed down to me by the women in my family. Tim Ingold (2015) states that the hands are "the means of togetherness and instruments of sociality" (p. 6). Robertson and Vinebaum (2016) affirm: "Textiles are embedded with social meanings, and they serve to bring people together and to foster social bonds" (p. 7). I was curious if engaging in these practices would provide insight into how to create kin and sociality with those that are non-human, more-than-human, and with place itself.

Textile work creates openings and that they "act as invitations to enter in and look through offering new views and perceptions-searching for and exploring the unstable and uncertain" (Kind, 2004, p. 50). In efforts to unsettle ways of "being" and "doing" relations, and before commencing with "what," I allowed myself to haptically and materially engage with Ivy. Nxumalo (2019) enacts a "methodology of *refiguring presences* as a way to creatively grapple with and interruptively respond to" (p. 39) the hidden and silenced aspects that are contained within human and non-human relations. She notes that practices involving touch allow for instances of reanimating and rethinking with these relations, resisting "taken-forgranted understandings" (p. 39). Alongside this line of exploration, continued research into English Ivy indicated that it was a valuable plant for birds providing shelter among the leaves for nesting and food through its berries (Lively, 2017, p. 54). The song-bird population has been declining, and it was reported that since "1970, overall bird populations in the U.S. and Canada have fallen by 29%, and the National Audubon Society, called the findings 'a full-blown crisis'" (Zimmer, 2019, n.p.). I wondered if there was a way for me to "make

with" both Ivy and birds who occupy the area around the land that I both walk and live on. Through this I wondered if I could lean on Puig de la Bellacasa (2012) where "making or thinking with" could be inextricably tied to "care," where "In worlds made of heterogeneous interdependent forms and processes of life and matter, to care about something, or for somebody, is inevitably to create relation" (p. 198).

As I explored how to "be with" this material, I experimented with ways to make the material pliable so that I could fold it into various shapes and become soft enough for me to sew on. As folding and unfolding the leaves of Ivy through this process renderings connected to "the fold" came forward, the fold "is both at once an interior and exterior" and "there is always the play of opposition and tension in the operation of the fold" (Springgay et al., 2005, p. 901).

These ideas are related to my notions of "making and being with" Ivy as both a plant that contains multiple meanings of mythical and medicinal significance hidden from mainstream narratives folded in with its ability to destroy native plant environments. When making relations within contamination there is dissonance contained within the entirety of the experience. Setting binary trajectories does not allow one to come to a new place in pedagogy and practice. As Holbrook and Pourchier (2014) maintain, folds "do not engender single points of view or rigid identities" (p. 755). Springgay (2018) notes folds disrupt hard edges and categories, bringing an aspect of "soft logics—the elastic, flexible and tensile" (p. 62). Folds allow for continuous interplays of similarity and difference movements of coming together and separation and how to hold these simultaneously. These folded Ivy creations were placed within the very same tangle of branches from whence they came. I also established openings within these objects where I could insert birdseed. Some of the seeds would stay, however, much of it would pour out onto the ground when hanging the Ivy "envelopes" among the living Ivy branches. This opening and contamination of seed on the ground around the Ivy was also an effort to reach out in further collaboration; as the Ivy spreads its way throughout my yard, I spread these seeds for the birds.

In an effort to interrogate the colonizing aspects of Ivy, I decided to work with the plant through needle felting. Springgay (2018) notes: "Felting disturbs, intensifies, and provokes a heightened sense of the potentiality of the present. It is a proposition that remains open; it is infused with experimentation, emergence, and undoings" (p. 62). Needle-enacted felting provided ways to poke through the plant material, and holes revealed spaces for light to shine through. Wool and plant were closely matted and combined, while holes were still present. How might we endeavour to "poke holes" in colonized systems? What happens to these structures and approaches when we disrupt them? How does this allow opportunities for light to shine through and "on" things that need transformation? Colonized systems could be identified as "striated—coded, captured, commodified and limited" (Springgay, 2018, p. 58). Felting is a process that encapsulates interruptions of these attributes as it tangles fibres through agitation and an unpredictable interaction of the materials that allows for the space in the fabric to be, "open and unlimited in every direction" (Springgay, 2018, p.58) as "felt moves as a woolly tentacle" (ibid, 61).

Felting is also "sticky," where the wool acts as a type of Velcro to adhere objects together. I wondered how I could experiment by collaborating with other plant materials through this process, and in turn, how these companions could "become" sticky relations with Ivy. In my process of collecting Ivy on my walks, I noticed that there was also a proliferation of the plant plantain growing in and around the Ivy in some areas. Like English Ivy, many settlers and gardeners see plantain as a weed and invasive because plantain is not Indigenous to this part of the world. Robin Wall Kimmerer (2013) notes that plantain came with the settlers trailing along after them "like a faithful dog" (p. 213). Everywhere they stepped the plant would appear, and it came to be known to Indigenous people in various regions as "White Man's Footstep" (Kimmerer, 2013, p. 213). Kimmerer (2013) attests that at first Indigenous people were leery of this plant, as they noticed many things settlers brought with them including destruction and death.

However, as the plant intermingled with Indigenous ecosystems, people made efforts to investigate the plant, and through experimentation found that it holds a proliferation of beneficial and healing properties. It can be used as a poultice for cuts and insect bites, halt bleeding, and heal wounds from infection. The seeds also act as a solution for digestive problems (Kimmerer, 2013, p. 214). Kimmerer (2013) poses this plant has become an "honored member of the plant community" (p. 214) and even though it came "uninvited" has found its place as a respectable companion with indigenous plants. As I used felting to intertangle the plantain and Ivy with each other, my actions were gentle and careful so as not to completely tear or damage the plantain. I pondered how this adhering and fastening to another in this way engenders intimacy, and within these types of collaborations, sensitivity and respect are required.

Further explorations on the land around my home had me thinking about another plant indigenous to this region, the Cedar tree. For the three original coastal nations who share the lands I inhabit (Musqueam, Squamish, and Tsleil-Waututh), the Cedar tree is a significant plant which provides materials that extend to a plethora of uses from clothing, ceremonial items, and regalia, building structures, "everyday use" items such as ropes, baskets, and boxes for cooking, to art and medicine—the list of uses is vast (Stewart, 1984). Each of these three Nations has contextual beliefs, cosmologies, and uses of this plant that vary slightly depending on the Nation. The relationship with land and plants within Indigenous communities is specific—traditions, understandings, and practices are passed down from generation to generation orally. It must be stated that I am writing as an uninvited guest on these lands and that my explanations and understandings of this relationship are partial and incomplete. Wendy Charbonneau (2012) Squamish Nation Elder and storyteller, and a direct descendent of Chief George Capilano, has shared with me that the land I live on is known by her people as "The Place of the Cedars" (Khupkhahpay'ay). Before colonization this area was a rich woodland where Indigenous people from the three nations would hunt and trap. Many streams that contained spawning salmon would flow into this area and connect to what is now referred to as the Burrard inlet (Charbonneau, 2012, n.p.). Wendy performed a witness ceremony for my husband and me on our wedding day under two Cedar trees that

were in a park adjacent to our home. This was a significant act to honour the Indigenous land we are living on. Since that time, Wendy encouraged me to "get to know" the Cedars I encounter as a "relation" and to see the plant as a physical and spiritual medicine that could support my life and family (Charbonneau, 2012, n.p.). Robin Wall Kimmerer (2013) shares how Cedar trees often "live in family-like groves" (p. 288).

Unfortunately, these two Cedar trees that became significant markers in my life through ceremony and relationship succumbed to the effects of climate change; various biologists and horticulture experts note that Western Red Cedars are dying across BC due to recurring summer droughts (Vikander, 2019). With no possibility to revive them and due to their location in a public park, the city decided to cut them down citing safety concerns. This loss was a poignant reminder that through my noticing and engagement with these trees and through further documentation and art, I was attempting to bring focus to ecopedagogical perspectives that highlight environmental devastation. Hence these circumstances might present themselves through a local lens and may appear small but are connected to larger worldwide ecological issues. Through my inquiry with the Cedar trees, renderings around loss, displacement, and dying emerged in correlation with contamination as collaboration. Tsing (2015) contends, "contaminated diversity is complicated, often ugly, and humbling. Contaminated diversity implicates survivors in histories of greed, violence and environmental destruction" (p. 33). Haraway (2015) speaks about grief as "a path to understanding entangled shared living and dying; human beings must grieve *with*, because we are in and of this fabric of undoing" (p. 39). From an a/r/tographic perspective "Loss, shift and rupture create presence through absence, they become tactile, felt and seen" (Springgay et al., 2005, p. 898). I connected with this loss through my textile art of body-knitting long lines and ropes and placed them at the site where the trees stood. These were attempts to make visible the invisible energetic lines of connection I felt with the trees, and in addition mirror the vast underground root systems trees produce that are often hidden below the ground. Through my inquiry with the Cedar trees, I was also reminded of the *Language of Flowers* (Greenaway, 1884) where Ivy symbolizes fidelity. Instead of Ivy becoming a plant that would strangle and diminish the Cedars, I thought and made with Ivy by weaving it into the knitted ropes, as a symbol of my tangled and emotional connection with these Cedar trees.

As Smith (2019) expresses through this type of acknowledgement, "each one beckons an imaginative sometimes painful, wayfinding into, through and because of each other" (p. 78). This making and unmaking of ourselves and "precarity" (Tsing, 2015, p. 20) puts us into liminal spaces where we can shift and make our way to the edges, and in turn new understandings can emerge. Within my artmaking practices and collection of Ivy and plantain, I also noticed Cedar seedlings had migrated and were growing in one of our large outdoor planters. Kimmerer states that "Cedar is a champion at vegetative reproduction. Almost any part of the tree that rests on wet ground can take root" (Kimmerer, 2013, p. 288). Over the course of my a/r/tographic exploration, the seedlings began to grow with fervour. Holding living and dying together is a practice of "making and be with" dissonance: it's a

pedagogy of moving beyond binaries to an intra-active becoming (Davies, 2014; Taguchi, 2010). Thinking with this "re-born" Cedar as it layered into and made itself known to the dirt around me had me layering its fronds through art with Ivy and plantain. With its hook-like tendrils, it attached to the wool and plants, and through its malleability it twisted around joining them together in a type of synergistic dance. I contemplated how these plants could "be and make" alongside one another through weaving practices. What might be discovered through creating these types of pathways? What is created when walking side by side? Are there still opportunities for "contamination" and transformation?

In preparing the Ivy, I engaged in cutting and stripping the stems to make them pliable for the weaving process. This enacted similar renderings to that of the "poking" that was experienced in the needle felting: "openings are cut deliberately and act as invitations to enter in and look through offering new views and perceptions and encouraging dislocations and disruptions" (Kind, 2004, p. 50). Cutting into a material and pulling it apart offered concepts to think with how we might cut into aspects of colonized systems and pull apart these mechanisms and practices that perpetuate particular ideas. Disruptions to concepts of extreme productivity and walking/moving in perfect alignment came to mind, as the Ivy bumpily wove in and out of the wool's warping and was left dangling and wiry with loose ends at the edges. As I wove with intricate and delicate Cedar roots, they meandered through both the warp and weft and provided rhizomatic traces of pathways reaching alongside the Ivy.

As I pause to reflect on what the materials and processes have revealed through this inquiry, I think back to how my walking practices brought me to think and make with Ivy. In turn, the materials have come together to create their own pathways. Knowings emerged from an "active following and tracking and *going along*" (Ingold, 2013, p.1). Furthermore, as Tim Ingold suggests, "materials think within, as we think through them" (ibid, p.6). Materials form pathways and stories through their innate dynamic qualities, thus projecting and putting forth movement. Natasha Myers (2020) notes acts of being with plant life this way through, "becoming *sensor*—where one experiments with modes of attention that might allow plant sensitivities and sensibilities to transform [one's] own sensorium" (p. 76). She urges that engaging this way disrupts "colonial logics that have for centuries constrained how we think about lands and bodies, and their relations" (p. 74) and allows for the plants themselves to express storied movements. It is in these stories a wayfaring takes place.

Sium and Ritskes (2013) state: "Stories in Indigenous epistemologies are disruptive, sustaining, knowledge producing, and theory-in-action. Stories are decolonization theory in its most natural form" (p. II). Furthermore, rather than perpetuating colonizing practices and appropriating, the materials and plants themselves offer up ways for us to think alongside Indigenous ways of knowing. As the Ivy wove alongside the Cedar and met the plantain through woolly relations, these contaminated collaborations unfurled wandering routes for me to think, be and make with:

For the things of this world *are* their stories, identified not by fixed attributes but by their paths of movement in an unfolding field of relations. Where things meet, occurrences

intertwine, as each becomes bound up in the other's story—moreover, within these acts of wayfaring it is the movement that is significant not the destination.

(Ingold, 2011, p. 162)

Tsing (2015) reminds us that, "a gathering becomes a happening" through acts of contamination and "multidirectional histories become possible through its emergent qualities" (p. 133). The humble and delicate offerings that emerged from experimental artistic practices explored with these plants will not erase the continued felt effects of colonization that are invariably woven into the numerous fabrics of our lives and carried as a heavy and living weight on Indigenous people. As one who has inherited intertwined Indigenous and settler ancestry, these realities are held within a constancy of tensions and may be incommensurable.

Moreover, my artistic efforts to "think and make with" plants may be seen as insignificant as we face the troubling speculation of a possible Sixth Mass extinction (Hurt, 2020). In addition, where the primary cause is placed on humanity's shoulders, thinking with the world encourages us to examine doings that can either perpetuate dominant values that allow us to sit on the sidelines (Puig de la Bellacasa, 2012, p. 107), or we can seek to offer something that might create other possibilities to understand the non-human and more-than-human world. These small strivings open potentiality in the creation of new stories and new pathways as we travel together on a shared planet.

References

Barad, K. (2007). *Meeting the universe halfway: Quantum physics and the entanglement of matter and meaning*. Duke University Press.

Davies, B. (2014). *Listening to children: Being and becoming*. Routledge.

Greenaway, K. (1884). *Language of flowers*. Routledge.

Haraway, D. (1988). Situated knowledges: The science question in feminism and the privilege of partial perspective. *Feminist Studies*, *14*(3), 575–599.

Haraway, D. (2016). *Staying with the trouble: Making kin in the Chthulucene*. Duke University Press.

Holbrook, T., & Pourchier, N. M. (2014). Collage as analysis: Remixing in the crisis of doubt. *Qualitative Inquiry*, *20*(16), 754–763.

Hurt, A. (2020, December 3). Earth is on the cusp of the Sixth Mass Extinction. Here's what paleontologists want you to know. *Discover*. https://www.discovermagazine.com/planet-earth/earth-is-on-the-cusp-of-the-sixth-mass-extinction-heres-what-paleontologists

Ingold, T. (2011). *Being alive: Essays on movement, knowledge, and description*. Routledge.

Ingold, T. (2013). *Making: Anthropology, archaeology, art, and architecture*. Routledge.

Ireland Calling (n.d.). Ivy—Symbol of strength and determination. https://ireland-calling.com/celtic-mythology-ivy-tree/

Kallis, S. (2014). *Common threads: Weaving community through collaborative eco-art*. New Society Publishers.

Kimmerer, R. (2013). *Braiding sweetgrass: Indigenous wisdom, scientific knowledge, and the teachings of plants*. Milkweed.

Kind, S. (2011). Openings and undoings: The text of textiles in curriculum and pedagogy. *Journal of Curriculum and Pedagogy*, 1(2), 48–51. https://doi.org/10.1080/15505170.2004.10411498

Lively, P. (2017). *Life in the garden*. Penguin Random House.

Marker, M. (2018). There is no place of nature; there is only the nature of place: Animate landscapes as methodology for inquiry in the Coast Salish territory. *International Journal of Qualitative Studies in Education*, 31(6), 453–464.

Mastnak, T., Elyachar, J., & Boellstorff, T. (2014). Botanical decolonization: Rethinking native plants. *Society and Space*, 32, 363–380.

Misiaszek, G. W. (2020). *Ecopedagogy: Critical environmental teaching for planetary justice and global sustainable development*. Bloomsbury Academic.

Myers, N. (2020). Becoming sensor in sentient worlds: A more-than-natural history of a Black Oak Savannah. In G. Bakke & M. Peterson (Eds.), *Between matter and method encounters in anthropology and art* (pp. 73–96). Routledge.

Noveille, A. (2015, December 21). *History and uses of common ivy*. Herbal Academy. https://theherbalacademy.com/history-and-uses-of-common-ivy/

Nxumalo, F. (2019). *Decolonizing place in early childhood education*. Routledge.

Parker, I. M. (2017). Remembering in our amnesia, seeing in our blindness. In A. Tsing, H. Swanson, E. Gan, & N. Bubandt (Eds.), *Arts of living on a damaged planet: Monsters of the anthropocene*. University of Minnesota Press.

Puig de la Bellacasa, M. (2012). "Nothing comes without its world": Thinking with care. *The Sociological Review*, 60(2), 197–216.

Robertson, K., & Vinebaum, L. (2016). Crafting community, *TEXTILE*, 14(1), 2–13. https://doi.org/10.1080/14759756.2016.1084794

Sium, A., & Ritskes, E. (2013). Speaking truth to power: Indigenous storytelling as an act of living resistance. *Decolonization: Indigeneity, Education & Society*, 2(1), I–X.

Smith, B. (2018). Revisiting: The Visual Memoir Project: (Still) searching for an art of memory. In A. Lasczik Cutcher, & R. L. Irwin (Eds.), *The Flâneur and education research: A metaphor for knowing, ethical actions and data production* (pp. 63–92). Palgrave.

Springgay, S. (2019). "How to Write as Felt" touching transmaterialities and more than human intimacies. *Studies in Philosophy and Education*, 38, 57–69.

Springgay, S., Irwin, R. L., & Kind, S. W. (2005). A/r/tography as living inquiry through art and text. *Qualitative Inquiry*, 11(6), 897–912.

Stewart, H. (1995). *Cedar: Tree of life to the Northwest Coast Indians*. Douglas & McIntyre.

Taguchi, L. H. (2010). *Going beyond the theory/practice divided in early childhood education: Introducing an intra-active pedagogy*. Routledge.

Tsing, A. (2015). *The Mushroom at the end of the world: On the possibility of life in capitalist ruins*. Princeton University Press.

Tuck, E., McKenzie, M., & McCoy, K. (2014). Land education: Indigenous, post-colonial, and decolonizing perspectives on place and environmental education research. *Environmental Education Research*, *20*(1), 1–23. https://doi.org/10.1080/13504622.2013.877708

Vikander, T. (2019, June 13). *Western red cedars are dying of drought in Vancouver and scientists say it's one more portent of climate change*. Star Vancouver. https://www.thestar.com/vancouver/2019/06/13/western-red-cedars-are-dying-of-drought-in-vancouver-and-scientists-say-its-one-more-portent-of-climate-change.html

Watts, V. (2013). Indigenous place-thought & agency amongst humans and non-humans (First Woman and Sky Woman go on a European world tour!). *Decolonization: Indigeneity, Education & Society*, *2*(1), 20–34.

Zimmer, C. (2019, September 19). Birds are vanishing from North America. *New York Times*. https://www.nytimes.com/2019/09/19/science/bird-populations-america-canada.html

Grounding

Resonances and Re-Entanglements in an Era of Climate Change:
Performing Reciprocity With the Cosmos

Peter Cole and Pat O'Riley

Coyote and Raven are having a walkabout with their southern relations, the Kichwa-Lamista of the High Amazon and the Quechua Andeans of the Sacred Valley of the Incas in Peru. Whenever they get together, they like to eat and talk and laugh and build and weave and garden and play fun outdoor games. And they never miss a chance to pick berries, mushrooms, roots, herbs, and medicines and talk around the fire about the good old [pre-Columbian] days. And sometimes, like their northern relations, they set fire to their environment to protect its rooted rhizomed mycelliaed mycorrhizaed integrity while renewing and regenerating its constituent wholenesses. Their walkabout usually begins in the High Amazon where they get a supply of particular varietal coca leaves to chew (and share) while visiting their friends in the higher elevations of the Andes so they don't get altitude sickness; it also improves their oral, nasal, sinusoidal, cardiac, pulmonary, mental, and spiritual health. For lowlanders to survive or safely cope, performing even minimal physical or mental activities in the rarefied atmosphere above 5000 metres requires learning specialized breathing techniques, including the ones that regulate interspecies breath-sharing (oxygen–carbon dioxide cycles). This sharing of breath across species is a vital part of whole-being reciprocity, including inter-species symbiogenesis and endosymbiosis. Breath does not consist only of the rationally patterned epistemo-methodologies of science, nor is breath exchange the lifeless flow of dead molecules. Breath is living reciprocal exchange, an intimate part of the world's gift economy. Scientific thinking systems, born and developed in Europe over centuries, offer a tiny sliver of awareness of creation's thinking and knowing possibilities. This paragraph is brought to you by the elimination of "the middle man" [citations from self-professed settler experts of Indigenous cultures: anthropologists, archaeologists, historians and linguists, leaving just the Indigenous precipitate].

Says Raven, "*many members of trickster-avian species take great joy walking, running, scampering, hopping and prancing, since most of us spend more time enacting pedestrian, nesting, feeding and perching activities than being airborne.*"

"*The first thing I notice,*" says Coyote, "*when visiting my mountain and jungle relations is they create and re-create their own ecotechnologies from what is available locally without mining, smelting, digging, hacking, fracking, smacking or otherwise attacking and toxifying the sacred body of Pachamama and the Apus. They use and repurpose what already exists, keeping their ethical-ecojust-spiritual pawprint (EESP) small compared to that of a median mainstream*

settler. The traditional lifeways of our Indigenous relations emphasize preserving, maintaining, repairing, caring and sharing, thereby leaving as small an imprint-impact as possible so as to not debilitate, injure, destroy or deactivate the shared journeys of our partners in ongoing creation," Coyote chuffs, *"From my digital [she counts on her phalanges] calculations, the average settler baby today in Canada has an ecological footprint at birth that is significantly larger than what a traditional Kichwa-Lamista or Andean Quechua person acquires over a long lifetime."*

Says Coyote, "When you have lived your life off-grid since (even before) time immemorial and do not participate in monied consumer economies, you cannot help but give back more to the ecosystem than you take, so that your lived life does not have deleterious effects on the land, water and air. We know our environment intimately, from the eddied whirlings of river and wind to the soft dancing voices of grass leaf and lichen; these are the forever choruses of inter-being; these are our teachers. The bubbles, ripples, shades, scents and tones, hues and textures are epistemological procedural variations on the theme of enacting lifelong gratitude. Our friends at Takiwasi call this interbeing commingling attunement of mind, spirit, body and feeling, 'our wifi' (Jaime Torres, personal communication, 2017). The only connecting and maintenance fees are reciprocity and deep respectful engagement."

Says Raven, fluffing his feathers, "As I flew over the village this morning before sunrise, I saw laughter, dancing and joy everywhere: people hauling wood, working in their chakras, caring for compañero animals and plants, weaving, cooking, and making coca tea. The experience and memory of it seem unimaginable, after living in sama7 cultures where self-referentiality, competition and feeding their limitless appetites are the mainstream predilections, addiction to destroying the living world through their senseless sensibilities. Eduardo Grillo (1998) speaks of work being a Western invention that affects the exploitation of the many for the benefits of the few. Greed is a sociopathy where one wants not just one's own share but everyone else's, too."

Says Coyote, "Our southern friends are happy with few possessions, but many of their settler neighbours see their lifestyle of cooperation and humility as naïve and irresponsible. The Kichwa-Lamista live with the realization that the more things you consume or 'own' own you; the more mentally, physically, emotionally and spiritually unstable and apathetic you become and the more your desires work against the whole of the natural world." Coyote gestures to fading pointillist marketing mirages floating in the air: "Such an illusory event horizon is the very maya the Buddhist seeks to escape." The images disappear like popped soap bubbles. "Myriad lives destroyed because of omnicidal desire. Narcissism is the gist of a soulless society."

Says a voice from the cloud forest: *"The less a society thinks, feels and cares about the struggles of the poor, the ill, the distressed, the invisibilized, the colonized, the more it becomes defined by its prurient appetites, its technologies of infinite self-absorption, its semio-fantasies reflecting*

life in the deadzone: *hic nihil est*. In such a world, all is violence; all is destruction. Walk on by. A phrase in so many lyrics and poems."

Looking towards the audience (readership), Raven says: "Now to determine ecological footprints. Okay, everyone take out and calibrate your footprintometers." Raven exhales audibly through the bristled nares of his beak.

"*Hmm*," wonders Coyote, "*does a paw count as a foot? Does a claw? A wing? Rodrigo, amigo mio, do your children take a bus to school or do you drop them at prescribed zones of anti-pedestrianism? How many internal combustion vehicles do you have in your village; how many labour-saving devices, large, medium and small appliances, how many smart watches, smart tvs? What is the ecological footprint of each child's daily commute to school?*"

Raven chips in, "It begins with extractive principles and practices so dear to the heart of Canadian mining and (de)forestry companies engaged in global Indigenous genocide. Mining-clearcutting-manufacturing is the very killing predication of the digital age; every screw, bolt, nut, washer, spoke, spoon, seal and gasket has a footprint, as do the machines that mass produce them. This is the mainstream Western notion of progress, to build personal, including corporate, fortunes by researching, developing, and manufacturing items en masse that no-one needs or receives any net benefit from, because planned obsolescence retroactively extinguishes any real benefit to the global, including local, environments, including the nonhuman and more-than-human ones."

Like everyone in the village, Rodrigo is slim, sinewy, and always smiling. Most often, he is barefoot, lightly dressed, with glowing skin. He is the *Apu* of the village, the headman, and he is related to every Indigenous family within a 100 km radius. He rises every morning by 4:00, long before the rooster. He has sharpened and oiled his family's machetes and hoes and knives on one of the village's stones that has been there for generations. He has rebraided and knotted and tightened all the ropes and tumplines that are spun and woven by the women from cotton or the wool of sheep or goats. Most technologies are manual and when they wear out they are made into other technologies. Rodrigo wears the same trousers, shirt, sandals, and baseball cap most days, washing them in the nearby river or leaving them to refresh in the rain. Nothing he wears off-gasses, bioaccumulates, or has toxic effects in the natural world.

Coyote says, "*You don't hear the people in the village talking about wanting anything from outside, though a cell phone could be useful for emergencies, but there is no signal reception in the village. I am reminded of our friend, Mutindi Ndunda, born in a small village in Kenya, now a professor in America for twenty-five years, talking to a group of high school students in metro Vancouver. She showed them a London Drugs flyer: "Nobody in my village needs even one thing in this flyer. Not one thing." This really shocked the young people who thought those Kenyans were underdeveloped and losing out or perhaps too ignorant to understand the importance of shopping to support the national economy.*

The temperature is 30 degrees Celsius as Rodrigo pulls his old baseball cap down, a habitual action for going through the jungle with all manner of insect, spider, reptile, amphibian, wingéd, or scaled creatures. You pay continuous attention to the beings you share the jungle with; if it's not second nature by the time you're 2 years of age, you will be in deep trouble. This awareness is part of a life-long covenant with the beings who are your elder sisters and brothers of the land. Respectful interaction with all of creation is the foundation of your interbeing, as a resident and citizen of the jungle. One is not above or beyond or outside one's environment, but forever contiguous with it and knowing this keeps one humble and grateful and cooperative. If you are not on your toes, someone else will be. There is no list posted on a tree telling you what the laws of the jungle are; you learn them by experience rather than memorizing them using mnemonic, including alliterative or assonant clues. Most of what you need to know about living in the jungle does not readily translate into human words, grammar and syntax; there is no naming, conceptualizing, or abstracting the world into words that just talk about themselves.

"So, getting back to your petrochemical or other energy footprint from dropping the children in your village off at school every day plus being escorted to extracurricular events at indoor sports arenas, sleepovers and birthday parties," Raven says. *"How will you reduce that footprint to mitigate climate change?"*

"Yes," says Rodrigo seriously. *"We have been speaking of that. Some of the children who now wear shoes or sandals or flip flops, might go back to attending school barefoot. It's a short walk across the village plaza for most, so no vehicles are needed. But some have to cross the river, which can be very deep and fast so they have to pull themselves over it manually in a cable car. Others have a 500-metre vertical descent through the hills so they have to leave home earlier. But before there is any thought of school, the children have morning chores. This is how our children go to school here in the Amazonia; they walk. Though, they do not confine themselves to just enacting one unnuanced verb; they also dance, hop, jump and skip."*

Each step on the earth is a blessing, so it is important to continuously have thoughts of gratitude, compassion, and generosity. This is a way of life. Our friends of the High Amazon are in constant conversation with all beings and walking is a prayerful activity, so one must take care to not do harm. The *ayllu* is their community of human, non-human, and more-than-human beings. Rodriguo tells us that the largest ecological footprint in the community is the school books which are retained in the school; they come from milled and pulped trees from Indigenous lands. It is a challenge to make education work here. Education is free but the people are not part of a moneyed economy so cannot buy school supplies. *"Our children play outdoor games and sports in whatever weather presents itself. All activities take place in the village or the paths around it or in neighbouring villages. We do not kill any living being for sport; we do not destroy the natural world so that we can entertain or sport ourselves. That would be neither personal nor communal integrity. The forest beings have the same right to*

living their lives as any other being and must be treated respectfully, not as conveniences, whose lives are to be sacrificed for the entertainment of self-entitling human beings. Each species is an elite species with none more important than any other. Each being, whether alive in the mainstream Western sense or not, is of equal value. If the weather encourages us to stay indoors, it teaches us to come together that way. We are in continual conversation with all of creation."

Says Coyote, *"You seem to be always thinking about your relationship with all of creation, my friend."*

"It is not thinking," says Rodrigo, smiling broadly. *"We sing and dance and experience beautiful visions and sounds and tastes and smells. Response in the form of thinking in words gets in the way and interrupts our non-representational inter-relationships. We learn, from our mother's dancing and singing, even before birth, to always remain united with all beings. It is this natural, communal way of being that Western and westernized education consciously corrupts and destroys. This is why we cannot communicate with Western-trained researchers who are in a prison of colonial thinking and doing. The Western-trained linguists who are multilingual are lost in all of their languages and can only build cages for all created beings because they have only the lifeless archives of their reductionist culture to find meaning and value. We do not promote Western education, rather, we seek mutual nurturance, as our friend and brother Grimaldo Rengifo (1998) attests. Education and schooling are Western terms that have nothing to do with how and what we learn and know and value in the village. The village school education is taught by a Mestiza from the nearby town, who helps us learn how Western thinking and actions come about and how we can protect ourselves from them, simply by being ourselves."*

"Hmm," muses Coyote, *"we coyote persons are like that too. We do not annotate the living world with mental representations like naming and numbering. Otherwise, we would simply be recreating the world in the image of our words and way of thinking and the direct connection is lost; the shared breath does not come to be. Only a simulacrum remains. Grimaldo looks to the huacas or deities which all have life and give life and share life. Each part of creation bridges to all other parts within a forever wholeness. By bridge, I mean the trees that fall across the stream, the stone path within the river; the sand or silt bar; it is not our intention to distance ourselves from the land or the water with a bridge. It is only when the water's depth and flow are dangerous to us that we seek other ways to cross over or through it."*

"Rodriguo," says Raven, *"I see you have sharpened the tools; we thought we'd walk along to the chakra if that is acceptable; if you like, we'll work alongside you and try not to get in the way."*

Rodriguo is glad to have the company though our hacking and chopping skills are rusty and even dangerous to ourselves, so we need to pace and distance ourselves accordingly. Usually, there is little talk, a word now and then, a chuckle; mostly silent assent that everyone understands without having to create meanings and understandings and interpretations.

Conversely, gesturing and body languaging does not encase the living manifest world in a prison of endless words and the representational understandings manufactured by those words. There is no formal philosophy, just stories regenerated from time past memory, which are learned from stories and experience. The moment gives birth to thought that is intuitive and improvisational, composed of sound, rhythm, and silence. More words does not mean greater thinking or increased awareness.

Coyote says, *"Raven, I remember John Cage (1961) writing of—and I paraphrase—silence as not absence of sound but being open to the whetherness of sound, allowing for hearing other/ed voices and resonances converse, cry, laugh and play."*

Raven says, *"I remember well, your many conversations and shared silences with him in your human O'Riley (2003) form. And likewise, our friend and shaman-in-training, Royner, says there is no need to talk on long hikes in the forest between those who are part of the forest community; it is only with newcomers that introductions and commentary is offered (Sangama Sangama, personal communication, 2017). Those who are one with the forest do not need to have themselves explained to themselves about themselves, otherwise there can be no oneness, which gets lost in the explanation, recounting and especially analysis."*

Raven adds, *"Royner shared that with us in his film, el mundo kichwa (Kichwa world), before entering the forest it is important to sing icaros [ritual chants] so that nature can open its path to us. It is in this way that we ask permission for entry. It is not taken for granted that just because a landscape or water or air scape exists that we have permission to enter it. If one does not know the language and the protocols of a place, one can offend, injure and even destroy many beings with one's boundless enthusiasm and curiosity to see and know and experience all things."*

Rodrigo carries only a machete, sometimes a hoe and a small folding knife and one or two tumplines, and he wears a bandana that has multiple uses, and his baseball cap. Everything is threadbare because it is used every day and not replaced until it has been repaired many times. Everything continually becomes something else, while remaining itself within the network of the wholeness of the jungle. And nothing is ever lost or misplaced because paying attention to *Pachamama* (Mother Earth) means being constantly aware of how you interact with her. Memory is not about drawing up lists or using tricks to remember; rather, it is about being in the moment, each moment, joined to all the other ones in mutual nurturance. Like soil in a field or plants interconnected, singing or being at home together. This is the living fabric of proactive compassionate creation.

"Human thinking," Raven muses, *"along with human knowing and realization, feel like intrusions, manufactured details that are simply reductive subjectivities that in their flow are little more than the posturings of self-serving narcissism. Our long-time friend and colleague*

Frédérique (Apffel-Marglin, 1998), whose voice I hear in a nearby chakra, speaks of Rengifo's insistence that all parts of creation are persons, not subjects or objects. If we let them imprison us and change us, words will replace our continuity in the natural world."

"Yes!" Coyote pipes up. "*Words talking endlessly about other words; that is Western education, westernized education. Language talking about itself and not engaging with the living world but with an invented conceptual world. A representational abstraction.*"

Rodrigo smiles, "*We do not want to all think the same way, but ceremony and ritual, these are places of shared heterogeneity. And some things are refrains, choruses; they seem to be clichés but only the words of them are. How does he keep up this quick pace; he's in his 70s, it's mid-morning, he's been up for four hours and hasn't even had breakfast.*"

Frédérique, whom we can see up the steep trail, has heard our exchange and joins in:

One of the most crippling implications of the rejection of the reality of this living, sentient and numinous cosmos and our integrality with it is for finding our way out of the present global ecological and climate crisis that threatens the very survival of countless species, including our own, and of the planet as we know it.

(Apffel-Margin, 2020, p. 13)

All of these thoughts are whirling everywhere and Rodrigo lets them go over his head because he knows he needs to always be in connection with the living manifest and mystical worlds and not just speaking words about them—namings and representations. The talkers who do not engage in silence are terrified of its power, authenticity, and compassion which cannot be captured by language or by knowing. Rodrigo walks on steadily with our talk swarming; he needs to just be a good citizen of the jungle. Not of the word or the naming of the "jungle," but the conversational partner and activist of that of which each of us is eternally a part.

Every member of every species in the vast rainforest, in any forest community, knows when a stranger, a visitor, enters its domain of interbeing. The flow changes. A short circuit happens immediately to every cell, every atom of the whole-in-part. The rhythms within the whole become interrupted. I am reminded of our revered elder and hereditary *St'at'imc* hereditary chief, Tenas Lake, Clarke Smith (personal communication, 2017) who talks about all parts of the forest knowing the thoughts and feelings of strangers that enter but are especially alert to malign intentions.

Coyote says, "*Indigenous artist and storyteller Ella Noah Bancroft (2021) of the Bundjalung nation in Australia writes that humanity needs to do a 'returning', walking on the earth at a slower, more gentle, pace so that we are able to reconnect and converse once again with our collective human and other-than-human communities.*"

"*Yes, Coyote,*" Raven says, "*humanity needs to walk away from the cultural trance induced by the progress narrative of modernity and its high-tech dystopia. This means re-learning the reciprocal and mutually nurturing human/more-than-human interdependent entanglements, intimate ecopedagogies of place that can profoundly affect all life on our finite planet.*"

"*Come along then,*" says Rodrigo, "*let's pick up the pace, that chakra's not going to hoe itself.*" Jollity all around …

Kukwstum̓c

References

Apffel-Marglin, F. (1998). Introduction. In F. Apffel-Marglin (Ed.), *The spirit of regeneration: Andean culture confronting western notions of development* (pp. 1–50). St. Martin's Press.

Apffel-Marglin, F. (2020). *Contemporary voices from Anima Mundi: A reappraisal.* Peter Lang.

Bancroft, E. N. (2021, October 21). Indigenous and feminine wisdom: An interview with Ella Noah Bancroft. *Local futures: Economics of happiness.* https://www.localfutures.org/indigenous-and-feminine-wisdom-an-interview-with-ella-noah-bancroft/

Cage, J. (1961). *Silence: Lectures and writings.* Wesleyan University Press.

Grillo, F. E. (1998). Development or decolonization in the Andes? In F. Apffel-Marglin (Ed.), *The spirit of regeneration: Andean culture confronting western notions of development* (pp. 193–243). Zed Books.

O'Riley, P. (2003). *Technology, culture and socioeconomics: A rhizoanalysis of educational discourses.* Peter Lang.

Rengifo, V. G. (1998). Education in the modern west and in Andean culture. In F. Apffel-Apffel & F. Marglin (Ed.), *The spirit of regeneration: Andean culture confronting western notions of development* (pp. 172–192). Zed Books.

Chapter 9

My Responsible Stewardship of a Place:
The Mother Tree Taught Me How

Kwang Dae (Mitsy) Chung

Elder trees provide an anchor for the diverse structure of the many-sized trees in their neighborhoods. These Elders are important not just as habitat for the many plant, animal, fungal, and microbial creatures that live in the forest, but also the people who depend on the woods for their cultures and livelihoods.

<div align="right">(Simard, 2017, p. 67)</div>

A/r/tographic inquiry as stewardship

Walking in the early morning and making art with natural materials has been my daily a/r/tographic inquiry for many years.[1] On my walks, I do not simply move my feet to transfer my body from one point to the next. I mindfully attune and respond to the forest's wisdom. I walk without expectations and without a plan. This is my time to dialogue with the air that dances around me, the animals that cross my path, and the plants that grow along the trail near my home. Where I live in North Vancouver on Canada's west coast, on the unceded traditional and ancestral territories of the Musqueam, Squamish, and Tsleil-Waututh Nations, I walk and make art as a practice of responsible stewardship, learning from the "mother tree" in my neighbourhood forest.

Mother trees are the "majestic hubs" of the forest that "pass their wisdom to their kin, generation after generation" (Simard, 2017, p. 6). In this essay, I would like to share my relationship with the humans and the more-than-humans I encountered on my daily inquiry, particularly the Mother Tree. Needless to say, I cannot hear the voices of trees. However, by being present and bodily engaging with the Mother Tree, I open myself up and let the tree show me her ways of being and living with humans and more-than-humans. Thus, I constantly ask myself, What does the Mother Tree want to teach me? What can I learn from her?

Most students in school can hear their teacher's voice, but apart from the obvious sounds of water and wind, bird calls or the howling of animals, we often cannot hear the more-than-human voices of the natural world. However, as phenomenological, post-human, decolonizing, and Indigenous perspectives (e.g., "First Peoples Principles of Learning," First Nations Education Steering Committee, 2012, in Government of British Columbia, 2019, p. 14) are increasingly becoming respected and valued, teachers might consider inviting their students to attune to nature's muted or inaudible voices. Practising this type of listening to natural phenomena requires being attentive, open-minded, respectful, and

thoughtful with others (Kimmerer, 2013). To attend or to be attuned to something is to grasp a moment and to move in a particular space and time (Greene, 2001; Kimmerer, 2013; Merleau-Ponty, 2002). Robin Wall Kimmerer (2003), a leading Indigenous scholar and member of the Potawatomi Nation, suggests that moss, for example, "and other small beings issue an invitation to dwell for a time right at the limits of ordinary perception. All it requires of us," she says, "is attentiveness. Look in a certain way and a whole new world can be revealed" (p. 10). Kimmerer (2013) asserts that humans are often seen as the youngest living creatures among all other forms of nature, such as land, trees, animals, and plants. This means that nature (the more-than-human world) plays an important role as one of humans' teachers. In this line of thinking, I ask myself: How might I become a student of nature?

My curiosity unfolds as I practice these walking events. I describe this practice as multiple layers of everyday *events* instead of a project or activity because those words imply an end result or a one-time-only presentation. Dennis Atkinson (2011) describes an event in an art education setting as a learner's individual, transformative, dynamic, and ongoing process of engaging in learning. Such an event exists in a particular situation where both discoveries and disruptions will occur. The a/r/tographical living inquiry I embark on is my learning process of *becoming* an artist, researcher, educator, writer, listener, dialoguer, and walker (Atkinson, 2011; Irwin, 2018).

John Dewey (1934) affirms that uncertainty, mystery, and the not yet known bring people to deepen their thinking and open up ongoing possibilities for learning. My way of being attentive to the land, space, time, trees, natural materials, and my own artistry invokes and provokes me to situate myself in the space in-between certainty and uncertainty, known and unknown, learning and unlearning, common and uncommon, as well as human and non-human.

Holding in mind uncertainty and the unknown, one day towards the end of the summer of 2018, I went for my daily morning walk on a local mountain trail. I came to a small bridge with a handrail on which five tiny rocks had been perfectly lined up (see Figure 9.1). The row of rocks was barely noticeable, yet it caught my attention. This moment drew me to think about how "walking allows us to be in our bodies and in the world without being made busy by them. It leaves us free to think without being wholly lost in our thoughts" (Solnit, 2000, p. 5). Following Rebecca Solnit's (2000) thinking, I stopped walking and gazed at the rocks. I also looked around the bridge and checked to see if anyone was observing my reactions. I took the encounter as an invitation from those five little rocks to experience being in the moment and dwelling with the materials, space, and time (Pacini-Ketchabaw et al., 2017) I was encountering.

After I encountered the five small rocks, I saw many people on my way home who were busy talking and checking messages on their phones. It is not my intention to critique other people's ways of walking or jogging, but it occurred to me that these people were disconnected from the natural environment. If these people were to cross the bridge where I had found the tiny rocks on the handrail, would they notice and wonder about the rocks?

Figure 9.1: Kwang Dae Chung. *Rocks*, 2019. Photograph. Vancouver. © Kwang Dae Chung.

Co-creating an outdoor atelier with the mother tree

With this question and the little rocks' invitation in my mind, on September 1, 2018, I commenced an a/r/tographic living inquiry (Irwin, 2008; LeBlanc & Irwin, 2020; Triggs et al., 2014) consisting of walking in nature and on trails near my home every day for a year. For this walking/making event, I chose an open space between an elementary school and a popular walking trail as an outdoor *atelier* (studio) where I would arrange creations using natural materials I found on my walk every day.[2]

In the open space, there was a stump that looked to me like a perfect canvas for artistic creations. In front of the stump was a tree so tall it appeared to be the Mother Tree—one of the oldest trees along the trail. Suzanne Simard (2021) calls Mother Trees Elders. In Indigenous ways of knowing, Elders always have a special role in their community and family; they are treated with respect because of "their life-long wisdom, knowledge and teaching" (Simard, 2017, p. 67). Feeling called by the Mother Tree to co-create a special place for creating invitations/provocations to our neighbours, I dialogued with her as if she were an Elder of my community listening

to my inner voice and thoughts. I asked her to watch and protect the space in which I would arrange and rearrange artistic creations over the twelve months. Promising that I would not hurt her or any being she protects, I told her I was naming her the Mother Tree of my outdoor atelier. She did not say anything, but I felt she smiled at me. Each day, just as I do when I see my family and friends, when I arrived at the Mother Tree I would touch her trunk and say "hello", and when I left the space, I touched her again and said, "See you tomorrow."

My original intention for the daily events was to arrange and rearrange creations by using natural materials—the leaves, acorns, petals, and sticks I found during my daily walks—to provoke other people to attentively stop and wonder at my invitations in nature. This intention, which had been sparked by the five small rocks I encountered, turned into unexpected and transformative ontological practices (LeBlanc & Irwin, 2020). Through walking, making, thinking, wondering, and intra-acting (Barad, 2007) with others both human and more-than-human throughout the year, I dwelled on the question of how I could live in the space with nature and others—children, their parents, elders, joggers, bikers, bears, coyotes, deer, birds, bees and dogs—in a way akin to Indigenous ways of knowing and learning (Kimmerer, 2003, 2013; McCoy et al., 2017; McKenzie & Bieler, 2016).

The practice of a/r/tographic living inquiry is not designed to find predetermined answers and acquire knowledge but seeks a "movement of art and pedagogical practices" (Irwin, 2008, p. 37). In this line of thinking, each daily walking event mapped my making, thinking, and dialoguing and became multiple layers of creative events (O'Sullivan, 2006). The ongoing process of making, learning, thinking, interconnecting, and becoming involves wondering and "questioning where artistic contexts, materials and processes create transformative events, interactive spaces in which the reader/viewer/audience can co-create in meaning-making" (LeBlanc & Irwin, 2020, p. 3). Thus, a/r/tographical living inquiry allows me to become an artist, researcher, educator, writer, and listener. As a becoming-artist–researcher–educator–writer–listener, I invite others, both human and more-than-human, to engage with my learning process, to enter aesthetic spaces alive with potential for wonder and discovery and to emphasize emergence and what might be learned through this emergence (Irwin, 2008; Lasczik Cutcher & Irwin, 2018; LeBlanc & Irwin, 2020; Lee et al., 2019). Lasczik Cutcher and Irwin (2018) write that:

A/r/tography happens when individuals feel the potential of what it means to embrace the identities of artist, researcher and educator simultaneously, not as a self-indulgent preoccupation, but as a means to ongoing living inquiry through the rich processes of doing, thinking, and making—those processes of engagement that link us to one another ecologically, aesthetically, culturally and historically.

(p. 132)

My practice was to gather natural materials on my walks and arrange them in my outdoor atelier (see Figure 9.2) as an embodied, mindful process to open potentialities of thinking, feeling, touching, listening, smelling, and moving (Lee et al., 2019). As I describe my practice throughout this chapter, I keep the following questions in mind: What does a/r/tographic

Figure 9.2: Kwang Dae Chung. *Mitsy's outdoor atelier*, 2019. Photograph. © Kwang Dae Chung.

living inquiry teach me about daily practice, not as an end result but as a deeper process of connecting with material experiences, ideas of land stewardship and spatial, temporal, and cultural differences along the way? By walking, making, engaging, listening, talking, and intra-acting with natural phenomena—the space, the land, and the mother tree—how do I co-create a space where I aesthetically engage in experiences connected with ecological, temporal, and cultural differences in ways that make me a steward of this place? With these questions, I hope that readers will walk alongside my attention, senses, visions, and words and wonder how this event is diffractive (Barad, 2007), messy, disruptive, and uncomfortable (Irwin, 2018).

Responsible relationality: Ethics of care

Before sharing two stories of my encounters with humans and more-than-humans, I would like to rethink how I understand this a/r/tographic living inquiry through post-human and *intra-active* (Barad, 2007) perspectives, as well as engaging in an *ethics of care* (Dahlberg &

Moss, 2005; Tronto, 1998) to respect ecological, temporal, and cultural differences. LeBlanc and Irwin (2020) state that "a/r/tographical research places emphasis on agency and the human and nonhuman interrelationships that shape our understanding" (p. 2), cultivating responsible stewardship as well as the desire to care for both the human and the more-than-human world. To understand and care for nature, others and my own practices, I used only natural materials that I found on the ground on my walks, rather than breaking off or picking leaves or flowers that were still living. Fisher and Tronto (1990) define care in this way:

> Care is a species activity that includes everything that we do to maintain, continue, and repair our world so that we can live in it as well as possible. That world includes our bodies, ourselves, and our environment, all of which we seek to interweave in a complex, life-sustaining web.
>
> (p. 40)

I chose to engage in repetitive acts of walking–making–remaking and entangling with others to attentively, responsibly, responsively, relationally, and committedly care, not only for my own acts, my neighbours, and other walkers but also for the land, space, animals, insects, and time (Dahlberg & Moss, 2005; Tronto, 1998). My careful approach was not a set of rules of what to do or what should be. Rather than being an event for pleasing my neighbours with my creations in nature, it was a process of becoming, committing, diffracting, listening, and responding to everyone's and everything's actions and reactions (Irwin, 2018; LeBlanc & Irwin, 2020). With this thinking and practising in mind, I share with you a day when I encountered wild animals and children in my outdoor atelier.

Unfolding with the Other

Building a relationship with the Other,[3] both human and more-than-human, is how I recognize my similarities and differences with the Other (Dahlberg & Moss, 2005). Especially when I recognize differences with the Other, I unfold myself into the Other and responsibly, respectfully, and responsively listen to and understand the Other. Thus, I grasp the Other. Then, my knowledge becomes ways of knowing and moving with the Other, because the Other and I become collaborators and coexist in the moment.

When I walk on local trails surrounded by nature, I greet everyone, such as dogs, cats, birds, squirrels, deer, snails, butterflies, and plants that cross my sight. My way of greeting is not always verbal; sometimes I wave my hands, nod my head, or smile at them. For instance, when I encounter tiny flowers or new spring greens and buds, I get close to them and say, "You are so pretty" or "Thank you for letting me know your new green." This is my way of saying "I see you. I care about you. And I feel thankful." Sometimes, when people see me talk to nature, they come to me and ask, "What is there?" Or, if they do not ask me, they might look at me with a puzzled face.

Kimmerer (2013) shares how she engages and talks with plants in her book *Braiding Sweetgrass*. There she introduces her guidelines for honourable harvest, which are:

Know the ways of the ones who take care of you, so that you may take care of them.
Introduce yourself. Be accountable as the one who comes asking for life.
Ask permission before taking. Abide by the answer.
Never take the first. Never take the last.
Take only what you need.
Take only that which is given.
Never take more than half. Leave some for others.
Harvest in a way that minimizes harm.
Use it respectfully. Never waste what you have taken.
Share.
Give a gift in reciprocity for what you a have taken.
Sustain the ones who sustain you and the earth will last forever.

(p. 183, original emphasis)

Kimmerer writes that these guidelines "are reinforced in small acts of daily life" (p. 183). During my a/r/tographical living inquiry from 2018 to 2019, I did not know about the guidelines for honourable harvest. However, I always attempted to encounter nature in respectful ways. When I collected some leaves or flower petals that had fallen from trees or plants and landed on the ground in my outdoor atelier, I always said, "Thank you for sharing your leaves" to the trees. Or when I arrived at a place that was covered in bright red autumn leaves, I was naturally excited and shook my body to share my excitement with the tree. I could imagine the tree's voice: "Here you are! We were waiting for you! Please take some leaves before the gardener clears them away. Use mine for your creation today." While my imagined dialogues tend to impose a human idea of communication on the situations, trees and other forest beings communicate in ways I can never be privy to (Kimmerer, 2013; Simard, 2017; Wohlleben, 2015). I can only pretend to understand the dialogues and signals trees send each other.

Entangling with the more-than-human: Coyotes

In the late spring while I was doing this inquiry, an Indigenous friend told me that both nature and animals can feel our feelings and our voices. According to my friend, if humans care about nature and animals and show respect to them, Mother Nature, even in the form of a bear, will not hurt humans. A few days after I received this teaching, I encountered a coyote that was almost the size of a big wolf. A few of my neighbours had also told me that they saw a few coyotes as well as a bear. Therefore, I had been cautious as I walked on the trail and made my artistic creations at my outdoor atelier, but when I encountered the coyote, I doubted my sight.

The moment I saw the coyote, I was carefully placing flower petals on the ground to complete the day's creation. I could feel something close to my body. I had the feeling it was not a human. I slowly and carefully turned and looked up. There was a coyote standing right in front of me and looking at me with curiosity. Even though I had heard that coyotes were around, I did not expect to encounter one at such a close distance. I was surprised, and my body jumped. My sudden movement surprised the coyote, and she jumped up and stepped back. I stopped my making, stood up, and told her, "So sorry if I scared you, but I would like to let you know you scared me, too. I am just creating something to provoke my neighbours and I do not have any food that you like. See? I have only flower petals." I showed the coyote the flower petals that I held in my hands. "I will not hurt you. So, could you please go back to your home or some other place?" I was not sure the coyote understood what I said, but I could see she was listening to my voice, and she slowly walked back and away from my atelier.

When the coyote left the space without any conflicts between us, I recalled what my Indigenous friend had said: "If we show our respect and do not hurt Mother Nature, nature will not hurt humans." I now also think with Karen Barad's (2007) ideas about diffraction. Both the coyotes and my actions and reactions, or our existences, can be understood as performances of agency. This means that the coyote and I, in our encounter, were part of the performative production of power in an entangled and unfolding relationship of intra-activity between humans and more-than-humans. Barad (2007) explains:

> According to agential realism, knowing, thinking, measuring, theorizing, and observing are material practices of intra-acting within and as part of the world. What do we learn by engaging in such practices? We do not uncover preexisting facts about independently existing things as they exist frozen in time like little statues positioned in the world. Rather, we learn about phenomena-specific material configurations of the world's becoming. The point is not simply to put the observer or knower back in the world [...] but to understand and take account of the fact that we too are part of the world's differential becoming.
> (pp. 90–91)

Therefore, both the coyote and I were intra-acting within and as a part of differences that emerged within the phenomenon, but we were not absolutely separated from each other because we were walking on, living on, and sharing the same land.

Assembling and attending to common worlds: Grownups/children/non-humans

As I follow the line of thought of the differences among humans and more-than-humans, I now approach "the worlding effects of human / more than human relations" (Taylor & Giugni, 2012, p. 109). Here, we humans are asked: "How do we live well together with others?" or "How do we flourish well with others, both human and more-than-human?"

These are great questions, but do we really understand them? Do we know what it means to live well together?

During my walking/making events, I continually asked myself these questions, because the events did not always respond or move forward the way I wished, or how I might have wanted my neighbours to respond, or in the way I fantasized the relationship between humans and nature (Taylor, 2013). Every moment of my inquiry was unpredictable; I did not know how humans and more-than-humans would respond, react, or act upon my daily events. Anna Tsing (2015) states that "unpredictable encounters transform us; we are not in control, even of ourselves. Unable to rely on a stable structure of community, we are thrown into shifting assemblages, which remake us as well as others" (p. 20). This line of thinking made perfect sense during these walking events because they involved ongoing entanglements, complications, disruptions, and diffractions of human/human and human/more-than-human relationships.

When my neighbours found the outdoor atelier and my daily artistic invitations, I heard many positive responses. During the events, I was just one among the other walkers. I purposely did not identify myself as the nature artist of the outdoor atelier. I tried to physically hide myself from others as much as possible because I did not want my external identity as a small Asian girl to influence others' thinking, responses, interactions, and engagements with my nature creations. If people enjoyed my creations and saw them as beautiful, that was fantastic. However, I did not intend them as representations of beauty, or as art, or to please people. Rather, I was thinking through and moving with other people's, and nature's, flux and flow (Tsing, 2015).

Even though I heard much positive feedback from others, I also encountered moments/days when my creations had been destroyed, damaged, or dismantled. I did not point to who did this. Some neighbours who were also frustrated with these disruptions recommended that I set up a camera to capture the people who had vandalized the space. However, I did not, because I believe, with Tsing (2015), that "the unplanned nature of time is frightening but thinking through precarity makes it evident that indeterminacy also makes life possible" (p. 20). Although I had expected to experience such difficult moments, it was not always easy. At these times, I always looked up to my mother tree and asked, "What can I do? Should I quit this? Or should I keep doing it?" The mother tree always quietly replied, "This is your commitment. It is not about who and what are right or wrong."

While I was struggling with these difficult moments, one day when I was finishing up the day's making and taking photos for my visual journal, a woman who did not know I was the artist came and said, "Have you seen these beautiful nature arts? I love them. And did you know they were made by children?" I said, "Really? Do you know the children who made them?" The woman responded,

> No, I have not seen the person or people who have been doing this, but you know there is an elementary school right there, and children always walk by this path. Adults never do these things. These are children's things.

I was interested in the romanticized notion of children that the woman held, so I said, "Really? I know a few nature artists who are adults who do these things as well. I have also seen children, dogs and mountain bikers who run across the nature atelier and damage the creations." The woman looked at me with surprise and walked away.

Just as the woman didn't know who had made the creations, I had no idea who disrupted them. However, the woman's comments led me to reflect on the common world (Taylor, 2013) framework that was developed to reconceptualize inclusion in early childhood communities of all others, both humans and more-than-humans. According to reconceptualist early childhood scholar Affrica Taylor (2013), "common worlds are worlds full of entangled and uneven historical and geographical relations, political tensions, ethical dilemmas and unending possibilities" (p. 62). Taylor and her colleagues in the Common Worlds Research Collective (https://commonworlds.net/) encourage educators to rethink historically romanticized images of child–nature relationships. From a common worlding perspective, humans (children and adults) and more-than-humans (land, plants, trees, water, air, and animals) intra-act (Barad, 2007; Taylor, 2013) within natural phenomena, leaving humans to grapple with questions about their relationships with others. In this line of thinking, everything that I encounter and all of my entanglements with others are perfect examples of how humans intra-act and live respectfully together (or not) with other humans and with more-than-humans.

Learning, thinking, and practising how to respectfully, responsibly, responsively, pedagogically, and dialogically live with differences (among both humans and more-than-humans) allows me to flourish with/through Others (Haraway, 2016; Taylor, 2013) in what Margaret Somerville (2007) refers to as *the contact zone*. Somerville's ideas support my practices; she declares that "negotiating difference in the contact zone [is] precarious, risky and difficult emotional work but it [is] also a place of productive tension based on difference and generative of new ideas and possibilities" (p. 14). Therefore, my progress amid multiple layers of temporal movement, thought, action, and response provides an ongoing learning space and time for becoming an artist, researcher, educator, and walker.

Composing the multiple walking events

Starting these walking/making events from the invitation of the five small rocks, this a/r/tographic living inquiry helped me understand the importance of unfolded commitments, as well as learning *with* others, both human and more-than-human, and becoming co-walker, co-creator, co-thinker, and co-learner with others within and through unsettled and unpredictable phenomena. As a result of my encounters with humans and more-than-human Others, as well as with learning through Indigenous ways of knowing, my a/r/tographic living inquiry shifted from individual learning to a process of becoming more pedagogical and responsible with all beings in my local community.

As a student of nature, my entanglements in human and more-than-human relationships during my mindful walking/making events allowed me to cocreate an unromanticized but

Figure 9.3: Kwang Dae Chung. *Honouring the mother tree*, 2019. Photograph. Vancouver. © Kwang Dae Chung.

spiritual and aesthetic space–time in the outdoor nature atelier (see Figure 9.3). To practice responsible stewardship of the place, I wondered about and thought with my Mother Tree. My time with the Mother Tree nurtured my practices and my mind, just as human Elders connect with and teach their kin across generations (Simard, 2017). I now hope this chapter will spark your own ideas as you walk—spiritual, immersive, and artistic ideas—as well as your own stewardship of nature.

Notes

1. According to Irwin (2008), a/r/tography starts with being and maybe is all about being. About being, Jean-Luc Nancy (2000) states:

 Being itself is given to us as meaning, Being does not *have* meaning. Being itself, the phenomenon of Being, is meaning that is, in turn, its own circulation—and we are this circulation. […] *Meaning*

> *is itself the sharing of Being.* [...] Being cannot be anything but being-with-one-another, circulating in the *with* and as the *with* of this singularly plural coexistence.
>
> (Nancy, 2000, pp. 2–3, original emphasis)

2. I purposely do not use the word *art* to describe my daily creations because everyone's ways of seeing, understanding, and defining *art* are different. I would like to avoid forcing my readers to think of my creations/invitations/evocations/provocations as *art*.
3. The philosophy of the Other is at the heart of the work of the French philosopher Emmanuel Levinas. Dahlberg and Moss (2005) write:

> For Levinas, in the face-to-face relation the Other is absolutely other. This is an Other which I cannot represent and classify into a category and hence not totalize. The face-to-face encounter ruptures my ego, eludes thematizations and formations and dissolves the capacity to possess and master the Other. Instead of grasping, I have to take responsibility for the Other: and this relation is one of welcoming, a welcoming of the other as stranger.
>
> (p. 80)

References

Atkinson, D. (2011). *Art, equality and learning: Pedagogies against the state*. Sense.

Barad, K. (2007). *Meeting the universe halfway: Quantum physics and the entanglement of matter and meeting*. Duke University Press.

Dahlberg, G., & Moss, P. (2005). *Ethics and politics in early childhood education*. Routledge Falmer.

Dewey, J. (1934). *Art as experience*. Perigee.

Fisher, B., & Tronto, J. (1990). Towards a feminist theory of care. In E. Abel & M. Nelson (Eds.), *Circles of care* (pp. 35–62). SUNY Press.

Government of British Columbia. (2019). *British Columbia early learning framework*. Ministry of Education, Ministry of Health, Ministry of Children and Family Development, & British Columbia Early Learning Advisory Group.

Haraway, D. (2016). *Staying with the trouble: Making kin in the Chthulucene*. Duke University Press.

Irwin, R. (2008). A/r/tography as practice-based research. In S. Springgay, R. L. Irwin, C. Leggo, & P. Gouzouasis (Eds.), *Being a/r/tography* (pp. 71–80). Sense.

Irwin, R. L. (2018). Walking to create an aesthetic and spiritual currere. In M. R. Carter, & V. Triggs (Eds.), *Arts education and curriculum studies: The contributions of Rita L. Irwin* (pp. 120–130). Routledge. https://doi.org/10.4324/9781315467016

Kimmerer, R. W. (2003). *Gathering moss: A natural and cultural history of mosses*. Oregon State University Press.

Kimmerer, R. W. (2013). *Braiding sweetgrass: Indigenous wisdom, scientific knowledge, and the teachings of plants*. Milkweed Editions.

Lasczik Cutcher, A., & Irwin, R. L. (2018). A/r/tographic peripatetic inquiry and the flâneur. In A. Lasczik Cutcher & R. L. Irwin (Eds.), *The flâneur and education research: A metaphor for knowing, being ethical, and new data production* (pp. 131–153). Springer.

LeBlanc, N., & Irwin, R. L. (2020). *A/r/tography*. Oxford University Press. https://doi.org/10.1093/acrefore/9780190264093.013.393

Lee, N., Morimoto, K., Mosavarzadeh, M., & Irwin, R. L. (2019). Walking propositions: Coming to know a/r/tographically. *The International Journal of Art & Design Education*, *38*(3), 681–690. https://doi.org/10.1111/jade.12237

McCoy, K., Tuck, E., & McKenzie, M. (2017). *Land education: Rethinking pedagogies of place from Indigenous, post-colonial, and decolonizing perspectives*. Routledge.

McKenzie, M., & Bieler, A. (2016). *Critical education and sociomaterial practice*. Peter Lang.

Merleau-Ponty, M. (2002). *Phenomenology of perception*. Routledge.

Nancy, J. L. (2000). *Being singular plural* (R. D. Richardson & A. D. O'Byrne, Trans.). Stanford University Press.

O'Sullivan, S. (2006). *Art encounters Deleuze and Guattari: Through beyond representation*. Palgrave.

Pacini-Ketchabaw, V., Kind, S., & Kocher, L. L. M. (2017). *Encounters with materials in early childhood education*. Routledge.

Simard, S. W. (2017). The mother tree. In A.-S. Springer & E. Turpin (Eds.), *The word for world is still forest* (pp. 67–71). K. Verlag and the Haus der Kulturen der Welt.

Simard, S. W. (2021). *Finding the mother tree: Discovering the wisdom of the forest*. Allen Lane.

Solnit, R. (2000). *Wanderlust: A history of walking*. Penguin Books.

Somerville, M. (2007). Space and place in education: (Still) speaking from the margins. Paper presented at Australian Association for Research in Education, Freemantle, Western Australia, November 26–29. http//www.aare.edu.au/07pap/som07563.pdf

Taylor, A. (2013). *Reconfiguring the natures of childhood*. Routledge.

Taylor, A., & Giugni, M. (2012). Common worlds: Reconceptualising inclusion in early childhood communities. *Contemporary Issues in Early Childhood*, *13*(2), 108–119.

Triggs, V., Irwin, R. L., & Leggo, C. (2014). Walking art: Sustaining ourselves as arts educators. *Visual inquiry: Learning and Teaching Art*, *3*(1), 21–34.

Tronto, J. C. (1998). An ethic of care. *Journal of the American Society on Aging*, *22*(3), 15–20.

Tsing, A. L. (2015). *The mushroom at the end of the world: On the possibility of life in capitalist ruins*. Princeton University Press.

van Manen, M. (2014). *Phenomenology of practice: Meaning-giving methods in phenomenological research and writing*. Left Coast Press.

Wohlleben, P. (2016). *The hidden life of trees: What they feel, how they communicate: Discoveries from a secret world*. David Suzuki Institute.

Grounding

Opening the Gate

Yasmin Dean

Leaving, Speaking, Listening, Watching, Moving, Arriving
In what order?

How to reach the sacred?
Walking home begins with the first step of leaving the nest
Leaving, Speaking, Listening, Watching, Moving, Arriving
In what order?

When earth is thanked,
Torji gate opens
Leaving, Speaking, Listening, Watching, Moving, Arriving
In what order?

When walked barefoot,
Journeys last longer
Leaving, Speaking, Listening, Watching, Moving, Arriving
In what order?

Markers show Kumano, 'not Kumano'
Giving way is the challenge
Leaving, Speaking, Listening, Watching, Moving, Arriving
In what order?

So many routes
A network of trees
Leaving, Speaking, Listening, Watching, Moving, Arriving
In what order?

Finding home by
Leaving, Speaking, Listening, Watching, Moving, Arriving
In what order?

Thank you, Earth
May I step through?

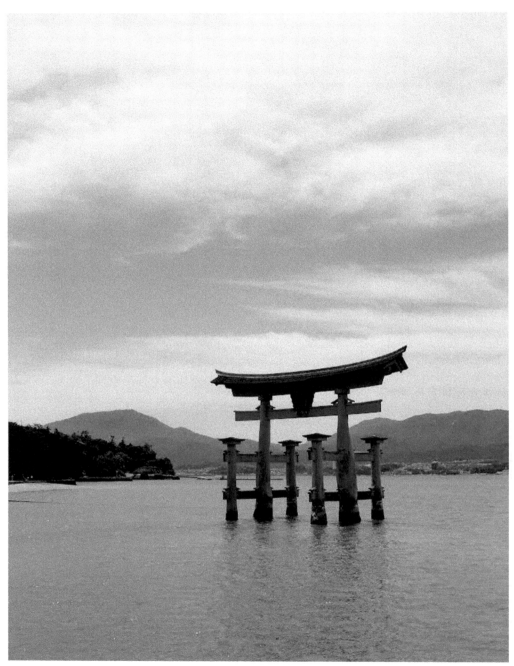

Figure G10.1: Yasmin Dean. *The gate*, 2020. Photograph. Vancouver. © Yasmin Dean.

Chapter 10

Collapsing Landscapes:
Walking as Acts of Belonging and Becoming

Tormod Wallem Anundsen

This is a story of three walks and three landscapes in Norway. Or, in fact, three stories of belonging and becoming in and with landscapes. In this chapter I ask, what do walking and memories of walking establish in a landscape? Or what do the landscape and memories of a landscape establish for us, who walk there?

First walk: Being received

This is the starting point for this exploration; it was the landscape that received *me*. I didn't grow up here, in the South of Norway. I didn't belong here, but I live here, an adult relocating. For several years, I walked this unassuming, modest landscape of small hills and small woods near my house, day after day. I talked to it, explaining my worries, sharing my thoughts, weighing paths and solutions. And then one day, the landscape talked to me.

It was on one of my many walks, a rainy winter's day a couple of years ago that it happened. I was approaching the same small mountain top that I always walk to, in the woods near my home. Or, can I really call it a mountain? I grew up walking in the mountains of western Norway, and I learned early on to appreciate reaching a peak and taking in the vast views, filling my lungs with air and breathing the expansiveness that I felt I became part of once the summit was reached. This place where I live now, in my adult life, can hardly offer such spectacular views from high above. Yet on this little peak (or… *hill*?) I do get an overview of the nearby woods and the city centre, and a bit of the sea. It's quite nice, yet I always thought of these woods and hills as less spectacular, less of a landscape that I desire and long for, less of where I belong.

On this walk, as on most others, I reached the top, looked at the views, took a series of snapshots on my phone for my digital log, and then started recording today's reflection to go along with it. I remember there was a low overcast, wet, chilly, short sight; the landscape was not trying to impress anyone. I talked about the landscape; how it felt modest, almost unambitious, like many things here in the South. Yet as I spoke, I realized: this has become my landscape. Or rather: This unspectacular landscape has patiently received me, time and again, and made me part of it (see Figure 10.1). After living here for almost twenty years, I had a sudden and unexpected sensation of belonging, of being taken in, accepted by something modest, and real. I felt a deep gratitude. And was humbled for having preferred the grand, the spectacular landscapes, while being cared for by the modest, the gentle, the long-term everyday practice; the repeated routes I had walked without taking too much notice of them.

Figure 10.1: Tormod Wallem Anundsen. *These modest hills,* 2020. Photograph. South Norway. © Tormod Wallem Anundsen.

Ritornello and territory

How can I understand such an experience of walking and belonging? When Deleuze and Guattari discuss *territorialization*, how a sense of home and belonging is established (either that represents physical, discursive, virtual, etc. landscapes), they stress the connection to *ritornello*: how repeated actions establish a territory (Deleuze & Guattari, 1987). Could this be a way to understand this sudden experience? Had my repeated walking become a ritornello that enabled a new belonging in a landscape, a new sense of home, even *creating* a territory; the landscape as my home? What I do not immediately recognize is the apparent possessiveness of the term "territory," and how "ritornello" may at first glance seem like the idea of a subject acting to create the territory. Because this was not experienced as me creating a landscape to belong in, but rather the other way around; that the landscape, by receiving me, created a different subject, one that belonged. Arjen Kleinherebrink (2015) points to more dynamic nuances in these terms, arguing that "territory" in Deleuze and Guattari's conceptualization is not to be understood as a fixed area, neither as something created *by* a subject, but as an interplay from where subjectivity may "emerge":

> Furthermore, there can never first be a human subject that then constructs a territory. Instead, Deleuze and Guattari argue that subjectivity can only emerge from the interrelation of expressive qualities that constitute a territory.
> (Kleinherenbrink, 2015, p. 220)

Taking this perspective, the relevance of the concepts becomes more apparent: the relation between ritornello and territory demonstrates that repeated actions enable belonging, and also establish the "place" to belong. Or, in other words: home, as well as belonging, is something you *do* rather than something that *is*; it is a practice rather than a place or a state. Could walking be such a practice, a mobile practice of belonging and becoming?

Second walk: Collapse

My new friend and I walk together, in a landscape I don't know, but still in the South; the same modest hills. We have just met, a fresh encounter between a middle-aged and an old man, both avid walkers. We talk, we share our experiences, our joy of walking, discuss shoes and the landscape we pass through; the buildings at first ("Look at the construction of that roof! The way they build nowadays is not like […]"), then the sea, and the woods and hills. He guides me through the landscape. Then he tells me about his walking in the West, where he grew up, where he belongs—used to belong—in the landscape (see Figure 10.2).

I enjoy his company, and I relish listening to the sound of his voice. I take it in; the melody of his dialect. It is exactly how the fathers and grandfathers of my friends spoke, there, in the West, where I relocated as a child. He has that sound of those who belonged, those whom I thought of as rooted in the landscape; farmers, teachers, and families with a local history. They say children adapt easily, but I was already too old, eleven years.

Figure 10.2: Tormod Wallem Anundsen. *Co-walking*, 2020. Photograph. South Norway. © Tormod Wallem Anundsen.

I couldn't change the way I talked, the melody, the sounds, the laid-back style, the way the tongue would insert an "s" into a word, softening it up, moisturizing it; "itsje." I said "ikke." Stretched it to "ikkje." That was as far as I managed to go. I tried changing my sounds and my words, but I couldn't change the melody, the way the voice meandered up and down carelessly, knowingly. Like the landscapes of the West; hilly, lush, moist.

The South African anthropologist Julian Kramer (1984) claims that Norwegian identity primarily is rooted in the local and that this local "rootedness" is signified through speech, the sound of a dialect. I was painfully aware long before reading the theory; I could change the words but not the detailed tone of the voice that was typical for this region; how an utterance would start on a high note to move in arches down towards the pause of a sentence, then to rise to a new arch again, yet on a lower pitched tone than the first, or—if expressing something of more importance—an even higher note. And how the end of a sentence—at least in my walking companion's way of speaking, in his dry and witty remarks—would decrescendo towards a careful hint, an understatement that would be left hanging in the air. This is not just a dialect, it is a way of communicating to insiders, where some words are not spoken, they are just hanging there. I was never an insider.

As we walked, we kept talking about the western landscape, from that place where I became a teenager, and the mountain that he always walked to as I eagerly asked him about the routes he used to follow, placing myself in his landscape through my memories of the landscapes and routes that I had followed too. And after about an hour, as we approached a top, a small peak, he pointed and told me: this was it. "We just cross over there and come down on the fields on the other side." I hesitated and tried to brush off the misconception without stopping him. He sped up his walking, as to shake off my gentle attempts at bringing him back to *this* landscape, reaching the peak before me, searching through the chaparral, insisting on finding the path he knew was there. We approached a cliff, and I stayed close, literally shoulder to shoulder, ready to grab him should he fall, yet trying not to block his new, forceful initiative, trusting his sense and experience of moving in such landscapes: An experienced walker like him wouldn't jump off this cliff. We looked down over the edge together. Confused, he saw what I saw: there were no fields, no trail down on the other side; it was not the right peak. His landscapes had collapsed; the western mountains he loved merged with these southern, small hills where he now stayed and walked, to return to the nursing home again, the assisted living facility.

Is this what dementia does; collapsing our inner and outer landscapes, gradually erasing the structures that keep things apart, that distinguish between then and now, here and there? At the same time, I felt that my landscapes had also collapsed: the belonging, the sounds, the mountains in the West that I used to walk, that *he* used to walk, where he belonged and I never quite could, the sound and melody of his voice that I could never make mine. Perhaps both of us, in different ways, experienced that moving through landscapes is a constant intra-play between ourselves and the world, a constant process of becoming and belonging.[1] And if this *is*, or could be, a shared experience between persons with and without dementia,

then what are we afraid of, and why this fear to see our world, our landscapes, and our places to belong, collapse, fall inwards, become one?

On dementia and othering

I don't wish to underestimate or underplay the pain that people with dementia and their close ones may experience through the gradual processes of memory loss and possible disconnection. However, as Fletcher (2019) points out, many common approaches to dementia—with their reduction of persons with dementia and their experiences, to problems—may inflict othering and stigma. It may thus be interesting in itself to explore approaches that try to avoid such implications and to explore something else: what we may have in common with and without forms of dementia, and what we could learn from some of the encounters with dementia that could speak to our shared experiences. This is also implied when Kitwood, in "The experience of dementia" (1997), argues for a view of people with dementia as ones having relevant experiences to discuss and learn from.

For a few days in 2017 and 2019, our research group *Art and social relations* moved into an assisted living facility for people with dementia. Not to do research, but to explore what we might learn from living and interacting with the residents and employees that could change our own ways of thinking about our practices as artists, educators, and researchers.[2]

Memory and here-and-now

The function of memory is commonly divided into explicit and implicit memory. Exploring *co-singing*[3] with persons with dementia, Helene Waage writes: "Explicit memory is conscious, often intentional effort to recollect prior experiences and facts, while implicit memory involves influences of prior episodes on current behaviour—without intentional retrieval—and sometimes without conscious remembering of those prior episodes" (Waage, 2022, p.335).

Dividing memory functions into *recalling* and *recognizing* sheds light on how persons with various forms of dementia often struggle with recalling memories on their own yet may instantly recognize something that is brought to their attention. When we were singing together in the assisted living facility, the inhabitants were usually not able to suggest any songs. When we—inadvertently, forgetting the circumstances—asked for suggestions, the inhabitants would cleverly evade the tricky question: "Oh, there are so many nice songs!" But once we started out on an evergreen from their youth, many would sing along on all the verses. This is a broadly recognized experience in musical dementia care.

Thus, one thing we gradually learned from the inhabitants was this: to explore the here-and-now of our own practices, the daily activities, and encounters that don't create their meaningfulness from past memories or from accumulated or "invested" competencies and

practice, nor from the plans ahead, but from the quality of what we are doing together in the moment (Svingen-Austestad et al., 2018).

Looking to go beyond the current exhaustion of my academic life, the practice I brought to this encounter between my research group and the assisted living facility was my walking. I was happy to find a walking partner to take me out of all the supposedly "right" activities in my field. Not to theorize the activity or make any research. Actually, just because I needed to walk. My new walking companion allowed me to do so.

But a perspective arising from this experience goes beyond the here-and-now perspective. Rather, it points to *repetition* (again, the ritornello). One thing we may have in common, that we share with or without dementia, is how our walking landscapes live with us, and how we live with them. How there is an exchange going on between ourselves and the landscape that, in some way or the other, establishes both who we are, and where we belong. Just that this "belonging," the territory, may be something we take with us and bring to new physical landscapes so that when the landscapes collapse, or merge or blur into each other in our minds, it is also because *we* merge, and blur and collapse into our surroundings, our timeline, our history. So, this we might have in common; establishing and understanding ourselves through interacting with something else is a process of becoming.

Third walk: Reconstruction?

About half a year later I went to his hill, no, his *mountain* in the West. I walked his route, his walk, as he had described it to me (see Figure 10.3). I recorded it: Starting from the houses by the river on the eastern side of the mountain, crossing the fields, reaching the woods, and then, gradually, finding the trails that would follow the curves of the landscape, climbing towards the summit. It was a little longer than I expected, and a few times I lost my way; the path seemed to vanish, and I couldn't recognize the landscape from my memories or his descriptions, or even the map. After three hours, following detours and searches, I reached the peak. Breathing deeply, I took in the views of my western landscape—the fjord, the islands, the woods, mountains, valleys—imagining him by my side, through my camera (see Figure 10.3).

A couple of months later I went back to where he lived, to show him the film. It was abbreviated and highlighted. I just wanted to let him experience the landscape once again, to see how it gradually changes; first looking down on the familiar houses, then going through the woods, experiencing the changes in vegetation as we approach the peak. And then, the views from the top: Of the sea, the many islands marking the expanse of this municipality, the open fjord, and the snow-covered mountains on the other side. I could see how he tried hard to remember, to point things out, to comment on the places; "Yes, this is typical; there's a lot of trees like these. They make good timber." I sensed how he, polite as he was, tried to meet me, receive my invitation and go along, and show appreciation for my efforts.

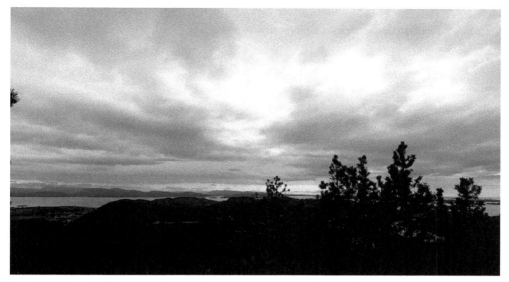

Figure 10.3: Tormod Wallem Anundsen. *Reaching his Mountain*, 2020. Photograph. South Norway. © Tormod Wallem Anundsen.

But I realized: this was not it. This was not anywhere near the experience of crossing through a landscape, merging, collapsing, and confusing. What we do when we walk when we interact, intersect, and cross through. That is something else, entirely. It is not a memory, nor a representation, but an intra-play; between people, between people and landscapes, and between landscapes. I realized we should rather get back there.

Conclusions

In this chapter, I have read different sets of experiences through and with each other; reading my experiences and my history through those of my walking companion, and his experiences of collapse with mine, and our landscapes as merging and collapsing. Space and time, we have been taught, are linear and unbreakable structures: yet that does not always correspond with how we might experience it; that time collapses, and with that what you are/what you were, where you belong/belonged, where you are/were. All of this seems to be more entangled.

I also experienced being entangled with my fellow walker, and an entanglement between his landscapes and mine, as I was brought back to the landscapes of my youth through the sound of his voice. And although his and my experiences of collapsing landscapes are by no means the same, they might still be read through one another to understand one aspect of

walking as a practice of belonging and becoming. And thus, also to see the experiences of people with dementia as relevant experiences, experiences to learn from.

Ritornello as practice

While ritornello may be a practice to establish territory, our ritornellos of walking might not be about a particular place, something rooted, but rather be a way to relate to our changing surroundings. A practice—like walking—is something we may take with us. Thus "belonging" doesn't have to be this heavy, rooted thing. Even a dialect is a way to practice a territory through melody and rhythm, much like Deleuze & Guattari (1987) claim birds do. In Norway, locality is thus not necessarily to be understood in the heavy sense of being "rooted in the soil" through generations that Kramer (1984) refers to,[4] but simply that you practice it right, that you catch the melody. You don't have to have a genealogy on site, nor to be born in the place (even though it helps); if you sound local, you are generally accepted as a local. It's performative.

A critique of Kramer's conclusion on the local, taken from stretching the performative of the sound of the voice through Deleuze and Guattari, may thus be that territory is about practising, and that we may repeat different places through a practice, collapsing different landscapes; not "belonging," as something rooted, but "becoming," as a way of relating to our varying surroundings through time.[5] And—without wanting to romanticize the experience of dementia in any way—perhaps this is still an experience that has relevance, something worth discussing and learning from: That practice—like walking—is something we take with us, and which may collapse space and time while creating both subject and territory.

Acknowledgements

I wish to thank my walking companion for walking with me, and thus for sharing his life realities with a stranger, trusting me and including me in his previous and present landscapes. I also wish to thank his family for allowing me to reflect on these experiences through this chapter. I am indebted to my Ph.D.-student-turning-colleague Helene Waage for her feedback on this chapter, and for sharing her insights into dementia research as well as discussing the theories applied in this chapter. I also acknowledge the work and input of our research group *Art and social relations* from our discussions and shared experiences in the *Inhabit* project and beyond.

Notes

1. For an elaboration of the term *intra-play*, see Richards and Haukeland (2020).

2. This project is so far only published in the self-produced "fanzine" of the research group, an experimental publication named *Bebo [Inhabit]*, rendering, in various artistic forms, the experiences the participants of the group had from inhabiting an assisted living facility with persons with dementia (Svingen-Austestad et al., 2018).
3. Waage is proposing the concept "co-singing" as a broader and more relationally oriented and inclusive term than "care(giver)-singing," and more specific than "singing," to suggest a novel approach to low-threshold singing activities with persons with dementia (Waage, 2022).
4. And although the relationships and connections between inhabitants and the "land" are interesting concepts to explore further, not least in relation to indigenous perspectives and decolonial studies (McCoy et al., 2016; Smith, 1999), we should also be aware of how claims of naturalized connections between people and land have been heavily misused, such as in the highly problematic and destructive "blood and soil" myths of the Third Reich.
5. Further perspectives on walking as practicing and *being practiced* by landscape are elaborated in Anundsen and Illeris (in press).

References

Anundsen, T. W., & Illeris, H. (in press). Inhabiting landscape: Walking as an act of practicing and being practiced. In N. Lee, M. Mosavarzadeh, J. Ursino, & R. L. Irwin (Eds.), *Material and digital a/r/tographic explorations: Walking matters*. Springer.

Deleuze, G., & Guattari, F. (1987). *A thousand plateaus: Capitalism and schizophrenia* (B. Massumi, Trans.). University of Minnesota Press.

Dolphijn, R., & Tuin, I. v. d. (2012). *New materialism: Interviews & cartographies*. Open Humanities Press. http://www.openhumanitiespress.org/books/titles/new-materialism/

Fletcher, J. R. (2019). Destigmatising dementia: The dangers of felt stigma and benevolent othering. *Dementia*, *20*(2), 417–426. https://doi.org/10.1177/1471301219884821

Kitwood, T. (1997). The experience of dementia. *Aging & Mental Health*, *1*(1), 13–22. https://doi.org/10.1080/13607869757344

Kleinherenbrink, A. (2015). Territory and ritornello: Deleuze and Guattari on thinking living beings. *Deleuze Studies*, *9*(2), 208–230. https://doi.org/10.3366/dls.2015.0183

Kramer, J. (1984). Norsk identitet – et produkt av underutvikling og stammetilhørighet [Norwegian identity – A product of underdevelopment and tribal belonging]. In A. M. Klausen (Ed.), *Den norske væremåten [The Norwegian way of being]* (pp. 88–97). Cappelen.

McCoy, K., Tuck, E., & McKenzie, M. (2016). *Land education: Rethinking pedagogies of place from Indigenous, postcolonial, and decolonizing perspectives*. Routledge.

Richards, B., & Haukeland, P. I. (2020). A phenomenology of intra-play for sustainability research within heritage landscapes. *Forskning og Forandring*, *3*(2), 27–46. https://doi.org/https://doi.org/10.23865/fof.v3.2406

Svingen-Austestad, A., Valberg, T., Illeris, H., Amundsen, E. L., Anundsen, T. W., Dalgård, L., Näumann, R., Fossnes, A.-M., Hansen, L. I. M., Kvist, P., Skregelid, L., & Øgård-Repål, A. (2018). *Bebo [Inhabit]*. Art and Social Relations Research Group, University of Agder.

Smith, L. T. (1999). *Decolonizing methodologies: Research and indigenous peoples*. Zed Books.

Waage, H. (2022). *Co-singing in families living with dementia*. In R. V. Strøm, Ø. J. Eiksund, & A. H. Balsnes (Eds.), Samsang gjennom livsløpet [Co-singing through the life course], (pp. 327–354). Cappelen Damn Akademisk. https://press.nordicopenaccess.no/index.php/noasp/catalog/book/162

Grounding

Mihšwēndam dakīn ohtē kowōndosayān—"I Love the Land From Where I Come"

Benjamin Ironstand

M*ihšwēndam dakīn ohtē kowōndosayān*—"I love the land from where I come." *Nīn Anihšinābē inini, Tootinaowaziibeeng n'dōndisē*—"I am an Anishinaabe man," Valley River is where I am from. Being back home on my reserve, there is nothing quite like it. When visiting *nōhkō* and *nimihšōmihš* ("my grandmother and grandfather") I'd wake up early in the morning, when the dew is still on the grass and the house is sleeping. I'd tiptoe through across that old floor so I wouldn't wake anyone up, then I'd slip outside and fill my nostrils with a deep breath of sweet fresh air before I'd wander into *sagakwang* ("the bush"). Depending on the day I might explore, walk and pray, or sometimes I'd hunt.

Being in the bush and hunting, you make a connection with the animal. I was taught once after walking through the thick bush and then reflecting afterwards on how difficult it was. Then I was told to apply that to how an animal would feel if it had a big rack how it would have to manoeuver, and if it was being chased or followed, how it would be stressed. And it's true. Tracking or searching for a buck, you gain an appreciation for its cunning, endurance, and agility, and its simple desire to live. When walking up on an animal, you can feel it; you don't want him to be afraid. Working with them and harvesting them, you get up close and personal and see how beautiful they really are. There is a bond that is made with them through the whole process and it carries forward. It carries into the food that you make, the drum that you stretch, or the art you create *with* them.

I had an opportunity to paint some tipi liners and one of my pieces reflected some of these understandings and the danger that happens when that relationship and understanding is lost or forgotten.

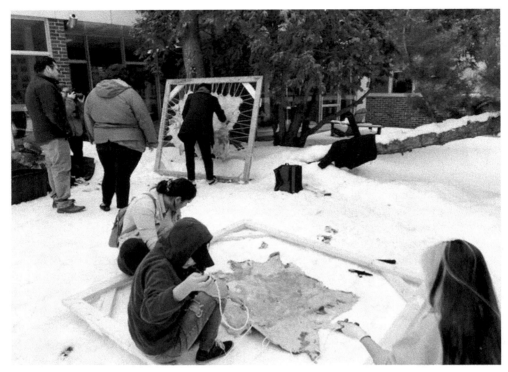

Figure G11.1: Benjamin Ironstand. *Students stretching and fleshing hides harvested from territory*, 2020. Photograph. Valley River. © Benjamin Ironstand.

Figure G11.2: Benjamin Ironstand. *Tipi liner*, 2020. Photograph. Valley River. © Benjamin Ironstand.

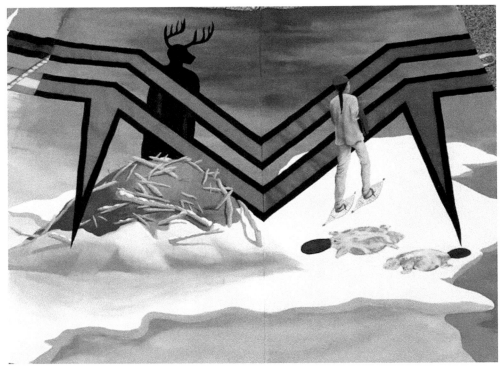

Figure G11.3: Benjamin Ironstand. *Tipi liner 2*, 2020. Benjamin Ironstand. Photograph. Valley River. © Benjamin Ironstand.

Chapter 11

(Random) Encounters in the Uncanny City

Chrysogonus Siddha Malilang

A nomadic poetic is a war machine, always on the move, always changing, morphing, moving through languages, cultures, terrains, times without stopping.

(Joris, 2003, p. 26)

In his time, Immanuel Kant was known more as the Königsberg clock than as a philosopher. It was said that everyone in Königsberg trusted him more than their clocks due to his routine walk every day. He never left the city limits and he was nothing short of adventurous. Despite these mundane routines, he emerged as one of the central Enlightenment thinkers and his *Critique of Pure Reason* has made him one of the most influential figures in modern Western philosophy. It was in these regular walks—known to the people of Königsberg as "The Philosopher's Walk"— that he played with and developed his thoughts, leading to several seminal texts that are still relevant today. This is perhaps best summarized by his statement at the beginning of his book, "I have traced a path which I will follow. When my advance begins, nothing will be able to stop it."

As argued by Frederic Gros (2014) in his book *A Philosophy of Walking*, "walking is not a sport" (p. 1). Walking is instead characterized as a thinking/inquiry method slower than any other method. This process of slowing down makes it possible for us to experience the "suspensive freedom" (p. 15)—a thinking space free from daily regularities and habitual familiarity. A short walk or a long excursion can thus transform into a "living inquiry [that] does not intend to pursue a particular thought; rather, it expands the thought and its practice to potential" (Irwin et al., 2018, p. 40). The freedom of movement in the walk/excursion both facilitates and embodies the random, directionless physical and mental roaming. This movement can potentially facilitate the slow expansion of thoughts through countless turns, both expected and unexpected. A "wandering mindset," as Smith (2016) called it, is at play here.

Contrary to a common misconception, a "wandering mindset" is not the state of being unfocused and unstructured. It is instead "a complete immersion in the current situation, a willingness to be open to whatever comes up" (Gros, 2014, p. 11). Just as the thoughts wander in multiple directions, they may be subjected to Deleuze and Guattari's (1987, p. 87; Malilang, 2017, p. 79) process of "deterritorialization/reterritorialization." Perhaps one of the fitting examples to illustrate these processes is by looking at the coffee beans. Coffee beans from a plantation in Brazil will surely taste different to those planted in Sumatra, Indonesia. Yet, when those Brazilian beans are plucked, they are freed (or deterritorialized) from the Brazilian geographical conditions. If the beans are then planted in Sumatra, some of the original characteristics will remain. However, the adjustment to the new geographic

condition (or reterritorialization) allows the beans to develop a new set of characteristics. In a similar manner, the wandering thoughts assume new sets of attributes or even transform into something new with each encounter. In combination with the physical movements during the walk, these multiplicities of thoughts and inquiries are given corporeal forms, paving the ways of "becoming" using the experiences as their bricks.

With the above-mentioned qualities, it is not strange that walking can also be used a/r/tographically to map the process of becoming an artist, researcher, and teacher. As an arts-based educational research practice, walking can "generate artistic making, critical reflection and scrutinizing temporality within a community of practice of artists/researchers" (Wenger, 1998 in Barney, 2019, p. 620). It also allows the a/r/tographer to express and disseminate his/her "knowledge generated by studying [...] experience which can encompass the physical experience of being in place, as well as the experience itself" (Malpas, 1999 in Hannigan, 2012, p. 85).

This chapter is an investigatory–exploratory cultural project about my process of becoming a creative writer through my walking across identities, cultures, places, and countries. Just like the coffee beans used to illustrate the Deleuzoguattarian concept of deterritorialization/reterritorialization, I have been plucked away from what I thought was my strongest root, Indonesia, to start my doctoral degree and process of becoming a creative writer in Macau SAR, China. How did all the walks across Indonesia and Macau affect or even change my identities? In order to further explore these various identities and changes, I used a walking proposition, "Explore the city and let the new, unfamiliar places invoke any picture of the past—both your past experience or an imagined past event that could have happened in that place."

Since it was (and still is) a journey, the chapter will take the form of an academic *haibun* (Malilang, 2019). Originally written based on Basho's *Oku no Hosomichi*, *haibun* is a traditional Japanese prosimetric travel account which combines essays and poems to capture different senses and thoughts that emerge throughout the journey (Malilang, 2019). In the context of this chapter, a going-back-and-forth between theories and poetry is used as the primary mode of expression.

The use of poetry in this *academic haibun* is chosen for its ability to best communicate the truth of experience; the truth that is felt and understood in the moment and at the same time, the truth that may shift and become something else (Leavy, 2010). Just as walking excursions provide an escapade from habitual familiarities to experience surroundings in a different way, poetry and poetic writing also rely on the creation of the uncanny—of detaching oneself from regularities and creating "a sense of foreignness" and "rediscovering the world through a new lens" (Kelen, 2011). Often, poetry is about wandering and getting surprised by the findings; the way, the feeling, and the thoughts just to name a few.

The opening(s)

Becoming, through a Deleuzoguattarian perspective, is a rhizomatic process driven by desire (Deleuze & Guattari, 1987). It shapes and follows complex structures in which various

multiplicities—lines, directions, identities, forms, and many others—are interconnected. Everything moves in multiple directions, and in the resulting construct neither the starting point nor the endpoint can be identified. As such, there is no definite starting point in the mapping of a rhizome. One can start by entering the structure through the openings. In this chapter, the mapping process will depart from openings within my own identity. Officially, it is easy enough to present myself as Indonesian. I was born there. My parents were born there. Yet, defining identity only based on the country of origin seems narrow, or as Chimamanda Adichi claims in her now famous TED Talk, as reducing identity only to a single narrative.

I was born as a mixed-race child between Javanese and Chinese parents. For years, I was encouraged by my family not to tell people about my half-Chinese identity. This secrecy was not done out of my or my family's hesitation or shame. It was instead a necessary precaution due to the aftermath of political unrest involving the Indonesian Communist Party in 1966. With China being one of the largest communist countries at that time, the Chinese-Indonesian ethnic minority automatically received the brand of communist, thus the enemy of the nation. This led to the mass killing of Chinese Indonesians between 1966 and 1970.

By the end of the 1960s, the New Order regime in Indonesia commenced a political campaign and slogan called the *Masalah China* ("Chinese Problem"). Following the political unrest related to the Indonesian Communist Party, all the Chinese Indonesians "were neutralized by a program, euphemistically called *pembauran total* ('complete assimilation')" (Chua, 2004, p. 466). Despite this planned assimilation, the Chinese Indonesians were kept visible through discrimination—"[w]hoever had a Chinese name and/or looked Chinese and/or could be exposed by official documents or questioning as Chinese had to pay higher fees or bribes" (p. 466).

Secrets

my real surname
is my family's
best kept secret

a chinese character
figure of a plum tree
in seven strokes

it's preserved in a calligraphy
my grandmother painted
two decades ago

as her brush moved
on a white paper
she told me the story

the story of her uncle
who went out with the army
and never came back

the story of her cousins
and their new names
she never got used to

the story of a letter
guarantee for the safety
of her family

a letter full of strange names
names chosen randomly for everybody
will it be the same old family?—she asked

no more surname for us
it can never be written down
it can never be acknowledged

only the calligraphy remains
a secret family insignia
kept on my grandmother's wall.

The duality in my identity granted me an opportunity, or perhaps a privilege, to settle only for the safer half—abandoning the other half in return. Instead of walking down that path, I found myself reverberating between the secret and the safe identities. Consequently, as "identity is conceptualized as 'sameness' of the features of individuals by which they are recognized as members of a community" (Lam, 2010, p. 658), I found myself trapped in the in-between space of racial identities. I am both identities and at the same time, I am neither. Within my identity construction, I did not have enough similarities to either ethnic group to be considered part of them. Without any strong sense of belonging, my position is similar to those of nomads, moving between places while navigating around and sometimes through various conflicts like a war machine. To drift is to fight in a perpetual battle.

This assemblage of drifting identities was complicated further when I encountered an offer to study creative writing in English, in Macau, China. I wondered if that was the opportunity for me to know more about the other half of my identity. Incidentally, Macau itself has a special place in my family's history. My great-grandfather stayed for a while in Macau before seeking refuge in Indonesia. His birth village is said to be located somewhere in close proximity to the Macau peninsula. By moving to Macau, I initiated

a movement, walking across borders, nations, and cultures. Is this a movement of going forward or backward?

first night in Macao

after five hours
of floating in the air

or a hundred years
since the sailing

a great escape
my great grandfather did

this place he transited
now I'll call it home

he could never
return

in flesh
his blood

that flows in me
now here afoot

he used to walk
or maybe run

whose house?
I won't know

what belonged to my ancestors
—will it still be mine?

should I stop asking
where home is?

should I instead
ask how?

A nomad

Could migration be understood as an iteration of walking? While Lee et al. (2019) present walking as a metaphor for immigration, I suggest that it may also work the other way around. Both processes address the state of being in-between the starting point and the point at which one has not yet arrived. It is the point where there is no at-home-ness while all else drifts (Joris, 2003). Gros (2014) defines this state of walking as "pilgrimage," experiencing the feeling of not at-home-ness where one is walking. It is the constant state of being a stranger, a foreigner. To capture this state of being alien, English became a logical choice for my working language in poetry writing. It was neither my mother tongue that could provide me with comfort and familiarity nor the language of my host culture, Macao. It is a foreign language from both perspectives. It has the capability of both making me further lost and at the same time capturing my experience and frames of mind of being a foreigner.

This choice to write everything in English instead of my first language is also in line with Joris' (2003) suggestion for aspiring poets, to write in a foreign language instead of using their mother tongue. With a foreign language, the writer will find it easier to make everything "foreign." What is automatized in the mother tongue might not translate literally to the target language. The nuances might be different in the translation. Or simply, the parallel words or concepts might not exist. This will lead to self-questioning and self-interrogation, forcing the writer to observe and investigate the concept/word that was previously taken for granted from various angles. Perhaps the best illustration for this process, as argued by Kellen (2011), is presented by Lewis Carroll in *Through the Looking Glass*, when Alice enters the Forest of No Name. The moment she steps into the forest, she forgets everything including her own name. Together with a fawn, she is forced to rediscover what she already knew before the forest. The temporary amnesia in this forest also allows the fawn to bond with Alice, forgetting her fear of humans.

Just like in pilgrimage, silence is an inevitable characteristic in the migration journey. Both migrants and pilgrims are tearing themselves away from the comforts of home and seek *xenateia*—the condition of foreignness to the world (Gros, 2014). Even when they encounter other people to rest, socialize, or seek sanctuary, there is a lack of similar social enthymeme—"a password known only to those who belong to the same social purview" (Volosinov, 1976, p. 101). In tradition-based events or celebrations, this condition could potentially further the feeling of isolation and/or void since the migrant is stuck in the middle space which belongs to neither the home culture nor the host culture. This *xenateia* provides the opportunity to revisit and initiate dialogues with the practised values for the sake of rediscovery.

Javanese New Year in Macao

stroke of midnight
can we tuck away
the insomniac island
music won't stop spinning
not even in bed will the lights go out
midnight I stood in the shower's trickle

cold trickling down to my toes
soul welcomed the shiver
my body danced with

midnight hosted
the feast of silence
the festival of purification

lullaby out of the trace of the breeze
blown from a child's cradle
laid in the navel

of the land where my heart still lies
breeze beckoning me to grace again
the old land of Java

*

Javanese New Year in Yogyakarta

simplicity celebrated
in the absence of sound
feast of void

no fireworks launched
no flashing lights
just this slow breath

then the big wash
soul purging trickle
under a moon's new sky

downtown a crowd
circulating in silence
attending earth's benediction

dawn of a new twelvemonth
life one less year to live
life only as long as this glass is to drink

joy of a new year
not in the banquet for the flesh
but in the calm of the soul

The walks

Fueled by the desire to further find my place (albeit temporary) and my own identity in this new environment, I started exploring the city. Instead of visiting the casinos and other famous tourist destinations, I decided to go off the beaten track and spent moments making sense of the architecture, the statues, or even just the nuances. I begin to make up my own fictional explanation and background story for them, often in playful manners involving little information about the Chinese culture that I grew up with or with the lens of spirituality from my Javanese side. Through those encounters, I created my own personal way of knowing, understanding, and being. The connections and ruptures are fostered through dialogues with ideas and one's surrounding environment and one's present self-in-relation is (re)imagined (Lee et al., 2019).

old court house, Macao

a ballroom for dust
never floats or dances
in the pillars light casts

only cobwebs dangle
silk drapes in still air
a cover for shadows

chandeliers hang lifeless
decades unlit
only rust can touch

floorboards creak
with creeping breezes
phantom steps

ghosts only come
for their last breaths
before vanishing

no wake or requiem
nothing to utter memory
in a city that never sleeps

During my walks, I realized that Macau and its identity are far from being a singularity. It is comprised of multiplicities and assemblages. After all, the city can be characterized as an assemblage, especially in grasping the generative nature of the city: "the momentum of historical processes and political economies and to the eventful, disruptive, atmospheric, and random juxtapositions that characterize urban space" (McFarlane, 2011, pp. 650–651). Despite being officially a part of the People's Republic of China (PRC) since 1999, it is difficult to fully see the people of Macau as Chinese. They accept being a part of China, but they never completely assume Chinese cultural identity. This hybridity is also encouraged by the new Macau government. The old, colonial exoticization of Macau as a point of encounter between the Portuguese-speaking world and China is kept. Portuguese remains an official language in Macau, despite there being more English speakers than Portuguese speakers in the city. The preservation of Portuguese influence got even stronger after the transfer of sovereignty over Macau from Portugal to the People's Republic of China in 1999.

The choice to promote the Portuguese colonial identity is done as a strategy to attract more international economic investments (Lam, 2010; Vong & Ung, 2012). The colonial identity in Macau has never been repressed and hybridity is encouraged. The people of Macau are also encouraged to take pride in their colonial past, incorporating Portuguese elements into their identity. This juxtaposition of multiple histories forms the city's cultural uniqueness and diversity (Vong & Ung, 2012), including the shaping and planning of urban spaces. While a small Buddhist temple standing proud next to the historical Ruin of St. Paul might seem random, this actually aptly reflects the multiplicities in Macau. The ubiquitous religious syncretism across the peninsula barely changes from the pre-Handover period (Lam, 2010; Vong & Ung, 2012).

My walk and my dialogue with the city are a meeting of assemblages. Following the Deleuzoguattarian perspective, this kind of meeting may result in new assemblages that reverberate and can even lead to the creation of a new plateau. In this kind of meeting, various aspects within both assemblages reverberate and resonate in a *glissement*—a Lacanian concept referring to the endless movement of signification in which the signified constantly slides beneath the signifier—which creates an instability of meaning and allows meaning to be produced continuously through retroactive completion of the signifying chain (Campbell, 1999, pp. 135–138). In a way, it is similar to repeatedly asking the Plutarch classic causality dilemma—which came first: the chicken or the egg? Does one signify/proceed the other or vice versa?

Ave A-Ma: Coloane, Macao

red temple behind me
marks the last stretch
of my hike to see her

it stays with me, the lingering
scent of incense sticks
from an altar below

it waits to break out
from my lungs to float
back of an ocean breeze

to rise up high before
a mother's face, star
of this vast ocean

noble lady in white
statued regalia
smile unmoved

a face familiar to
tales from my childhood
same lady, different names

dream of a mother
gentle arms open
too perfect for a corporeal world

my tongue unable
to utter devotion in
a language from around here

so I call her in my way
with a name from my home
with a solemn sign of cross

Despite partly having similar roots with the people of southern China, I have never really heard the story of A-Ma, the revered guardian deity of the Macao area and the hypothetical mother for people who live there. I grew up instead with the tales of Guan Yin and of Virgin

Mary. This ignorance actually resulted in an interesting, if not uncanny, inner dialogue when I saw the big A-Ma statue on top of a hill in Coloane, Macau. In an attempt to capture her mythological role as the goddess who watched over the ocean, her statue is standing firm facing the sea from a high peak.

Upon my first visit, my Catholic upbringing brought me a big question, "Is this the regional version of The Virgin Mary?" My brain recalled what I have learned before, how Catholicism first planted its roots in Asia through syncretism. The portrayal of Virgin Mary imbued with local attributes is not something strange. It happens in different parts of the world. Maria Kannon from Japan, for example, is a figure of Mary disguised as the goddess of Mercy, Kannon Bosatsu (McClelland, 2020). The strong Catholic influence in Macau further fueled my curiosity and drove the inner dialogue further. When I finally read the plaque that it was a statue of A-Ma, the feeling of *déjà vu* struck me. I started comparing A-Ma as the guardian of the ocean and one of Mary's titles, *Stella Maris* ("Ocean's Star").

The title of this poem is a play on the prayer to Mary, *Ave Maria*. While *Ave* means a hail or salutation, the Javanese translation of the prayer uses the term *Sembah Bekti*—implying "a complete devotion and sincere submission." Moreover, the Javanese uses the term *dewi* ("goddess") to refer to the Virgin Mary. This denotes a different, somewhat special position of Mary in the Javanese interpretation of Catholicism. She is portrayed in a similar light as the other feminine divinities, such as the traditional Dewi Sri (the Javanese goddess of rice), Guan Yin, and A-Ma. They are all seen as both loving mothers and powerful deities at the same time. Thus, the *déjà vu* or uncanny feeling is inevitable in this encounter.

The random sound

As atmosphere, according to McFarlane (2011), is also an important aspect in the construction of the city as assemblage, soundscape—as one of the building blocks for urban atmosphere—is an integral part of building the city's identity. Chattopadhyay (2013) characterizes the urban soundscape as "an amalgamation of overwhelming sensory interactions with the city's shifting landscape, encompassing the flux of people and life, which are part of the ongoing narrative of multilayered auditory experiences in the city" (p. 14). This also means that my own existence in the city of Macau has made me a part of that soundscape. As I walk around Macau, I experience this assemblage from within. I contributed to the shifting soundscape and at the same time being influenced by the sounds.

sounds of Taipa Park

computer faces me
sitting at a stone table
wordless, observing

babies in strollers
suck their thumbs
coo

kids on swings
eyes wild
screaming

young Filipino women
red lips and handbags
they spin tales

dogs on leash
run tongues out
bark

sleeveless shirted men
jog round, faces of determination
making out-of-breath sounds

grey haired ladies
stretch their joy
to music

old men sit
warm with their tea cups
reminiscing

as I do with these sounds
now the words
are here

*

watching fado in Macao

old fortress
under moon that blooms

gentle sea breeze
of a humid October night

husky contralto
belting the ballad out

from her throat
deep the waves
in which we swim
ears least perhaps

this is rhythm
all in the chest

where memory
is found

because of the words
all out of language

because as the singer says
this is heart's translation

While it may be true that creative writers have their own voice, their writings are never just the product of a singular voice. Poetry and other literary texts are, as Bakhtin (in Holquist, 2002) argues, vessels for multiple voices acquired both consciously and subconsciously. Bakhtin's original argument, however, concerns only ideological voices in the author's surrounding such as voices emerging from existing social structure, from the author's own social class, from the author's cultural background, and voices articulated by the historical forces at work in that time (Holquist, 2002). A/r/tography and the walking propositions complement this list with the more tangible voices, such as those from the urban soundscape. The heightened awareness from the immersion in walking opens up a space where these voices we might have taken for granted are made foreign, allowing the rediscovery of such sounds from a new perspective.

Postscript

Walking (and migrating) in the a/r/tographic frame is indeed a form of *currere*, the active form of curriculum with emphasis on the acts of inquiry instead of the resulting answer (Barney,

2019; Irwin, 2006). The knowledge gained through the process of inquiry is not only formed cognitively but also as embodied knowledge. Even in the period of writing this text, I realized that the walking propositions, both physically and virtually, expand the space of inquiry and generate an abundance of material—so much that one can get lost (Lee et al., 2019). Just like a living rhizome, the inquiry grows, not just in linear movement, but in multiple directions.

This exponentially growing space of inquiry grants the a/r/tographer a license to get lost. Through each encounter, through every stop to rest, a new turn—either expected or unexpected—will emerge. It is through these enriching distractions that the a/r/tographer might end in the unpredictable spot, the unforeseen one. I, for example, never thought that this very investigation would lead me to an exploration of tourism, urban planning, and urban soundscape, just to name a few. Meanwhile, various other unexplored fields of study and critical thoughts continue appearing—further expanding the space of inquiry.

A/r/tographers are never finished walking. They will sit and take a break for a while, ruminating and savouring the experience through the writing of texts like this, before continuing the excursion for further inquiry. Nobody, not even a/r/tographers themselves, can tell where they will end up next.

References

Barney, D. T. (2019). A/r/tography as a pedagogical strategy: Entering somewhere in the middle of becoming artist. *International Journal of Art and Design Education*, 38(3), 618–626.
Campbell, K. (1999). The slide in the sign: Lacan's glissement and the registers of meaning. *AngelAki*, 4(3), 135–143.
Chattopadhyay, B. (2013). Sonic drifting: Sound, city and psychogeography. *Sound Effects: An Interdisciplinary Journal of Sound and Sound Experience*, 3(3), 139–152.
Deleuze, G., & Guattari, F. (1987). *A thousand plateaus: Capitalism and schizophrenia*. University of Minneapolis.
Gros, F. (2014). *A philosophy of walking*. Verso.
Hannigan, S. (2012). A/r/tography and place ontology. *Visual Arts Research*, 38(2), 85–96.
Holquist, M. (2002). *Dialogism: Bakhtin and his world* (2nd ed.). Routledge
Irwin, R. L., LeBlanc, N., Ryu, J. Y., & Belliveau, G. (2018). A/r/tography as living inquiry. In P. Leavy (Ed.), *Handbook of arts-based research* (pp. 37–53). The Guilford Press.
Joris, P. (2003). *A nomad poetics*. Wesleyan University Press.
Kelen, C. (2011). Community in the translation/response continuum: Poetry as dialogic play. In G. Fischer & F. Vassen (Eds.), *Collective creativity: Collaborative work in the sciences, literature and the arts* (pp. 281–298). Brill.
Lam, W. (2010). Promoting hybridity: The politics of the new Macau identity. *The China Quarterly*, 203, 656–674.
Leavy, P. (2010). A/r/t: A poetic montage. *Qualitative Inquiry*, 16(4), 240–243.

Lee, N., Morimoto, K., Mosavarzadeh, M., & Irwin, R. L. (2019). Walking propositions: Coming to know a/r/tographically. *International Journal of Art and Design Education*, *38*(3), 681–690.

Malilang, C. S. (2017). Drawing maps for research in creative writing through a/r/tography. *Journal of Urban Society's Arts*, *4*(2), 71–88.

Malilang, C. S. (2019). A multicultural community of practice in creative writing. *Educare—Vetenskapliga Skrifter*, *2019*(2), 6–29.

McClelland, G. (2020). Mary, mothers, lament and feminist theology: The dead non-war heroes of Nagasaki. *Journal of Feminist Studies in Religion*, *36*(2), 85–106.

McFarlane, C. (2011). The city as assemblage: Dwelling and urban space. *Environment and Planning D: Society and Space*, *29*(4), 649–671.

Smith, K. (2016). *The wander society*. Penguin.

Volosinov, V. N. (1976). Appendix I: Discourse in life and discourse in art (concerning sociological poetics). In N. Bruss (Ed.), *Freudianism: A Marxist critique* (pp. 93–116). Academic Press.

Vong, L. T., & Ung, A. (2012). Exploring critical factors of Macau's heritage tourism: What heritage tourists are looking for when visiting the city's iconic heritage sites. *Asia Pacific Journal of Tourism Research*, *17*(3), 231–245.

Zhang, K. (2018). Being pregnant as an international PhD student: A poetic autoethnography. In M. Cahnmann-Taylor & R. Siegesmund (Eds.), *Arts-based research in education: Foundations for practice* (pp. 67–81). Routledge.

Grounding

My Body, My Spirit Is Tied to This Land

Marg Boyle

We have been here for at least a hundred thousand years. Horses have been our guides. They know how to live in herds, to follow the guidance of the matriarch. They always protect foals facing in four directions with the babies inside a circle. Their babies learn to stand and to walk, then to jump; in the first daylight hours of their first day. I am Sacred Maned Woman. My mom went to school by horse in the 1950s. I learned how to be a doula by helping horse moms. I sang them through labour, by helping them relax through their first nursing and by babysitting their foals. They trusted me because I have been part horse since birth.

I am L'nu. My body, my spirit is tied to this land. My ancestors have been on the shores of the ocean since before memory. They travelled inland each winter up salmon rivers to valleys protected from winter winds. I am Eagle Woman who Flies Outside the Universe, and I am tied to the land where caribou once lived, where cod was plentiful and where pepinau still picked. I am who my ancestors intended me to be and who my grandchildren need me to be. This land knows the trails of those who came before. It has witnessed genocide and land theft. My great-grandfather walked into the sea. I understand why he could not leave Mikmaki.

We were given clans to learn how to live in community with nature: from birds, fish, and animals. I am from the Gitpu clan, the Eagle clan. My clan comes from the lodge, and it tells me what roles I am to take in community. Being from the Eagle clan requires us to have an understanding of the gifts of the eagle; birds that can see things, fly close to the spirit world, and guide others. Eagles are leaders, but not in the European sense of leadership, rather be one who facilitates, sees from a distance the full picture, and points out the direction needed. I also descend from The Boyle clan of Scotland, whose insignia has a double eagle. Thus, I wear a tartan ribbon on my eagle dress. I am a mixed-race woman descendant of colonizers, slaves, from people of the land, yet I descend from resiliency, beauty, and the wind under my wings.

Ancestral Love is a core value I carry. We do ancestor feasts and spirit plates because we must feel gratitude for not only life given but for lessons taught. My ancestors come to guide me, in dreamtime, in ceremony, in prayers; they have my back. I hope to have loved as a good ancestor and to live as a good ancestor. The Christians who colonized our lands tried to shame us for praying to our ancestors. They still don't take the time to understand the simple teaching of ancestral love; they judge. We see our ancestors before us in the stories we carry and in blood memory, and trauma passed down. The past is right in front of us. Our children come behind us, it is to the next generations that we are responsible

for our decisions, and choices. Sadly, too many humans focus on the now and don't aspire to be good ancestors. They do not value their responsibilities to the next generations. *Msit No'kmaq.*

Figure G12.1: Marg Boyle. *Outside the universe*, 2022. Photograph. Gespeg. © Marg Boyle.

Figure G12.2: Marg Boyle. *The gifts of the eagle*, 2021. Photograph. Gespeg. © Marg Boyle.

Contributors

Tormod Wallem Anundsen is an associate professor of musicology and music education at the University of Agder, Norway, where he is also a founding member of the interdisciplinary research group *Art and social relations*. He came into a/r/tography through an interest in the methodological interactions between the practices of arts, research and education, and his current research and teaching particularly explore ethnography as a creative practice.

Kanami Ban completed her degree at the Graduate School of Education, Tokyo Gakugei University. She is currently an art teacher at a high school and specializes in Japanese painting, creating paintings of fantastic landscapes and nostalgic themes.

Sheila Blackstock is a member of the Gitxsan First Nation and is an assistant professor at Thompson Rivers University (TRU) School of Nursing. Dr. Blackstock is also a member of the board of governors for the B.C.'s First Nations Health Authority, representing the Interior region. Her research interests include Indigenous health, workplace bullying, and community and occupational health. She has more than 32 years of nursing experience, working in leadership positions and in rural and regional Indigenous nursing practice in speciality areas, community health, and occupational health nursing. Dr. Blackstock is a founding member of TRU's Indigenous Health Nursing Committee and its first chair, where she has directed the work of promoting Indigenous nursing education and curriculum development in partnership with Indigenous communities.

Marg Boyle (L'nu) from Gespeg/Gaspe is an artist and art-educator. She retired from teaching Art and Indigenous Studies in 2019 and continues to teach at the Ottawa School of Art in the Children and Youth programmes. She is also a sessional instructor in post-service Indigenous Education at Queens University. Marg is a full-time visual artist, curator, and community arts activist.

Kwang Dae (Mitsy) Chung is an artist, researcher, and early childhood educator. She is a Ph.D. student in curriculum studies in the Faculty of Education at the University of Western Ontario. Her doctoral research, which is funded by the Social Sciences and Humanities Research Council of Canada and the Ontario Graduate Scholarship, examines the

complexities of subjectification in early childhood education. Mitsy has been an early childhood educator for over fifteen years, with a primary focus on young children's drawings and aesthetic art. Her master's thesis, *Early Childhood Educator's Dialogical Engagement in Artmaking Space,* received the CAREC Research Award.

Peter Cole is a member of the Douglas First Nation, one of the *Stl'atl'imx* communities in South West British Columbia, and also has Celtic heritage. He is currently an associate professor, Indigenous Education in the Department of Curriculum and Pedagogy, in the Faculty of Education at The University of British Columbia. Dr. Cole has taught at universities in Canada, the United States and Aotearoa-New Zealand. He has played key roles in the development of the Aboriginal & Northern Studies degree programme at UCN; the Developmental Standard Teaching Certificate with four Vancouver Island First Nations communities to certify language teachers to teach their Indigenous languages in schools; and, while at Massey University, was invited by Maori colleagues to participate in the reshaping of the *pakeha Technology in the New Zealand Curriculum* document into *Hangarau: i roto i te Marautanga o Aotearoa,* a curriculum based on Maori spiritualities, knowledges, and technologies. Dr. Cole has been instrumental in initiating a dialogue with the Social Sciences & Humanities Research Council of Canada to be more inclusive and respectful of Aboriginal research protocols, epistemologies, and methodologies.

Yasmin Dean is the chair of child studies and social work and an associate professor of social work at Mount Royal University. Dr. Dean has extensive interest in the scholarship of teaching and learning including internationalization efforts in social work education at local and global levels. She is especially focused on the design of international field schools that commit to principles of collaboration and reciprocity. She has worked in South Korea and the United Arab Emirates and has participated in culturally dynamic initiatives with community and academic collaborators in Australia, Cambodia, India, Vietnam, and within the Canadian context.

Biljana C. Fredriksen is a professor of art and craft education in the Department of Visual and Performing Arts Education at the University of South-Eastern Norway (USN). She has been teaching early childhood education programmes in the USN's Faculty of Humanities, and Sports and Educational Sciences for over twenty years. Her Ph.D. (2011) focused on understanding preschool children's negotiation of meaning through experiential, explorative play with diverse materials. Since then, her research interest in young children's embodied forms of learning has been expanded to include more-than-humans: both more-than-humans' (alpacas', horses', etc.) experiential learning from their intimate relationships with physical environments, as well as human learning through complex interactions/intra-actions with more-than-humans and materials/matter. Fredriksen's most recent studies address ecological challenges, deconstruction of anthropocentrism in education, and enhancement of students' ecological awareness. Fredriksen has published two books in Norwegian, and a number of articles and book chapters in English.

Contributors

Chiaki Hatakeyama completed her graduate studies at the Graduate School of Education, Tokyo Gakugei University. She is currently an art teacher at a high school. She is a member of the Japan Art Institute. She specializes in Japanese painting and conducts practical research.

Jun Hu is the dean of the A/r/tography Research Center at Hangzhou Normal University. He considers himself an a/r/tographer and is the author of *The Cosmopolitan Character of Chinese Expressive Ink Painting*, which won "First Prize Award of Social Science Research Achievements of Zhejiang Province" in 2021, and chapter author of *Ma as a Machinic Component in Ma: Materiality in Teaching and Learning*, an edited book that won the "Outstanding Book Award Honorable Mention" of the Society of Professors of Education (USA) in 2020. Starting the A/r/tlink programme, he promotes "reverse inclusion" to engage social problems by empowering the disadvantaged with artistic creativity. The programme has won national and international recognition for functionality and ingenuity, including the "In/visible" that enables blind children to engage in printmaking, which has also won two Gold Prizes and one Award at the national level, and two Gold Prizes and one Copper Prize at the provincial level.

Seisuke Ikeda completed his studies at the Graduate School of Education, Tokyo Gakugei University. He is currently an elementary school teacher. His areas of interest are classes and workshops focusing on the expression of words and art.

Nanami Inoue completed her graduate studies at the Graduate School of Education, Tokyo Gakugei University. She is currently an art teacher at a high school, specializing in oil painting.

Benjamin Ironstand "*Niin Anishinaabe inini. Benjamin Piabiko-kabo n'dizhnikas. Makwa dodem niin da'ow. Tootinaowaziibeeng n'doondsay.*" I am Anishnaabe and I am a member of the Bear clan. My home community is Tootinaowaziigeeng First Nation in Manitoba. I am a practising multi-disciplinary artist. My foci include visual art, performance, and traditional arts such as beading and quillwork, drum making, and bow making. I am also a proud husband and hunter. I currently work at the First Nations Education Steering Committee (FNESC) in BC as the Jurisdiction Communications Coordinator to support First Nations in BC and negotiate sectoral self-government agreements in education with Canada and BC. I graduated from the First Nations University of Canada with a Bachelor of Indigenous Education and was the valedictorian.

Rita L. Irwin is a settler of European ancestry living on the traditional, ancestral, and unceded territory of the Musqueam First Nations. She is a distinguished university scholar and professor of art education and curriculum studies and former associate dean of teacher education and head of the Department of Curriculum and Pedagogy at The University of

British Columbia. Rita has been an educational leader for a number of provincial, national, and international organizations. Rita publishes widely, exhibits her artworks, and has secured a range of research grants, including a number of *Social Sciences and Humanities Research Council of Canada* grants to support her work in Canada, as well as internationally in Australia, China, Japan, Kenya, Norway, Spain, Taiwan, and the USA. She is best known for her work in a/r/tography that expands how we might imagine and conduct arts practice-based research methodologies through collaborative and community-based collectives.

Shelly Johnson (*Mukwa Musayett*), *Saulteaux* is the world's first Canada Research Chair in Indigenizing Higher Education and an associate professor at Thompson Rivers University. She is a member of the Keeseekoose First Nation and is an educator and researcher who has spent more than two decades working for Aboriginal communities. She has worked within the child protection field in varying capacities since 1984 and spent seven years as the CEO of Surrounded by Cedar Child and Family Services. Johnson earned her Doctor of Education in educational leadership and policy at The University of British Columbia. Her doctoral thesis examined the over-representation of First Nations children in the child protection system, and the social and political forces that put them at risk. In 2008, Johnson was recognized with a Governor General's Canadian Leadership Award and received an Honorary Citizen of the Year award from the City of Victoria, BC in 2006.

Koichi Kasahara is an associate professor of arts education at Tokyo Gakugei University, Japan. He received his doctorate from Kyushu University. His research focuses on methodological development of art education and teacher training programmes utilizing arts-based research, arts-based education research and a/r/tography, and collaborative social art education practices. He has published many articles and has a co-edited book titled: *A/r/tography: A Methodology of Living Inquiry as Artists/Researchers/Teachers* (in Japanese, Book Way 2019).

Takeshi Kawahito completed his degree at the Graduate School of Education, Tokyo Gakugei University. He is currently an art teacher at a Junior and Senior High School at Komaba, University of Tsukuba, specializing in painting and design education.

Anna-Leah King is an *Anishnaabe kwe* woman. She is the chair of Indigenization and an associate professor in the Faculty of Education at the University of Regina. Her doctoral dissertation focused on Anishnaabe song and drum in education using traditional story, experiences, archives, and Elder's teachings as a focus to move forward in Indigenizing education stemming from Anishnaabe worldview. At the University of Regina, Dr. King oversees the implementation of the Faculty of Education Indigenization commitment, liaises and supports the work of Elders and knowledge keepers, and provides guidance to faculty, staff, and students with respect to protocols and creates opportunities for faculty and staff to engage in learning and professional development with Indigenization.

Contributors

Momoka Kiyonaga completed her studies at the Graduate School of Education, Tokyo Gakugei University. She is currently an art teacher at a high school, experimenting with painting in various situations such as on a tree, in a field, or in a bath.

April Martin Ko is a MA student at The University of British Columbia and currently works as a pedagogist for the Early Childhood Pedagogy Network. Her pedagogical and research interests connect to the unfolding material and embodied relations that arise through living inquiry and encounters with place and artmaking. The methodologies of a/r/tography and research-creation guide her as she considers the ethical implications within these contextual encounters—thinking alongside Indigenous histories, cosmologies, and multispecies entanglements. As a person who is neurodiverse and also possesses intersected Indigenous and settler ancestry, April is an artist who experiments through dance, poetics, photography, and textiles to uncover what it means to dwell within the "in-between" spaces. It is with gratitude to the xʷməθkʷəy̓əm ("Musqueam"), sḵwx̱wú7mesh ("Squamish"), and səl̓ilwətaʔɬ ("Tsleil-Waututh") people that she may live and carry out her work on these unceded traditional territories.

Naoko Kojima completed her graduate studies at the Graduate School of Education, Tokyo Gakugei University. Her speciality is plastic arts. She is interested in the development of art education programmes and curricula in Japan and abroad.

Sheena Koops, born in Lampman, Treaty 2 Territory, Saskatchewan, to Bill and Mary Muirhead, is of Norwegian, Irish/Scottish, and Irish/Cornish descent. Her people immigrated into Treaty 4 Territory in the late 1800s and early 1900s while great, great, great grandparents immigrated into the Robinson Huron Peace and Friendship Treaty in the mid 1800s near Thesslon First Nation, Ontario. Sheena grew up on the farm in a teaching/farming family. She married Michael and together they became educators, living in Regina, Black Lake (Treaty 8 territory), Wolseley, and Fort Qu'Appelle. They share three daughters, two sons-in-law, and one granddaughter. Sheena's interests are table tennis, folk music, and horses. She is a Ph.D. student at the University of Regina, instructing sessional classes. Sheena works as a Nation Builder Advocate at Treaty Education Alliance in Fort Qu'Appelle. She is a past president of the Dr. Stirling McDowell Foundation for Research into Teaching.

Shannon Leddy (Métis) is a Vancouver-based teacher, artist, and writer whose practice focuses on decolonizing education and Indigenous education within teacher education. She holds degrees in art history and anthropology from The University of Saskatchewan (1994), and an MA in art history (1997) and a B.Ed. (2005) from the University of British Columbia. She earned her Ph.D. in 2018 at Simon Fraser University and is currently an associate professor of art education in the Faculty of Education at The University of British Columbia.

Jennifer MacDonald is an assistant professor in physical education and outdoor/land-based education in the Faculty of Education at the University of Regina. She completed

her Ph.D. at the University of Calgary. Her research arises from experiences with students on extended wilderness expeditions and focuses on how students make meaning with kinship relations in outdoor learning programmes. As a non-Indigenous educator, she is committed to modelling how all learning students can dialogue with topics of Truth and Reconciliaiton to understand themselves, and to interact with others, in ways that challenge colonial logic. Her work has been published in the *Journal for the Canadian Association of Curriculum Studies*, *McGill Journal of Education*, and the *International Journal of Qualitative Methods*.

Chrysogonus Siddha Malilang is a senior lecturer in English at Malmö University, Sweden, where he teaches children's literature, creative writing, and a/r/tography. He received his Ph.D. from Universidade de Macau with an a/r/tographic doctoral thesis, "A Cross-Cultural Community of Practice in Creative Writing" (2018). His creative works—short stories, young adult novels, creative translation, and poetry anthology—have been published in Indonesia, Macau, and Australia. He is currently serving as the editor of *Bookbird: A Journal of International Children's Literature* 2023–26.

Ken Morimoto is a doctoral candidate in the Department of Curriculum and Pedagogy at The University of British Columbia. With interests in arts-based educational research and philosophy of education, his research entails the development and exploration of conceptual landscapes as a way of study. As an uninvited visitor on the traditional, ancestral, and unceded territories of the Musqueam, Squamish, and Tsleil-Waututh Nations, part of his work involves addressing his a/r/tographic research as situated in between Indigenous, Japanese, and North American places and ways of knowing.

Yukito Nishida completed his graduate studies at the Graduate School of Education, Tokyo Gakugei University. He is currently an elementary school teacher. His speciality is clay sculpture, mainly mask making.

Pat O'Riley is an honorary associate professor in the Department of Curriculum and Pedagogy, in the Faculty of Education at The University of British Columbia. Pat has taught at universities in Canada, New Zealand, and the United States, in remote northern communities, First Nations reserves and the High Amazon of Peru. Her teaching is shaped by ecological, Indigenous, post-structural, and post-humanist theory and practices. Her research focuses on the intersections of social justice, ecology, technologies, and global capitalism. For the past two decades, Pat has been conducting research with Indigenous communities in BC in the regeneration of their traditional ecological knowledge and practices. Her research has expanded to include communities in the High Amazon of Peru to support them in their efforts towards community and ecological sustainability and to examine the significance of their traditional ecological knowings as counter-narratives to the predominant "progress" narratives offered in mainstream education.

Contributors

Patricia Osler is a public scholar and Ph.D. candidate in art education with Concordia University, Montreal, and is a director of the Convergence Initiative www.convergenceinitiative.org. Her research interests draw upon new materiality and the neuroscience of creativity, artistic and arts-based research, and museum education. Patricia's transdisciplinary practice aims to deepen understanding and awareness of arts-based approaches to critical thinking through embodied engagement with the environment and through artistic inquiry. Her work seeks connections emerging from the becoming, empowerment, and reciprocity of place-based artmaking, temporality, and materiality. Blending soundscape, image and narrative in her artistic practice, she explores the entangled exchange between memory and identity, the human and non-human, reimagining the discrete and integrated persona of the a/r/tographer.

Natalie Owl is an Ojibwa woman from Sagamok Anishnawbek First Nation on the northern Ontario shores of Lake Huron. She is a doctoral candidate in the Faculty of Education at the University of Regina, and a sessional lecturer at the First Nations University of Canada where she teaches Indigenous health. Her doctoral research is a multi-phase, mixed-methods study that includes digital storytelling. In her work, Owl explores Indigenous language education and two social determinants of health: cultural continuity (the transfer of traditional Indigenous knowledge between Elders and the younger generation), and self-determination (the ability for individual and community control of political, social, and education systems). Her master's thesis focused on the impacts of the residential school system and negative racist stereotyping on the Ojibwa language, known as *Nishnaabemwin*. Owl holds three undergraduate degrees in history, native studies, and Ojibwa linguistics.

Shauneen Pete is from Little Pine First Nation (SK) and is the mother of three independent and adventurous young people. She is a teacher, storyteller, and public speaker, and is currently a professor of leadership studies in Indigenous education, at the Faculty of Indigenous Education at the University of Victoria. As a teacher educator dedicated to anti-racist and anti-oppressive education, Dr. Pete has spent more than a decade doing the difficult work of engaging students with the realities of racism and colonialism. She is deeply committed to undoing the years of violence and silence towards Aboriginal peoples. She does this work in a generous way, by opening up spaces and inviting her students and colleagues to increasingly see themselves as allies and begin to act as such. This generosity makes even difficult conversations about systemic racism and colonialism productive, enabling us to move forward together.

Nicole Rallis (settler) is a doctoral candidate in art education and curriculum studies at The University of British Columbia. She is grateful for the opportunity to live and learn on the ancestral and unceded territories of the *Hul'qumi'num*-speaking peoples of the Cowichan Valley. Her research interests include a/r/tography, poetic inquiry, embodied learning, and land-based pedagogies. She is passionate about exploring how artists and arts-based

researchers can provoke complex discussions about human–land relations, and cultural and ecological justice. Nicole holds an interdisciplinary MA from the Institute on Globalization and the Human Condition at McMaster University, and a Joint-Honours degree in political studies and history from Trent University.

Gloria Ramirez is an associate professor at the Faculty of Education and Social Work at Thompson Rivers University in Kamloops, BC, where she teaches courses on reading, writing instruction, assessment and intervention of language-based learning difficulties, and research methods in education. Dr. Ramirez is interested in understanding children's biliteracy and bilingual development and the mechanisms that facilitate the transfer of skills across languages. She is also interested in identifying reliable reading assessment tools and effective language and literacy teaching strategies for minority groups and diverse populations such as English language learners, First Nations students, and children and youth from disadvantaged backgrounds. Recently, she has been examining innovative (e.g., digital technology) and culturally sensitive approaches (e.g., working with Aboriginal Elders) to revitalize Aboriginal languages.

Cathy Rocke is the dean of social work at the University of Regina. Her research programme is focused on addressing and evaluating how we reconcile the relationships between Indigenous and non-Indigenous peoples in Canada, both on campus and in the community through intergroup dialogue. Prior to her academic career, Dr. Rocke gained wide experience in both the education and social work fields, including developing postsecondary educational programmes for indigenous communities, diversity training for child welfare professionals, quality assurance for child welfare agencies, counselling women who were victims of domestic violence, and child protection.

Isabel Scarborough is a professor of anthropology and chair of the Department of Social Sciences at Parkland College. She holds a Ph.D. in sociocultural anthropology from the University of Illinois at Urbana-Champaign, where she is a research affiliate in the Anthropology Department and Center for Global Studies. Her latest work focuses on cultural heritage, nation-building, and spiritual imagined communities in the Andes, for which she was awarded a Mellon/American Academy of Learned Societies Fellowship. She has published in several academic journals. Her article *In Search of a New Indigeneity: Archaeological and Spiritual Heritage in Highland Bolivia* (2019) won the Thomas Robbins Award for Excellence in the Study of New Religions, by the American Academy of Religion. She is a contributing editor to the Library of Congress's *Handbook of Latin American Studies* and is currently co-editing the official introductory archaeology textbook for the American Anthropological Association in an open-access format.

Kanae Shimoji completed her graduate studies at the Graduate School of Education, Tokyo Gakugei University. Currently, she is an elementary school arts and crafts teacher in

Thailand. She specializes in art education and Japanese painting, and her artwork is based on the theme of nature in Okinawa.

Michele Sorensen, a woman of Mi'kmaq ancestry, is an associate professor in the Faculty of Social Work at the University of Regina. Social work practice with and for Indigenous populations is of prime importance to her, and in this regard her research focuses on curriculum and pedagogy of social work, the role of the professional associate in practicum experience, and benefits of community opportunities for engaging youth in the game of tennis. She uses new materialist philosophies to access diffractive research methods that focus on aesthetic experiences of embodied practices for generating difference and for augmenting feelings of capacity that can reconstruct one's sense of self in ways not aligned with binary thinking or easy polemics.

Mika Takahashi graduated from the Department of Education at Tokyo Gakugei University. She is currently working as a graphic designer for an advertising production company in Tokyo.

Valerie Triggs (settler) is a professor of arts education and visual arts education in the Faculty of Education at the University of Regina. Her research interests focus on the ecological impacts of art and aesthetic practice in extending classically scientific modes of research and pedagogies. In particular, her study concentrates on potential for educational practice and human adaptability that is generated when sociopolitical and cultural awareness appreciates a broader empiricism, one that includes human responsiveness and aesthetic realities which may be felt but are not directly accessible as sense data and rational understanding. Other areas of research include affect theory, diffractive methods, a/r/tographic research, new materialism, curriculum in the Anthropocene, and the field experience in initial teacher education.

Milton Keynes UK
Ingram Content Group UK Ltd.
UKHW050744070124
435498UK00002B/35